VICTORIAN
ILLUSTRATED
BOOKS
1850~1870

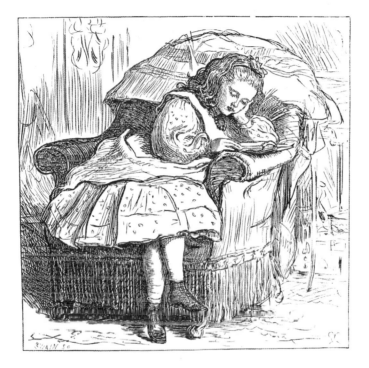

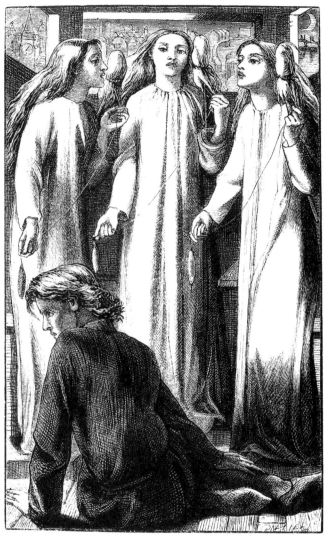

(*Frontispiece*) 1. Dante Gabriel Rossetti (1828–1882), 'The Maids of Elfen-Mere', facing p.202 William Allingham *The Music Master* 1855. 126 × 76mm. 1992–4–6–7

(*Half title*) John Everett Millais, 'The Sweet Story of Old', p. unnumbered, Henry Leslie *Little Songs for Me to Sing* [1865]. 99 × 98mm. 1992–4–6–165

VICTORIAN ILLUSTRATED BOOKS

1850~1870

THE HEYDAY OF WOOD~ENGRAVING

THE
ROBIN DE BEAUMONT
COLLECTION

PAUL GOLDMAN

David R. Godine · Publishers
Boston

For my parents, June and Alfred, and for Corinna

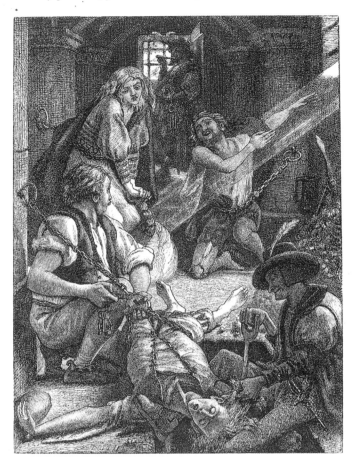

2. Ford Madox Brown (1821–1893), 'The Prisoner of Chillon',
p.111, R.A. Willmott (ed.) *Poets of the Nineteenth Century* 1857.
126 × 94mm. 1992-4-6-398

Book design by James Shurmer
Typeset by Create Publishing Services, Bath, Avon

First published in 1994 by David R. Godine, Publisher, Inc.
Horticultural Hall, 300 Massachusetts Avenue, Boston, Massachusettes 02115

ISBN 1–56792–014–4 LCC 93–81021

First American edition
Printed in Great Britain by The Bath Press, Avon

Contents

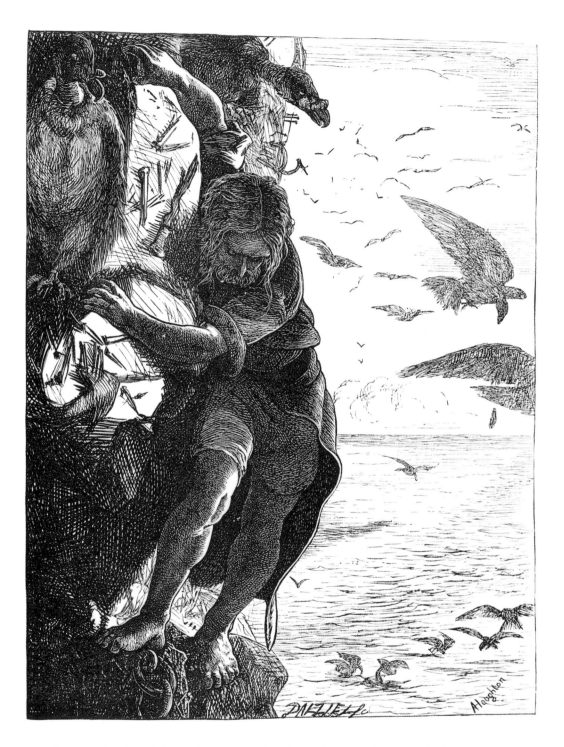

3. Arthur Boyd Houghton (1837–75), 'Agib ascending the Loadstone Rock', p.81 Dalziel's *Arabian Nights* vol. i 1865. 177 × 134mm. 1992–4–6–13

List of Illustrations

Within the main text the illustrations are arranged alphabetically by artist, with the exception of the four pre-1860s illustrations included for comparison in Chapter 1.

Colour Plates: Bindings
(*between pp 120–121*)

Preface

The purpose of this publication is to record the gift in May 1992 by Robin de Beaumont of the collection of 1860s illustrated books that he has formed over the past thirty years. As the checklist at the end reveals, it consists of 366 books, nearly 200 individual illustrations, a number of drawings and associated reference material. It is one of the most important collections of such material in the world, and is notable for the excellent condition of the copies of the publications that it contains.

The British Museum is most grateful to Mr de Beaumont for his generosity, which has ensured that there is available for students in this country a collection of these famous books such as they could otherwise now only find in American institutions. He has added to his kindness by contributing a short memoir, 'Collector's Progress', to this publication. In it he explains that one of the factors that led to the gift was the enthusiasm and knowledge of the subject shown by a member of this Department's staff, and it is Paul Goldman who has written this book to accompany an exhibition of some of the chief treasures from the de Beaumont collection. His own complete catalogue of the illustrations of the 1860s is on its way to completion, and will serve, like this book, to complement what Gleeson White and Forrest Reid have previously published.

The Department of Prints and Drawings in the British Museum has long possessed significant holdings of material in this area. While the Department of Printed Books formed part of the British Museum, its role was to complement what the Library held in the field of book illustration, and it acquired a large number of separately printed proofs of the wood-engravings used to illustrate these books, some corrected by the designers. These came both from the Swain and Dalziel shops, and number over 2,250. Most importantly, it purchased the Dalziel guard books in 1913. As is explained in the following pages, the Dalziel brothers were central figures in the story. They became the largest (though not necessarily the best) firm of wood-engravers, employing dozens of craftsmen, and commissioned many artists to draw designs for them. The forty-nine volumes in the Department were assembled between 1839 and 1893, and as each block was completed a proof was stuck in as a record: the total number of prints is about 54,000. Scholars have as yet hardly begun to exploit the material here, which ranges from proofs for *Alice in Wonderland* to illustrations of machine tools for trade catalogues.

But, despite having so many proofs for the illustrated books of the 1860s, the Department lacked the books themselves – and, as Mr de Beaumont explains,

many of these editions are not to be found in the British Library (where the British Museum Department of Printed Books has rested since 1973), or, if there, are now in poor condition after years of handling. The fragility of the paper and bindings of many of these books means that a heavy responsibility now rests on the Department to maintain the de Beaumont collection in good condition. However, the collection is now here to be used and enjoyed, and we hope that this book and the exhibition will introduce the beauties of this currently neglected field to a new generation of admirers.

Antony Griffiths
Keeper, Department of Prints and Drawings

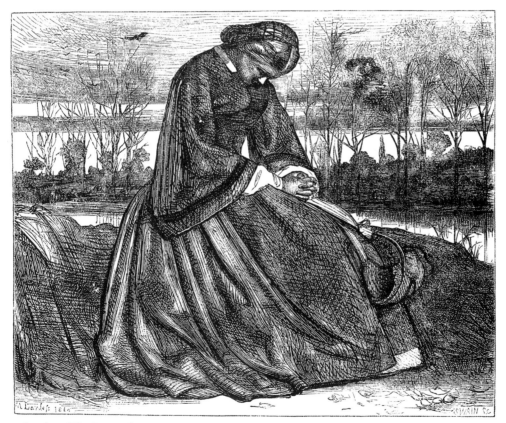

4. Lawless, 'The Betrayed', p.155, *Once a Week*, August 4th 1860, later reprinted in Thornbury's *Historical and Legendary Ballads and Songs* 1876 as 'The Wreck off Calais', p.145. 94 × 113mm. 1992-4-6-495

Acknowledgements

As with any project of this kind, there are many people who have helped me in various ways and to whom now I wish to pay tribute. First and foremost, I would like to thank Robin de Beaumont, not only for giving his collection to the British Museum and thus prompting this publication and exhibition, but also for his time and enthusiastic help and advice during their preparation. Leonard Roberts of Vancouver was initially responsible for introducing me to Mr de Beaumont, an introduction which turned out to be fortuitous, not only for me but also for the British Museum. Amanda-Jane Doran of the *Punch* Archive and Dr Gordon Huelin of the Society for Promoting Christian Knowledge both provided me with special insights into the archives for which they care. I have also benefited from discussions with acknowledged experts on the period, notably Rodney Engen, Simon Houfe, Simon Eliot and Professor W. E. Fredeman.

I must thank also the staffs of the British Library (Department of Printed Books, Department of Manuscripts and the Newspaper Library, Colindale), of University College, London (Routledge Archive), and of the University of London (Senate House) Library. Within the British Library I wish to thank my colleagues Peter Barber, John Barr and Elizabeth James for their assistance generously given. In the British Museum, Virginia Hewitt of the Department of Coins and Medals guided me through matters of economics, and, in my own department, I am especially grateful to Claire Messenger and Paul Dove, who smoothed out numerous technical and organisational problems, with energy and good humour.

I must thank finally my photographers, Graham Javes and John Heffron, and my editor at the British Museum Press, Carolyn Jones.

Paul Goldman

(*Right*) Detail of fig. 27

Introduction

This book aims to provide a new introduction to the books, the periodicals, indeed the entire phenomenon which was Illustration of the Sixties.

Traditionally, the illustrations have been discussed largely in terms of their artistic merit with little reference to the associated texts and overwhelming importance has been accorded to the work of the Pre-Raphaelites. Yet there are many other issues essential to an understanding of the production of the period: printing technology, the diversity of publishing practice, the nature of the readership, a whole variety of aesthetic, social, economic and educational developments, as well as matters of taste.

One of the points of departure is to establish how illustration at this period differed from what was produced in the 1830s and 1840s, and whether it is really correct to view the Sixties as an unique moment in English illustration. The books of the Sixties were preceded, in the 1820s and 1830s, by the Annuals. These essentially tasteful productions, aimed almost exclusively at women and children, were modest in appearance, small in size, and illustrated by steel-engravings, generally made after well-known paintings. It was unusual for any of these books to contain more than twelve engravings a volume. Although the engravings themselves were newly made, the paintings which they reproduced had sometimes been painted years earlier. In other words, these illustrations had little function beyond decoration.

By the 1840s, however, wood-engraved illustration, made specifically for literature, became popular and increasingly feasible, caused in the main by improvements in the technology of printing. The illustrators of this period, whose drawings were usually reproduced by wood-engraving, among whom were Mulready, Maclise, Horsley and William Harvey, produced delicate designs – nearly always vignettes, lightly printed and invariably respectful of, and subservient to, the text. (See figs 6 and 8.) A typical example of the genre is *The Vicar of Wakefield* 1843 (117), entirely illustrated by Mulready. Something of the motivation behind the designs for this book is revealed in a letter, only recently discovered by Robin de Beaumont. Written by John Pye (a contemporary engraver but not the one responsible for this particular book) to the publisher John Van Voorst, this passage recalls the attempt he made to persuade Mulready to undertake designs for the book. 'I took occasion, when seated beside him, to make him acquainted with it [the proposal], and to endeavour to induce him to make the designs for the Vicar, by pointing out to him the advantages that would result to his own reputation from making a series of designs illustrative of a moral subject that could be

looked at in connection with each other, after the model of Hogarth.'[1] The 'moral subject' was one which pre-occupied the Sixties artists just as much as their immediate predecessors, even though their artistic approach was very different. These later illustrators, emboldened by the intellectual rigour and self-confidence brought to the subject by the Pre-Raphaelites, practised within a milieu already partly created by artists like Mulready. There was clearly a market for imaginatively illustrated literature before the Sixties, but it was a smaller and far less highly developed one. A collection of illustrated literature of the 1840s would be diminutive compared to the one assembled here, since there are simply fewer books which are relevant. The massive growth in magazines as vehicles for illustrations both for literature and for journalism, which took place during the Sixties, also provided an impetus for book publishers, and it is this remarkable phenomenon which particularly distinguishes the period. Illustrations now increased in size, were frequently confined by borders, and often appeared full-page and printed on separate sheets, sometimes toned. The printing of many of the illustrations of this later period became increasingly black and strongly defined. In several cases the illustrations even came before the text: for example, in *Pictures of English Landscape* 1863 (259), Tom Taylor was asked to provide a text to complement Birket Foster's large designs. Thus, by the Sixties, the whole status of illustration had been transformed. It was above all J. E. Millais whose fluent grasp of the medium of wood-engraving and sensitivity to the portrayal of contemporary mores elevated the practice of the genre, even among many minor artists, to a truly distinguished form of visual culture. A markedly increased emphasis on realism, sincerity and truthfulness, albeit often tinged with nostalgia and even sentimentality, is a hallmark of the style of the Sixties. The remarkable change in illustration was acutely perceived by Ruskin, who wrote of the Moxon Tennyson 1857 (374) shortly after its publication, 'An edition of Tennyson, lately published, contains woodcuts from drawings by Rossetti and other chief Pre-Raphaelite masters. They are terribly spoiled in the cutting, and generally the best part, the expression of feature, *entirely* lost; still they are full of instruction, and cannot be studied too closely. But observe, respecting these woodcuts, that if you have been in the habit of looking at much spurious work, in which sentiment, action, and style are borrowed or artificial, you will assuredly be offended by all genuine work, which is intense in feeling.'[2]

(Right) Detail of fig. 17

Collector's Progress

by Robin de Beaumont

Michael Sadleir, in his Preface to *XIX Century Fiction*, lists the various stages by which he came to collect his major interest. Starting as an undergraduate with contemporary 'firsts', he progressed via French Symbolists, nineteenth-century Londiniana, books on coloured paper, obscure nineteenth-century private presses, Gothic novels and yellow-backs, to first and other editions of nineteenth-century literature in one to four volumes *in original cloth*. In my case I seem to have started at the expensive end and progressed downwards, beginning with eighteenth-century architectural books while on an RAF short course at Cambridge in 1944. With a school friend I managed somehow to acquire reasonable copies of Vitruvius, Vignola, Pozzo's *Perspective*, James Gibbs and the like, all of which had lain dormant in Cambridge bookshops throughout the war. This was followed by memoirs of the French Revolution in contemporary bindings, at the time a fairly easy task, but which later turned out to be disastrous when my interest lapsed and I wanted to get rid of them. At least the architecture books were readily saleable and, in fact, ten years later they went to Marlborough Rare Books, who were then also in Masons Yard, St. James's, where I worked. This sale provided for a holiday in Elba for my wife and myself, the making of a new suit, some new bookshelves and some old books, with still something left over. Once children started to appear I turned to Victorian children's books, not very original perhaps, but they were plentiful and generally affordable. However, when the first volume of the Osborne Collection in Toronto appeared in 1958, it became obvious that to do the field justice one would have to be a millionaire and live in a small castle. I had already seen what that kind of collecting involved on a visit to the Reniers in their small house in Barnes. Here all the books were double banked, the narrow hall being lined on both sides and the front room having a central cube of books as well as double banking all round the walls. The Reniers themselves seemed banished to a small rear addition.

Though dates are now rather hazy, it must have been around 1955 when I was in Thorp's bookshop in Albermarle Street one lunchtime talking to Mr Harris about 1860s illustrators, when a large, rotund American asked me if I was interested in them. Heywood Hill had recently given me a copy of Forrest Reid, the 'bible' for a Sixties collector, from which I learnt that many of the children's books I had already acquired and liked came into the period. I had also started to pick up Victorian publishers' bindings in fine condition, only to find that some of those books too were listed in the Appendix at the rear. What attracted me, apart from the fact that such books were often still in sparkling condition after a century, was

the sheer technical brilliance of the wood-engravers combined with the fine designs of the artists – though it must be admitted that there are a considerable quantity of excruciating designs in the period as well. To fully appreciate the skill of the engravers from the workshops of such families as the Dalziels, Swains, Thompsons and Williams's, one must understand just what one is looking at. For instance, Holman Hunt's illustration to 'The Lady of Shalott' on page 67 of the Moxon Tennyson is some 9.5×8 cm ($3\frac{3}{4} \times 3\frac{1}{4}$ in). In this, the magic web of her hair which she weaves surrounds her, flowing crazily through the whole design, changing as it goes from black to white and back to black again. Wherever it is white the wood block is incised; where black, the wood is cut away on either side to let the thread stand in relief. How anyone could perform such a miracle of precision seems quite incredible – and there was no electric light either. The design, though, is remembered as Holman Hunt's and the tiny signature of the engraver, John Thompson, needs a magnifying glass to be seen clearly. Yet at that time there was little interest in Victorian illustrated books, particularly if they were religiously inclined, and they could generally be had for the equivalent of about ten to thirty shillings (50p to £1.50) or about £5.50 to £17 at today's prices. The large American turned out to be Henry P. Rossiter, Curator of the Department of Prints at the Museum of Fine Arts in Boston, over in England to investigate the purchase of the Harold Hartley collection. This was possibly the finest collection of 1860s illustrators' material ever and had been used as a source for many of the illustrations in Forrest Reid's book. Hartley's son, Air Marshal Sir Christopher Hartley, happened to be a member of my club and I had, in fact, once discussed my interests with him, though I would not say I knew him.

To get some idea of the importance of this collection and the context of the sale, some background is necessary. The pioneering work on the subject is Gleeson White's *English Illustration: 'The Sixties' 1857–70*, published in 1897. White, co-founder and editor of *The Studio* in 1893, had formed his own collection of books by artists who treated their subject matter seriously and who were precisely unlike Leech, Cruikshank, or 'Phiz', the caricaturists who have always been so admired by English collectors and institutions. Indeed it would seem that those who favour one type of illustration seldom like the other. Gleeson White's book was sufficiently appreciated to warrant a second impression in 1903, followed by a third in 1906, but thereafter interest appears to have waned, though there was a detailed Victoria and Albert Museum catalogue of *Modern Wood-Engravings* (54) in 1919 which included all the major Sixties artists and which, for some reason, seems to be extraordinarily uncommon. Possibly as a result of the appearance of this catalogue, the largest and most prestigious exhibition on the subject that there has ever been opened in 1923, comprising the Harold Hartley collection together with a collection of original woodblocks belonging to J. N. Hart. It was held at the National Gallery, Millbank, no less, now the Tate, with Hartley writing the introduction to the catalogue himself. After some months the exhibition moved first to the Whitechapel Art Gallery and then on to Birmingham in

1924, with, astoundingly, a further move to Glasgow in 1925. Never before or since have the Sixties artists had such public exposure. Almost certainly as a result of all this activity, the next major work on the subject written for a modern readership, and correcting many of the errors in Gleeson White, appeared in 1928: the Irish novelist Forrest Reid's *Illustrators of the Sixties*. This was the stimulus for a new generation of collectors, which included such luminaries as John Betjeman, John Sparrow, John Carter and Reynolds Stone, though by 1955 all except Reynolds Stone appear to have moved on to other fields. Nevertheless, John Sparrow's books at Christie's South Kensington in December 1992 still had a few examples to record his interest.

If there were few private collectors in the inter-war period there were even fewer institutional ones. The V & A had been given the Harrod collection in 1933 but this, despite having some fine things, either was, or became, in sadly poor condition. In the 1950s an eccentric dealer in St. Martin's Court off Charing Cross Road acquired a considerable archive from the descendants of the Dalziel Brothers family in, I think, Hampstead, which included family photographs, account books, their own copies of works they had produced at the Camden Press and proofs of their illustrations in the original priced folders recording the price and number sold. This was offered to the V & A which purchased a few items but left the remainder in the dealer's chaotic upstairs room where they became 'lost', or at any rate dispersed piecemeal, some of them to me. The account books I think were never recovered.

Then in 1955 Harold Hartley's son wished to find a buyer for his father's outstanding collection of about a thousand proof wood-engravings, many with the artist's instructions to the engravers, 300 actual drawings, 80 wood blocks, including two for Allingham's *Music Master* of 1855, and nearly 500 of his Sixties books, together with an almost complete collection of the periodicals in which the drawings first appeared, not to mention a large collection of letters from the Dalziels to Hartley. Quite rightly Harold Hartley had said, 'I am anxious that the collection should not be broken up as it would be impossible to make such a collection again'. For this complete collection he was asking £3000 (about £34,000 at 1990 prices) but no one in Britain was interested enough. It took the far sighted Mr Rossiter to acquire it for Boston, where it languished in its packing cases for some considerable time but is now, at last, catalogued – though whether this will ever be published seems uncertain.

In 1965 the last major collection, this time belonging to the other participant of the 1923 National Gallery exhibition and now 'The Property of the Executors of the late J. N. Hart Esq' came up for auction at Sotheby's. The first part, Lots 623–820, appeared on Wednesday 3 February, the majority single lots dating from 1596 to Doves Press and with no more than half a dozen lots, if that, of Sixties books. These were reserved for 1 March and were catalogued thus: 'The following seventeen lots contain a large number of books collected by Forrest Reid in connection with his *Illustrations of the Sixties*, many of them with his signature.

The collection was extended by the late Mr. Hart'. Of these seventeen lots, Nos 94–110, five were single items, one contained the two major books on the subject (Gleeson White and Forrest Reid), five lots comprised a total of twenty items, another consisted of eleven books of Ruskin's works – and lot 102 was listed as: 'Nineteenth Century Book Illustration. A collection of over four hundred volumes and bound periodicals with illustrations by J. E. Millais, Walter Crane, Birket Foster, George du Maurier, John Tenniel, Arthur Hughes, A. B. Houghton and others, *the majority Forrest Reid's copies with his signatures, sold as a collection, not subject to return various sizes (a stack)*' (their italics). This stack, then, comprised the main collection of 413 books. I had spent most of my lunch hours over the previous fortnight closeted in an upper room at Sotheby's making a list of every book, recording whenever possible the association copies and those in exceptional condition. Once again no institution was in the slightest bit interested and it was left to another American collector, acting through Pickering & Chatto, to buy the major lot 102; lot 94 (*Dalziel's Bible Gallery*, the 1880 *Pictures of English Landscape* and the 1881 *English Rustic Pictures*); lot 95, a Sixties collection of 20 volumes including five presentation copies from the Dalziels with five ALs; and lot 101, a Phil May collection. The other buyers were a Miss Robertson (a single lot of Richard Doyle's *Manners and Customs* ...); Francis Edwards (three lots); Seligman (two lots consisting of the Ruskin and the two reference works); the Folio Society, Samuel Palmer's 1883 *Eclogues*; Quaritch, Palmer's 1889 *Milton*; Thorp (two lots, both reference); Joseph, one lot, non-Sixties; and Brimmell, lot 96, the only other Sixties lot of 37 items, including another *Bible Gallery*. It was this last lot which had some items I wanted and which, thanks to Max Brimmell, I was able to acquire. The Pickering lots went to that giant in every way, Gordon N. Ray, who subsequently gave them to the Pierpont Morgan Library in New York. In 1976 the Pierpont Morgan issued a magnificent catalogue for an exhibition of Dr Ray's collection, *The Illustrator and the Book in England from 1790 to 1914*, or rather what had begun as a catalogue and had been expanded into the first comprehensive study of 'a period during which England held its own in book illustration with any country in the world'.

In 1978, by a series of fortuitous accidents – including redundancy – I found myself in charge of a new department of Stanley Gibbons, the stamp firm, dealing in Antiquarian Books. This, apart from a fierce learning curve, meant that I was turning a hobby into a job and looking at hundreds more books than before. Victorian books, and especially Victorian illustrated books, had gained a little more acceptance generally as a result of Ruari McLean's pioneering *Victorian Book Design* of 1963, with the larger 1972 edition, and his *Victorian Publishers' Book-Bindings* of 1974, though McLean himself had always had something of a blind spot for Sixties books being a firm devotee of, and writer on, Cruikshank. Despite this increased interest there were still only a handful of dealers regularly featuring such books in their catalogues and even fewer aware of the relative scarcity of some of these books. It was, therefore, possible to make a speciality in

this field and build up an interest, both in this country and in America, Canada and Australia.

Over the years I had become convinced that there were a few incontrovertible bibliographical laws which went something like: collectors can be divided into those who read their books and those who don't; dealers can be divided into those who collect and those who don't; both collectors and dealers are in general a curiously different breed from normal mortals; and book collecting and family life are more often than not incompatible. Now fully employed in the book world I soon found confirmation that, quite probably, I was right. In the three years that the department flourished, before the firm was taken over and yet another recession forced the closure of most of the non-philatelic areas, it was possible to give Victorian illustrated books a higher profile than they had previously been accorded, a process I continued once I set up on my own. I also had a golden opportunity to upgrade and extend my own collection despite the strange fact that, although I saw so many more books and there seemed to be, still, relatively few private collectors and even fewer institutional ones, it became harder to find additions of substance. In 1964 Gordon Ray had issued a paper on 'Bibliographical Resources for the Study of Nineteenth Century English Fiction', in which he set out to show how few of the institutions in Britain and America held representative collections of the kind of books to be found in the Sadleir collection which had come to rest at UCLA. He chose certain key titles and had twenty-nine respondents (four private and twenty-five institutional) to seven categories, the last being 'Later editions of fiction with new illustrations'. His findings are of interest. 'The general conclusion which I draw from this survey is that first and significant later editions of nineteenth-century fiction are much scarcer than has been realised. The time has long since passed when a representative collection of the finest copies of carefully chosen titles such as Sadleir assembled could be duplicated. There is no library in England or in the United States which does not have a long way to go before its holdings in nineteenth-century English fiction can be regarded as adequate for serious literary and bibliographical study, and each year sees new university libraries giving continuous attention to the field. Hence competition for the limited number of available books is bound to be increasingly widespread and keen. Since this conclusion regarding nineteenth-century English fiction applies equally to most other areas in which research libraries are interested, my final word to those concerned with the acquisition programs of these institutions, scholars, librarians alike, can only be: "It is later than you think!"' Substitute illustrated books for fiction, and Hartley for Sadleir, and the words are prophetic.

So it was, that when I had a letter from the British Museum Department of Prints and Drawings in the summer of 1991 to say that they were interested in adding to their collection of 1860s illustrators, I sat up and took notice. There were two or three shelves of such books in stock and I was glad to think that at last they might have found such a suitable home. The only other British institution which had

shown the slightest interest over the years was the College of Librarianship in Aberystwyth, and this was because it had acquired a collection of books on Victorian Colour Printing and Signed Bindings put together in 1971 by Tony Appleton, a particularly far-sighted bookseller. This had been ably catalogued by Douglas Ball, whose resulting thesis *Victorian Publishers' Bindings* published by the Library Association in 1985, became the standard work on the subject. But Douglas had sadly died the month before his book came out – and the College's enthusiasm had died with him.

Following the British Museum's letter I was visited by Paul Goldman of the Prints and Drawings Department and it immediately became obvious that here was a truly knowledgeable devotee of the subject. By this time my own collection was taking up a considerable amount of space and, although I was always attempting to upgrade condition, additions were becoming ever more difficult. Having found an interest in such exalted circles it was not long before I was considering whether an offer to give my own books might be accepted. In the current climate it seemed unlikely that they would be purchased outright and in any case the actual cost over the years – about thirty-five as it happened – had not been that great, though to buy them now, if they could be found, would be a different matter. Once the subject was broached and the new head of the Department, Antony Griffiths, had paid me a visit and had subsequently shown me round his Department, the idea began to take shape. Strangely the suggested location for the books was in a room in which the Dalziel Brothers' own archives were situated. I had no idea that they even existed and certainly not that they were in the British Museum, and I quickly discovered that I was not alone in my ignorance, even though they were clearly listed in the Department's *User's Guide*. I was fairly strongly cautioned about what such a gift would mean and the restrictions that would be imposed; but in the event, as I rather suspected, far from restrictions I have been allowed to assist in cataloguing, working on different aspects such as binding designers and binders' tickets – all things that I have always wanted to do but knew that I would never get round to while the books were at home. Though in no way comparable to the Hartley collection, the attempt to make condition of importance and the fact that the collection has been put together over such a number of years means that it has its merits. It is particularly gratifying that it undoubtedly fills a gap in the Museum's collections. Hopefully the awareness of conservation, so apparent now, will ensure the collection's preservation in a way that might well not have been the case in the past, and I cannot think of a better place for it to be. Although admittedly a specialised field, the proposed exhibition will, I hope, introduce the merits of the Sixties illustrators and their wood-engravers to a wider and more appreciative audience.

Robin de Beaumont, *July 1993*

Reference Ray, Gordon N., *Nineteenth Century English Fiction*, School of Library Service, University of California, Los Angeles, 1964.

Notes

Numbers included after individual titles refer to checklist numbers, and these will also be found to be identical to the last number in the BM register number (see Checklist, pages 126–142). Where a title is mentioned in the text without a number, it should be assumed that the item is not contained in the de Beaumont collection. However, numbers are not always repeated for items frequently referred to, or where references to an item recur in quick succession.

Publication dates and names of authors, enclosed by square brackets, denote that this information is not given anywhere in the book, but is known from external evidence.

Books referred to, both in the text and in the notes (including reference books), are published in London, unless stated otherwise.

Within the main text the illustrations are arranged alphabetically by artist, with the exception of the four pre-1860s illustrations included for comparative purposes in Chapter 1 (see List of Illustrations p. 7).

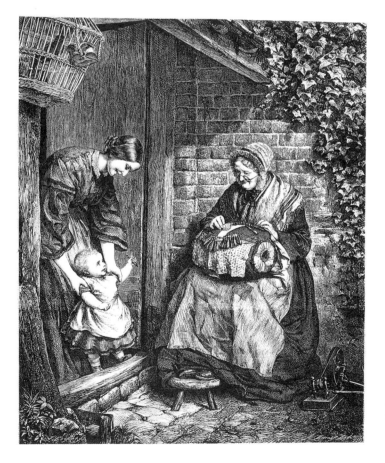

5. Robert Barnes
(1840–1895),
'At the Cottage Door',
plate 1,
Pictures of English Life 1865.
262 × 215mm.
1992–4–6–260

20

The Literature

Book illustrations or single-sheet prints?

There is a tendency to view the illustrations of the 1860s as works of art which somehow exist apart from the books and magazines which they were intended to ornament. It is understandably tempting to want to look at them like cabinet paintings in black and white, rather than as designs essentially intended to complement texts. Pioneering studies, such as those by Gleeson White (1897) and Forrest Reid (1928), helped to foster such concepts, while at the same time also raising successfully the status of the entire period and focusing public awareness on the high quality of many of the images. Even in more recent times, excellent exhibition catalogues, such as Belfast (1976) and New Haven (1991), have done little to redress the balance and to consider the illustrations in close relation to the text. One almost lone voice was that of the late Edward Hodnett who accurately, though arguably a little harshly, wrote, 'although mid Victorian artists made many splendid drawings they rarely produced a book full of vital interpretive illustrations'.[3]

The gift by Robin de Beaumont in 1992 of his collection of 1860s illustrators' books provides, therefore, an opportunity for a fresh look at the illustrations, at the very nature of the books themselves, and at the relationship between the two. This is not intended, however, as some subtle attempt to downgrade the artistic importance of the designs, but rather as a chance to examine the varieties of literature which lent themselves to particular genres of illustration.

Such an approach to these illustrations inevitably raises a number of questions. Two obvious ones are. Why was there in mid Victorian England so apparent a public need for imaginatively illustrated literature? And why do so many of the illustrations, lovely though they may be judged simply as drawings, often fit so awkwardly into the texts, as Hodnett observed? Perhaps a close examination and analysis of what the collection contains in terms of its literature may go some way towards answering this and other fundamental questions. It is essential, however, always to strive for a middle way between the extremes of either admiring these works as 'paintings in books', or denouncing them as Percy Muir (sharing Hodnett's view) does in a comment on Thornbury's *Historical and Legendary Ballads and Songs* 1876 (382): 'Beautiful though its pictorial contents are the Thornbury volume is a disgraceful piece of book-cobbling, which helps to show once again that throughout the period and beyond it the conception of a book as a unit was virtually non-existent.'[4]

One reason for the divorce between image and text was an organisational one,

mentioned by Gleeson White, who, together with Forrest Reid, did more than any other commentator to dignify the Sixties illustrators. In his chapter entitled 'The new appreciation and the new collector', he wrote, 'if you have picked up odd numbers, and want to preserve the prints, a useful plan is to prepare a certain number of cardboard or cloth-covered boxes filled with single sheets of thick brown paper. In these an oblique slit is made to hold each corner of the print.'[5] In these few words an attitude to these illustrations as 'prints' rather than as functional illustrations was created. Interestingly enough, the loose impressions included in the de Beaumont gift are mounted in almost just such a way (426–592) and it is not uncommon to find illustrations of this date kept similarly in other collections (notably in the University College of Wales, Aberystwyth, and the Hunterian Art Gallery, Glasgow) as well as some already in the British Museum collection.

Another point to be made, which helps to explain the traditionally problematic position of these illustrations in both the public and the scholarly perception, is the fact that – unlike some of their predecessors – they were not usually issued in single sheet proof form. For instance, proof engravings of Turner's illustrations to Rogers' poetry were readily available in the 1830s, as were those of the numerous artists whose pictures were engraved in the Annuals. It might have been expected, therefore, that Routledge or Dalziel would have seized on the opportunity to

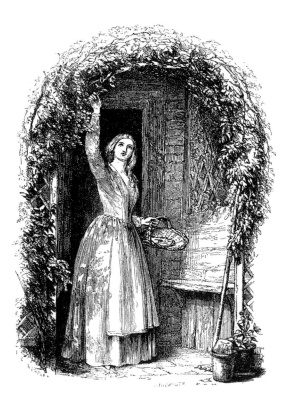

6. John Callcott Horsley (1817–1903), 'The Gardener's Daughter', p. 203, Tennyson *Poems*, 1857 (The Moxon Tennyson). A wood-engraving in a style popular before the 1860s. See the Introduction. 98 × 73mm. 1992-4-6-374.

7. Adoph Menzel (1815–1905), untitled woodcut vignette illustration, p. 488, Franz Kugler *Friedrichs des Grossen (Frederick the Great)*, Leipzig 1840. Of the 1860s illustrators, Keene and du Maurier in particular were influenced by Menzel. See Chapter 6.
101 × 130mm.
1921–2–15–160 b 37

market the wood-engravings of Millais or Leighton as separate prints, but in the event this almost never happened. A small number of Gift Books were issued at the time which contained collections of wood-engravings, often printed from the wood and on better quality paper, but these are seldom entirely satisfactory, either as books or as collections of designs. In a few cases, and years later, some de luxe editions were produced of Sixties books. An example is *Romola*, illustrated by Leighton, which first appeared in *The Cornhill Magazine* in 1863 and 1864. Some of the engravings were reprinted in *The Cornhill Gallery* 1865 (69), but a complete edition, carefully printed, containing all Leighton's contributions to the work, was not published until 1880.

A look at the constitution of the collection helps to evaluate the position of illustration itself in the wider artistic context.

The de Beaumont collection

The de Beaumont collection can be divided into at least twelve literary categories, although many of these overlap untidily. Nevertheless, it may be useful at this point to look at these divisions to see which areas were dominant in terms of illustration during the period. The categories which I have identified are as follows, arranged roughly in order of the number of books in each category:

1 Secular children's books
2 Secular poetry for adults
3 Religious poetry for adults
4 Religious prose for adults
5 Novels
6 Gift books and anthologies
7 Improving literature for children
8 Improving literature for adults

8. William Mulready (1786–1863), 'My compassion for my poor daughter . . .', p. 194, Oliver Goldsmith, *The Vicar of Wakefield* 1843. This is a typical 1840s illustration – see the Introduction. 77 × 89mm. 1992-4-6-117

9 Foreign literature in translation

10 Humour

11 Books for women and girls

12 Music.

The two largest groups by far are the secular children's books and the secular poetry for adults.

Children's books: secular and religious

The children's books can be divided into three further groups. The first and most obvious of these are new works which appear accompanied by designs made specifically for them. Examples of these are Lady Lushington's *Hacco the Dwarf* 1865 (186) and *The Happy Home* 1864 (187). *The Happy Home* is a particularly significant book because it contains Pinwell's first book illustrations. Others which fall into this area are Elizabeth Eiloart's *Ernie Elton* 1867 (99), illustrated by Arthur Boyd Houghton, and Mayne Reid's *The Boy Tar* 1860 (335), illustrated by Charles Keene. Undoubtedly this list could be enlarged but this is only one of the origins of these secular children's books.

The next group consists of reprinted established classics with newly commissioned designs. A clear example is offered by Thomas Hughes's *Tom Brown's Schooldays* 1869 (134), which is the sixth edition of a book that first appeared unillustrated in 1857. Here it re-emerges with the notable drawings by Arthur Hughes (no relation to the author) and others – which are surprisingly satisfactory – by the little-known Sydney Prior Hall. Another example is the frequently reprinted *Original Poems* 1868 (368) by Jane and Ann Taylor, whose names so rarely appear on the title pages. This was first published in 1804–5 in two volumes

entitled *Original Poems for Infant Minds*. The 1868 edition is illustrated by several artists including Robert Barnes and the underrated John Lawson.

A further group contains works which are reprinted in book form, having first appeared in other apparel, such as in parts, or (frequently in the case of the children's books) in magazines. The most obvious examples are the stories of George Macdonald, such as *At the Back of the North Wind* 1871 (190), which made its first appearance with Arthur Hughes's celebrated designs in *Good Words for The Young* (207)[6]. Once again the list might be lengthened, but the point to be made is that in this large category of secular children's literature, illustrators were hard at work supplying new designs for material of different types which had come to publication in various ways.

Judged purely in terms of numbers of works, and as represented in the collection, it is clear that secular material predominated over the religious and improving literature available for children in the period, but it must be stressed that even the secular books were always highly moral in tone. The simple fact that so many of the children's books here are not overtly religious in character may point to some subtle shift in the expectations of children, if nothing else. It is arguable whether a true line can be drawn between religious and improving literature, but I would include among the former Watts's editions of *Divine and Moral Songs* (392, 393) and a work such as *The Gold Thread* 1861 (198) by the Rev. Norman Macleod (illustrated chiefly by J. D. Watson) with the latter. One book which might fit into either category is George G. Perry's *History of the*

9. Alfred Rethel (1816–59), *Der Tod als Erwürger (Death the Slaughterer)* 1851, woodcut by Gustav Steinbrecher (1828–1887). Rethel's emphasis on death and mediaeval settings struck a chord with many 1860s illustrators. See Chapter 6.
310 × 274mm.
1862-11-8-112

Crusades, first published in 1865 (253), illustrated by J. Mahoney (d. 1882), which emanated from the Society for Promoting Christian Knowledge. The SPCK, together with the Religious Tract Society, dominated religious publishing at this date; the former organisation was responsible for vast numbers of illustrated books for children, most of which, with the notable exception of Mahoney, were illustrated by undistinguished artists. If the collection contained more books from these two sources, then the balance of numbers between secular and religious would be very different, but clearly the SPCK, while believing firmly in illustration as important in conveying its message, did not consider it sufficiently worthwhile to employ the greatest artists.

Secular poetry for adults

This is the second of the two most dominant literary categories to be considered. In terms of actual numbers of volumes, there are probably more such works in the collection than children's books, but many of these are variant editions of the same poet. The chief poet of this collection, and surely of the Sixties as a whole, is undoubtedly Longfellow. Indeed, there are no fewer than eleven copies of editions of his poems, ranging from the *Poems* 1852 (179), which is almost certainly the first English collected and illustrated edition, to the interesting and scarce *Chandos Poets* edition 1867 (182), with designs by William Small and A. B. Houghton. In the 1850s the Longfellow editions were dominated by the well-established artists, notably Birket Foster and John Gilbert, but by the Sixties, as already mentioned, a newer wave was beginning to take over. If Longfellow was the most illustrated contemporary poet of the period, he was closely followed by Tennyson and then by others such as Charles Mackay and James Montgomery. However, although this poetry was reasonably modern, almost without exception the illustrated editions were reprints of works which had already proved good sellers in unillustrated form. Only two clearly important examples of contemporary poetry, which are true first editions, appear in this collection. These are *Goblin Market* 1862 (342) and *The Prince's Progress* 1866 (344), both by Christina Rossetti. Dante Gabriel Rossetti made drawings for the frontispiece and title-page of both, and also designed the bindings, which compelled Alastair Grieve to write, in reference to the latter, 'The unity, balance and restraint found in Rossetti's designs were not rivalled until the first Penguins started to appear in the early 1930s.'[7] In the same article Grieve also refers to Rossetti's illustrations for *The Prince's Progress* and relates them to the binding design, suggesting that, at least in this book, there is something of the unity so often thought to be missing from books of this period. 'The design resembles the pattern of wrought-iron hinges found on medieval doors. It hints at the fairy-tale subject of the poem and Rossetti's own illustrations to it of episodes set in medieval interiors.'[8]

Earlier poets, such as Burns, Byron, Campbell, Goldsmith and Gray, also lent

themselves to illustration, and equally popular were poetry anthologies, usually, though not invariably, of reprinted material. A typical example is *The Poets of the Elizabethan Age* 1862 (265), illustrated by several artists including the ubiquitous Foster and Gilbert.

In contrast, two important and interesting books which manage to be both anthologies and gift books at the same time, and yet also contain new poems, are *A Round of Days* 1866 (346) and *Home Thoughts and Home Scenes* 1865 (127). The former, illustrated notably by Houghton, Pinwell and Frederick Walker, contains 'Original Poems' by William Allingham, Robert Buchanan, Jean Ingelow and Christina Rossetti. The latter, which also boasts that the poetry it contains is 'original', is entirely illustrated by Houghton, with poems by the leading women poets of the day. Even if one has the odd lingering doubt as to whether every one of these poems makes its very first appearance in these luxurious books, it seems fair to accept that most of them will have done so.

10. Henry Hugh Armstead (1828–1905), 'The Trysting Place', p. 363, *Poems by Eliza Cook* 1861. 138 × 116mm. 1992–4–6–68

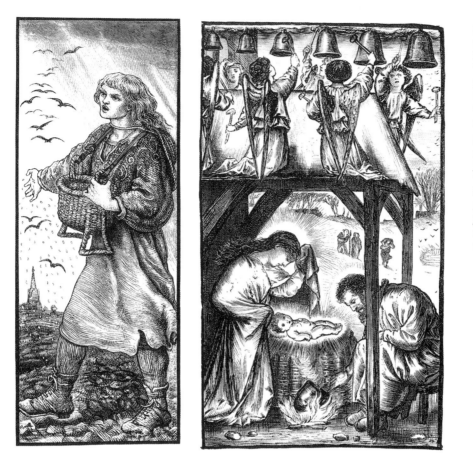

(*Far left*)
11. Ford Madox
Brown (1821–93),
'He that soweth ...',
p. 45, *Lyra
Germanica* 1868.
129 × 50mm.
1992-4-6-403

(*Left*)
12. Edward Burne-
Jones (1833–1898),
'The Deliverer',
facing p.205,
Mrs Gatty *Parables
from Nature* 1865.
140 × 79mm
1992-4-6-110

Religious books for adults

Religious and improving poetry and prose were also popular areas and proved
suitable for illustration. Almost all of the poetry was in the form of anthology
reprints, and two obvious examples are Willmott's *English Sacred Poetry* 1862
(399) (Holman Hunt, Watson, Keene, Sandys et al.) and *English Sacred Poetry of
the Olden Time* 1864 (101) (du Maurier, J. W. North, Walker et al.). One notable
exception is the outstanding Milton *Ode on the Morning of Christ's Nativity*
1868 (225) (William Small and Albert Moore et al.), which contains a single
major poem, and (unusually) is illustrated with several equally fine designs which
genuinely complement the text. Disappointingly, however, as with so many of the
books, the other illustrations do not reach so high a standard.

Another genre of religious publication which attracted illustration was what
might be termed the 'Biblical Gift Book'. These were religious texts or sections of
the Bible which were published sometimes in extravagant covers and frequently –
though not always – illustrated by one hand. The two most distinguished are
Millais's *Parables of Our Lord* 1864 (244) and Dean Henry Alford's *The Lord's*

Prayer 1870 (6), entirely illustrated by F. R. Pickersgill. Bunyan's *The Pilgrim's Progress*, which must rank among the most illustrated books of all time, was certainly not neglected by the illustrators of the Sixties. There are no fewer than seven different editions in the collection and two of the most distinguished are those illustrated by C. H. Bennett 1860 (39), and by Frederic Shields, originally published in 1864 (43). Some books can be viewed as 'improving' rather than as totally religious in content, and one such is Tupper's *Proverbial Philosophy* 1854 (387) (Tenniel, Foster, Gilbert et al.).

Novels

The novel dominated Victorian literature but it was rarely, if ever, illustrated at the outset, if published in volume form. Most of the illustrated novels represented in the collection, such as Trollope's *Orley Farm* 1862 (386) (Millais), were re-prints, having already proved popular in either part, serial or unillustrated three-volume issue. Trollope was seriously interested in illustration and published many of his works first in illustrated serial form rather than in unillustrated book form. *Orley Farm*, for example, appeared first in parts together with all Millais's drawings, while *Framley Parsonage* was initially published in *The Cornhill Magazine* (203), also with all the Millais designs.[9]

Many of the other novels in the collection, however, had originally appeared without any illustrations and this seems to have been the most common practice. The unillustrated 'three-decker' novel, which retailed at 31s 6d, was the more usual way for novels to appear if they did not begin life as part issues or in magazines. One such work is Thackeray's *Esmond* 1868 (378), which was first published in three volumes in 1852 without illustrations. Here it appears in a single volume, bound in uniform green publishers' cloth, with du Maurier's designs, which are new. A more contemporary novel, first published in a similar way, is *Citoyenne Jacqueline* by Sarah Tytler (Henrietta Keddie), which appeared in 1865 in three unillustrated volumes and re-emerged the following year in a single volume with a frontispiece and a title-page illustration by Houghton (388). It seems clear that novels had to win their spurs in the market-place before publishers would commit themselves to illustrated editions. Works such as those already mentioned which had first appeared in parts or serially with original illustrations were a surer bet for illustrated re-issue. However, straight reprinting of such works was not necessarily always the rule. Often it proved more economic to advertise an illustrated edition but, in the event, to cut down on the actual number of designs included. For instance, when Trollope's *The Small House at Allington* appeared in two volumes in March 1864, though it retained all the eighteen full-page illustrations by Millais which accompanied the novel when serialised in *The Cornhill Magazine* from September 1862 to April 1864 (203), the nineteen vignettes at the chapter headings were omitted.

Gift books

Two varieties of gift book – works of a religious or biblical nature and anthologies of reprinted and 'original poems' – have already been identified. A third, however, which seems almost exclusively a product of the Sixties can now also be isolated: volumes in which magazine (and sometimes book) illustrations are reprinted, frequently with little or no regard for their original settings. Some, such as *Millais's Illustrations* 1866 (223), reprint designs both from magazines and from books with no letterpress at all; others, such as *Pictures of Society, Grave and Gay* 1866 (261), reprint drawings which first appeared in the magazines published by James Hogg, but are here accompanied by wretched verses and newly titled. For example, Sandys's 'The Waiting Time' reappears as 'Lancashire's Lesson'. The book also reveals that the publisher, Sampson Low, possessed little skill in differentiating between important artists such as Millais, Watson, Sandys and du Maurier, and others whose names are rightly forgotten. In the Millais volume the choice is also a strange one, since many of the best and most expected designs are curiously missing. On the credit side, however, most of these books have the great advantage of printing the illustrations from the original wood blocks and not from metal electrotypes, as was normal in the case of the magazines. One of the best of these, both in terms of the choice of illustration and the quality of printing, is *The Cornhill Gallery* 1865 (69).

Humour

Humorous books in general fall outside the scope of this study, but two important examples are included in the collection. *Mrs Caudle's Curtain Lectures* by Douglas Jerrold 1866 (145, 146), illustrated by Keene, was reprinted from *Punch*. Unusually, the frontispiece is a colour lithograph rather than a wood-engraving. *The Story of a Feather* 1867 (147), also by Jerrold, is illustrated by du Maurier and is remarkable for its comic achievement, especially in the initial letters and the vignettes. Both these books were published by Bradbury & Evans.

Books for women and girls

Several books in the collection were clearly aimed at the female market, and one, *Home Thoughts and Home Scenes*, has already been mentioned. The poets, who were all women, included Jean Ingelow, Dora Greenwell and Jennett Humphreys and it is perhaps a little surprising that the designs were not similarly entrusted to a female illustrator, such as Mary Ellen Edwards, rather than A. B. Houghton. In the event, the result is remarkable, and the illustrations are anything but sentimental. As Robin de Beaumont has acutely commented, they are 'socially extremely interesting and almost surrealistic'.[10] A review from the *Daily News*, quoted at the back of *A Round of Days*, suggests the intended recipients of *Home Thoughts and Home Scenes*: 'A work which will be doated over by ladies and which will even be

(Left) 13. Burne-Jones, frontispiece, [Archibald Maclaren] *The Fairy Family* 1857. 147 × 100mm. 1992-4-6-195.

(Right) 14. Burne-Jones, *The Fairy Family*, title-page illustration. 147 × 100mm. 1992-4-6-195

tenderly regarded by those of the male sex who have an amiable fondness for children.' Other books transparently intended to appeal to women and girls are *Studies for Stories from Girls' Lives* by Jean Ingelow 1866 (141), illustrated by Millais, Barnes and Houghton, and the provocatively entitled *What Men have said about Woman* by Henry Southgate 1865 (363), illustrated by J. D. Watson. Doubtless this was a volume meant to be read openly by women, and probably less openly by their husbands. The text, not surprisingly, is eminently respectable.

Foreign literature in translation

Translations from other languages include, from German, Catherine Winkworth's two volumes entitled *Lyra Germanica* 1861 and 1868 (402, 403); and, from Breton, *Ballads and Songs of Brittany* by Tom Taylor 1865 (369). The latter, illustrated by several artists including Millais, Tenniel and Keene, was reprinted from the pages of *Once a Week*.

Music

Finally, there is a book of music intended for children: Henry Leslie's *Little Songs for Me to Sing* 1865 (165), illustrated by Millais. This apparently artless little book is, in its directness and simplicity, a gem; it shows that a major artist, on occasion, did not disdain to undertake something relatively minor, and in the process, enhanced it greatly.

Various useful insights can be drawn from this brief survey of the collection. The first and most obvious must be a recognition of the richness and the range of material which attracted illustration. This in turn leads to a sense of the wealth and the sheer volume of designs generated during the period, and, in addition, to some comprehension of the range of forms in which illustrations came before the public. The cavalier re-use of illustrations (often years after their first appearance) can also be appreciated. Furthermore, the remarkable variety of the de Beaumont collection, which is a microcosm of the literature of the entire period, should now be apparent.

15. Edward Dalziel (1817–1905), 'The Battle-Field', p. 261 *Bryant's Poems* 1854?. 138 × 100mm. 1992–4–6–33

The Explosion in Popular Publishing

The reasons why the 1860s saw such a growth in imaginative illustration, and indeed in illustration as a whole, must now be examined. This growth of creative illustration was paralleled in other areas, such as technical and topographical illustration, but both of these fall outside my brief here. Colour illustration too expanded by leaps and bounds, but this again falls beyond the scope of the collection.

The reasons for the increase come under three main headings: social/educational, economic and technical/mechanical. A combination of these factors created conditions ideal for books and magazines to attract illustrations in enormous numbers – many of them of a high artistic level.

The growth of religious publishing

Certain social and educational developments at this period encouraged a growth in the production of religious and improving literature intended both for adults and for children. There had been a massive increase in working-class literacy, brought about to a great extent by the influence of religious organisations. In 1780 Robert Raikes started the Sunday School Movement, and nineteen years later Hannah More, an ardent follower of Raikes, founded the Religious Tract Society (RTS). This was an inter-denominational – though firmly Evangelical – foundation, which during the nineteenth century became the largest distributor of Bibles and tracts, and, in the period under discussion, of improving works in general. The British and Foreign Bible Society (founded in 1804) added to the numbers and editions of the scriptures available at home and abroad, but more important in terms of illustration was the impetus given through the energy of these two organisations to a third, which had already been involved in publication for many years: the Society for Promoting Christian Knowledge (SPCK). Essentially High Church, it became increasingly active in the publishing and distribution of religious and improving material, much of it illustrated, during the period.

Thus, while the Sunday School Movement provided the means for the poor to acquire literacy, so these organisations produced the material to feed the minds of those who could now read and write. The sheer numbers of items distributed by the RTS and SPCK still make staggering reading. By 1861 the RTS was distributing annually about twenty million tracts and in addition thirteen million copies of periodicals.[11] The magazines which they distributed included several to which artists of the period contributed, such as the *Sunday at Home*, *The Leisure Hour*

(209), *Cottager and Artisan* and *Churchman's Family Magazine* (201, 202). It was in *The Leisure Hour* for 1866 that Simeon Solomon contributed his celebrated series devoted to Jewish Customs while *Churchman's Family Magazine* in 1863 was illustrated by Armstead, Millais, Lawless and Morten among others. Similarly the SPCK produced over eight million separate items of literature in 1867.[12] Both these organisations not only published their own material, but also distributed suitable publications produced by the commercial publishers. A typical example of a work published by the RTS is *English Sacred Poetry of the Olden Time* (101), already mentioned in Chapter 1, while another is *Our Life Illustrated by Pen and Pencil* 1865 (240), with illustrations by Barnes, Watson, Pinwell and du Maurier. *Art Pictures from the Old Testament* 1894 (15) was published by the SPCK but was, at its heart, a direct reprint of the celebrated *Bible Gallery* 1881 (21), which was illustrated by all the most prominent artists.

If these societies increased both the production and distribution of certain kinds of literature, how then did this material reach poor people? Even the cheaper books were probably out of reach of the very poorest, but it seems likely that many were purchased by the middle classes and given to the poor. Sales and circulation figures alone (see Chapter 4) are misleading indicators of how many people may have seen certain books or periodicals. The magazines, for example, were available for free perusal at the Mechanics' Institutes and other such organisations for self-improvement, while, then as now, magazines were passed from hand to hand and read by a number of people besides the purchasers. In addition, books reached those who could not afford them in other ways, most notably in this period in the form of prizes and rewards (see Chapter 4).

Literacy and reading

The State also played its part in the increase in literacy with the introduction (in 1862, in the Revised Code) of *Payment by Results*, which must be seen as a Victorian forerunner of the National Curriculum. The author was Robert Lowe, who prescribed for two-thirds of all children in school the subjects to be taken, the books to be studied and the nature of the examinations to be sat. Every failure per pupil per subject, lost the school 2s 8d from the following year's grant.[13] Lowe's attitude to education was hard-nosed, to say the least, and he wrote in his pamphlet *Primary and Classical Education* (1867), 'Hitherto we have been living under a system of bounties and protection; now we propose to have a little free trade.'[14] The grinding emphasis by teachers on rote learning to maintain funding, although hated by the children, meant that the number who could read adequately was increased, and hence the potential market for books, many of which were illustrated, was enlarged. Matthew Arnold was deeply critical of this method of education and believed rightly that the usual choice of mediocre literature for use as readers in schools meant that 'the whole use that the Government . . . makes of the mighty engine of literature in the education of the working classes, amounts to

(*Above, left*) 16. George du Maurier
(1834–1896), 'What ail's yo at me ?', facing
p. 194, Elizabeth Gaskell, *Sylvia's Lovers*,
1863. 138 × 88mm. 1992-4-6-107

(*Above, right*) 17. Du Maurier, title-page
illustration, Elizabeth Gaskell, *Cranford* 1864.
139 × 88mm. 1992-4-6-108

(*Right*) 18. Du Maurier, 'Unwelcome
attentions', facing p. 695, *Cornhill Magazine*
vol. 10, December 1864; in the serialisation of
Elizabeth Gaskell *Wives and Daughters*. (See
also fig. 20.) 158 × 108mm. 1992-4-6-203(j)

19. Du Maurier, frontispiece, 'Patty at her mother's bedside', Douglas Jerrold *The Story of a Feather* 1867. 110 × 143mm. 1992-4-6-147

little more, even when most successful, than the giving them the power to read the newspapers'.[15]

In the Public Schools the emphasis was more on physical development and was often fiercely anti-intellectual, apart from an overwhelming dedication to learning the classics. The result, as related by Pelham in Bulwer-Lytton's novel, first published in 1828, was likely to have been repeated many times over the years up to the Sixties: 'I was, at the age of eighteen, when I left Eton, in the profoundest ignorance.'[16] The uncomfortable fact that many of the Sixties books, both in this collection and in others, contain school prize labels, and yet seem never to have been read, can scarcely be unconnected to this phenomenon.

Economic conditions

If the increase in popular literacy encouraged by both Church and State ensured that conditions were suitable for more books and periodicals to be produced, so economic developments taking place at the same time helped to develop a market where more people than ever before could afford to read.

On 1 July 1855 the compulsory newspaper stamp duty was removed and this, coupled with the abolition of paper duty in 1861, meant that there were now no fiscal disincentives to publish either books or periodicals. In addition, the introduction of a North African grass, esparto, into papermaking, as a cheap substitute for rags at about the same time, helped further to reduce production costs.

The new financial atmosphere encouraged the growth of periodicals in particular, and the search was soon on to find new and potentially lucrative markets. The Newspaper Press Directory for 1865 lists 1271 newspapers and 554 periodicals published in the UK. Between 1830 and 1880 between 100 and 170 new maga-

zines (mostly to serialise novels) began in each decade, though many were short-lived. The ones relevant to this study are those containing illustrations to literature, and the collection contains fifteen of the leading titles. The three outstanding illustrated magazines were *Once a Week* (212), *Good Words* (206) and *The Cornhill Magazine* (203), all of which began publication at the beginning of the Sixties. The illustrated periodicals are directly relevant to any understanding of why there was a marked increase in the number of illustrated books in the period, and several of the books in the collection began life in periodical form. The works of Trollope have already been mentioned in this connection, but there were others. One example is Norman Macleod's *The Gold Thread* 1861 (198), which first appeared unillustrated in *Good Words* the previous year. Macleod was the editor at that time.

The illustrated magazines of the *Cornhill* type appealed to the well-educated

20. Du Maurier, 'Oh! It is no wonder', facing p.1, *Cornhill Magazine* vol. 12, July 1865. Another illustration for Elizabeth Gaskell *Wives and Daughters* (see fig. 18). 156 × 106mm. 1992–4 6 203(l)

middle classes, who nevertheless had relatively little spending money, while *Good Words* had a wider appeal because it catered both for a general and for a religiously inclined, though also decently educated, audience. Slightly lower down the social and educational scale came periodicals such as *The Leisure Hour* and the *Quiver* (216), while beyond these and even cheaper, and not represented in the collection, were periodicals such as the Temperance *Band of Hope Review* and the *Cottager and Artisan*. The most important point to make, however, is that all these magazines employed illustrators, some of whom were excellent, some adequate and some frankly poor.

There are two further economic factors which need to be considered. The first was the advent of free trade in bookselling. Since 1848 the Booksellers' Association had guarded the interests of the bookseller and fought against the practice of underselling which had gone on with the connivance of the publishers. In addition, it suited men such as Charles Mudie, with his circulating libraries, as well as his competitors, to keep book prices high. Cheaper prices would mean fewer

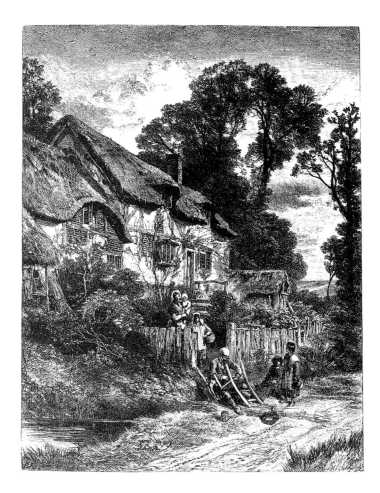

21. Myles Birket Foster (1825–1899), 'The Old Chair-mender at the Cottage Door', plate vi, *Pictures of English Landscape* 1863. 179 × 137mm. 1992–4–6–259

subscribers and lower profits. However, in 1852, the bookseller John Chapman challenged the domination of the Booksellers' Association in the *Westminster Review* and he garnered the support of Gladstone, the *Times* and the *Athenaeum*, and numerous authors.[17] Authors, in contrast to their publishers, were keen on large circulation figures, even if these had to be achieved by price-cutting. In April 1852 the matter went to arbitration, and a committee under Lord Campbell adjudicated. William Longman and John Murray argued vehemently in favour of protectionism, but with the powerful support of the Liberal press, and especially of Gladstone, the battle was lost. As a result, the Booksellers' Association was dissolved, and prices for books swiftly fell. The consequences were that over the next fifty years a bookbuyer in England both expected, and usually received, a discount on books of 2*d* or 3*d* in the shilling. A 6*s* book could be bought for 4*s* 6*d* (for cash) and a 3*s* book for 2*s* 3*d*.[18] Many of the books in the collection must have been subject to such discounted prices and it may be fair to presume that even the large gift books, which retailed at 21*s* and sometimes as high as 42*s* or more,

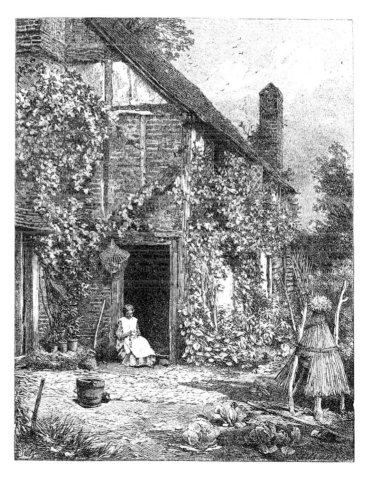

22. Foster, 'At the Cottage Door', plate xix, *Pictures of English Landscape* 1863 (see also fig. 21). 178 × 136mm. 1992-4-6-259

particularly if specially bound, could not have been entirely immune from such practices. (For more on prices see Chapter 4.) Many of the publishers and the more old-fashioned booksellers continued to complain, however, as did Alexander Macmillan to Gladstone in 1868: 'Few live by bookselling: the trade has become so profitless that it is generally the appendage to a toyshop, or a Berlin wool warehouse and a few trashy novels, selling for a shilling, with flaring covers suiting the flashy contents.'[19]

Finally, yet another economic change brought books within the reach of more people, especially the middle classes, who were the most likely to buy the kind of books under discussion. At this time, incomes in general rose, while prices fell sharply. The average yearly income of a lower middle-class family rose from £90 in 1851 to £110 in 1881.[20] At the same time and especially between 1874–96 (slightly outside the period) prices fell so much, that real income increased faster than wages, and during the half-century the average family's real income rose by between 70 and 80 per cent.[21]

These enormous economic changes were clearly major factors in providing a climate conducive to the production of books and periodicals. They also meant that it was now possible for publishers to offer reasonable fees to artists and for some, if not all, of these artists to make a living from illustration. By the same coin, the wood-engraving shops, such as those of the Dalziels and Swain, could employ skilled labour relatively cheaply. None of this could have been achieved, however, without the two technological catalysts: technical advances in the production of illustrations, and the increase in rail transport.

Printing technology

Wood-engraving, which was the method by which most drawings were reproduced during this period, was not new. Bewick and his pupils had employed it earlier in the century for illustration, and English wood-engravers enjoyed a vogue in France and Germany in the 1830s and 1840s (see Chapter 6). Several notable English books of the 1840s had used wood-engraving and one of the finest examples, *The Book of British Ballads* 1842, 1844 (124), is included in the collection. The Dalziel Brothers, by far the most prominent wood-engraving firm in London during the period, were already active in the 1840s.

Three technical developments made wood-engraving the preferred method for large book editions and huge numbers of periodical issues. First was the decline in the use of the hand-press and its replacement by much quicker power platen presses and cylinder presses; by the late 1850s the laborious hand-press was almost a thing of the past. The Dalziels wrote that the first edition copies of the Moxon Tennyson 1857 (374) 'were done at the old hand press, for at that time cylinder machine work was not considered good enough ...'[22] Clearly they felt that hand-press work was already old fashioned in 1857. By the middle of the 1860s the hand-press was used only for the most expensive and luxurious of the

gift books. According to Martin Hardie, Edmund Evans employed a hand-press for the last time for *A Chronicle of England* (1864).[23]

Another development of equal significance was the discovery of electrotyping in about 1839 by Thomas Spencer of Liverpool and others. In 1840 he published a book called *Instructions for the Multiplication of Works of Art by Voltaic Electricity*, in which he outlined his methods for making electrotypes, and in April the same year the first electrotype illustration published in England appeared in the *London Journal of Arts and Sciences*.[24] Within a short time many books and most periodicals used electrotyping for their illustrations. This was a fundamental and far-reaching change in procedure, which greatly increased both speed of production and the numbers of impressions which could now be printed. The woodblocks were retained in case new electrotypes proved necessary and, on occasions, especially for luxury books such as the *Cornhill Gallery*, were themselves employed for the actual printing of the designs.

23. John Gilbert (1817–1897), 'The Skeleton in Armour', p.103, H. W. Longfellow *Poetical Works* 1857 (first published 1856). 126 × 95mm. 1992–4–6–181

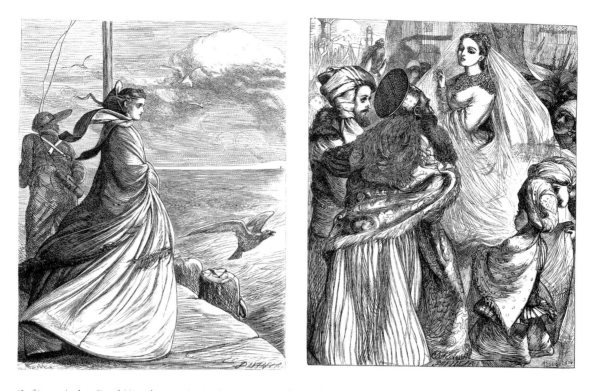

(*Left*) 24. Arthur Boyd Houghton (1836–1875), 'Outward Bound', p. 71, *A Round of Days* 1866. 165 × 126mm. 1992–4–6–346

(*Right*) 25. Houghton, 'Queen Labe unveils before King Beder', p. 449, Dalziel's *Arabian Nights*, vol. ii 1865. 175 × 136mm. 1992–4–6–13

Finally, photography had an increasingly important part to play in transferring drawings on to wooden blocks of boxwood, ready for the engraver to cut. The process was first used as early as 1839 for an illustration which appeared in the *Magazine of Science* on 27 April, but for some reason does not seem to have been used for book illustration for over twenty years.[25] One great advantage in using photography for this purpose was that the original drawing could be preserved by the artist and was often sold, thus enabling him or her to be paid twice for the work. When drawn direct on the block, the original design was inevitably disfigured by the engraving process, and blocks were often destroyed in large numbers when their usefulness was outlived. According to Henry Bohn, it was Thomas Bolton who first applied the process to book illustration and the book in question was *Lyra Germanica* 1861 (402).[26] Just how extensively photography was used in this way during the period is difficult to estimate with any accuracy, but there can be little doubt that its employment was widespread. Its use was just one more factor in the mechanisation of wood-engraving, which confirmed its role as a key medium in the reproduction of artists' drawings at this time.

One other technical development was of crucial significance to the growth of publishing in the Sixties, and this was the virtual completion of the rail network which had been achieved during the previous decade. The distribution of books was made simpler and more efficient, aided by the low carriage charges. Improved postal services also made ordering and payment less of a problem, hence any book advertised by publishers or booksellers could now be obtained easily, anywhere in the country.

It is incautious, however, to assume that illustrated books were necessarily available at the railway bookstalls operated by W. H. Smith. By the end of the Sixties, Smith had over five hundred railway bookstalls nationwide but these tended, as a rule, to provide the cheaper (and largely unillustrated) 'railway reading'. Such reading, however, was part of a general climate propitious to literature as a whole, even if the perusal of de luxe editions took place chiefly in the home. Magazines, periodicals and part issues were certainly available at the bookstalls, and it is more than possible that fractious children would have their illustrated books or magazines packed for them, to help while away the hours of a

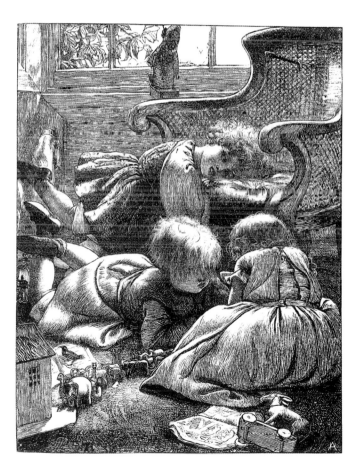

26. Houghton, 'Noah's Ark', p. 2, *Home Thoughts and Home Scenes* 1865. 177 × 135mm. 1992-4-6-127

long train journey. Rail travel confined travellers in metal boxes for extended periods and these boxes were much more stable than the coaches on the roads. It was genuinely possible to read on a train in a manner impossible in the arguably more picturesque, but bone-numbing, carriage.

All the social, educational, economic and technical changes which were taking place during the Sixties go some way towards explaining both the growth in popular publishing and the increase in wood-engraved illustration. Publishers had the means, both technical and economic, to supply increased quantities of illustrated material, and an enlarged and more prosperous public arose to meet and consume what was produced. In other words, illustrated literature fed and nurtured a readership with ever extending expectations. The idea of a visually starved British public eager for illustrations is an attractive but a misleading picture. It is closer to the truth to suggest that the means stimulated the demand. The fact that there was so much produced of a high artistic standard is, however, remarkable and this aspect will be dealt with in Chapter 5, The Artists.

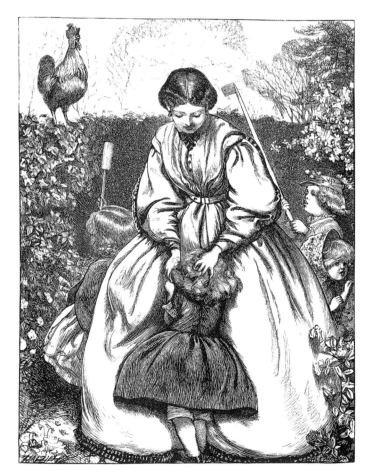

27. Houghton, 'The Enemy on the Wall', p.14, *Home Thoughts and Home Scenes* 1865. 176 × 133mm. 1992–4–6–127

CHAPTER THREE
Publishers, Editors, Engravers and Entrepreneurs

Leaving aside the artists, it is clear that protagonists from at least four separate groups made substantial contributions to book illustrations of the 1860s: publishers, editors, engravers and entrepreneurs. The publishers and engravers could also be seen as entrepreneurs, but for clarity I have reserved this title for Mudie, the operator of circulating libraries, and for Smith, the bookseller. Much has been made, quite rightly, of the role played by these two in the book world of the period. More tricky to discover is how significant an influence they had on illustration.

Publishers

The de Beaumont collection provides examples of the output of most of the major firms and many of the lesser ones during a busy period in publishing history. It is fair to say that most publishers operating at the time used illustration to some extent in their productions. It is worth noting that much of the literature illustrated during this period, almost as a matter of course, would probably be unillustrated now. For example, adult novels today are not illustrated and nor is poetry, as a rule. Private press books are another matter altogether, but they are entirely different in spirit from the 'trade' books which the collection contains. There is no comparison to be made between these books and the special productions of the Whittington Press, Gregynog and the Folio Society of today. They have two features in common, however: the continued use of wood engraving as a medium, and the commissioning of artists to make original designs. In other words, public expectation has altered. Today it is only in the field of children's books that new illustration is normal and indeed usually a prerequisite.

Although most publishers realised that sales could be enhanced by the inclusion of illustrations, there were two in particular who were outstanding for the range and the quality of what they produced. They were George Routledge and Alexander Strahan.

Routledge (1812–88) made his name first as a distributor of remainders and a publisher of reprints. In 1848 he started the 'Railway Library' which 'bestrode the bookstall market for decades' and by 1898 comprised 1300 titles.[27] In the field of illustrated books, he was no less adventurous. He published most varieties of literature, and not all of it by any means was reprinted material. He was responsible for William Allingham's *The Music Master* 1855 (7), illustrated by Millais, Arthur Hughes and Rossetti, a book which is frequently seen as the first to contain

a genuinely new type of illustration. Rossetti's single contribution 'The Maids of Elfen-Mere' had a profound influence on the Pre-Raphaelites and many of the other illustrators. Routledge published new children's books such as Adams's *Balderscourt* 1866 (1), with illustrations by Houghton, as well as Dulcken's anthology *The Golden Harp* 1864 (94), with designs by Watson and Joseph Wolf among others. The latter is especially interesting since it contains translations from German writers for the young, notably Matthias Claudius, Rückert and Hans Sachs, and reveals that there was an interest at this time not merely in German art (see Chapter 6), but in German literature as well. This interest stemmed from the 1840s, when translated editions of German sentimental texts, and especially of ballads, had become very popular. In addition, Routledge published books for girls, such as Owen's *The Heroines of Domestic Life* 1862 (242), as well as ubiquitous poetry anthologies, all extensively illustrated, such as Eliza Cook's *Poems* 1861 (68). Indeed, there were few categories of literature with which Routledge was not concerned. Finally, and of particular importance here, Routledge published virtually all of the major Gift Books. A complete list would be a lengthy one, but suffice it to say that in 1864 he published Millais's *Parables of Our Lord* (244) and seventeen years later brought a much delayed giant before the public – Dalziel's *Bible Gallery* (21).

Given Routledge's important contribution to the publication of illustrated books, the Routledge Archive (University College, London) might have been expected to throw light on the role played by Routledge himself in the commissioning of illustrations. However, the Archive is possibly the more telling for what it omits, rather than for what it includes. Routledge appears to have concen-

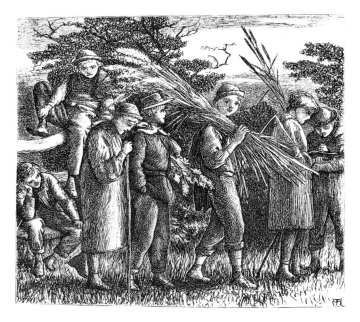

28. Arthur Hughes (1832–1915), 'Tom's earliest playmates', p. 60, [Thomas Hughes] *Tom Brown's Schooldays* 1869.
93 × 105mm. 1992-4-6-134

29. Hughes, 'While Enoch was abroad', p. 10, Tennyson *Enoch Arden* 1866. 76 × 113mm. 1992-4-6-371

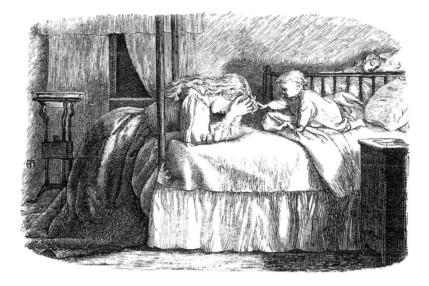

trated his activities on the book publishing side, and entrusted most of the dealings with the artists to his engravers, the Dalziel Brothers. The letters between the artists, authors, recipients and the Dalziels seem to suggest that, at least in the case of Routledge, it was the Dalziels above all who handled matters concerning illustration. One example from the collection serves to illustrate the crucial role played by the Dalziels here. It was written by Effie Millais (addressed, presumably, to Edward Dalziel) thanking him for the gift of a Routledge book: 'it is so very kind of yr brother and you to remember me as Christmas comes round with your sweet books and this year with yr. lovely songs'.[28] The point here is that the book was sent not by the publisher, but by the engraver; furthermore, Effie Millais refers to the books as essentially being the achievement of the engravers.

Even more interesting, however, are the numerous letters between artists and engravers in other collections. Among the most significant are those from Millais to the Dalziels concerning the *Parables*, a notable Routledge book, and arguably Millais' masterpiece. Although they have been much quoted, one example (undated but probably *c.*1859) will serve to highlight the close relationship between artist and engraver. 'I am determined to be always at work upon them. It is almost unnecessary for me to say that I cannot produce them quickly even if supposing I gave *all my* time to them, – they are separate *pictures* and so I exert myself to the uttermost and make them as complete as possible. I can do ordinary illustration as quickly as most men, but these designs can scarcely be regarded in the same light.'[29] Here Millais gives yet another reason why these illustrations are so often treated apart from their texts.

The Dalziels sum up Routledge and his attitude to publishing in a telling, but probably accurate way. Referring to the edition of Longfellow's *Poems*, which Routledge first published in 1856 with Gilbert's illustrations (181), they wrote:

'We remember asking Routledge what he thought of it. He was a pure business man. His reply was: "We will wait and see what the trade has to say about it first – see whether they will subscribe largely, and then I will tell you what I think about it".'[30] Leaving aside the Dalziels' ever constant desire to show themselves as men of art before they were men of trade, and remembering also that their book is notoriously inaccurate, especially as regards dates (they frequently misdate their own publications), there is a significant kernel of information in this statement. There is no doubt at all that the Dalziels and Routledge enjoyed, in trade terms, a 'special relationship'. The temptation, however, is to conclude that this was the usual state of affairs between publisher and engraver. By turning now to a rival publisher, Alexander Strahan, it will become apparent that in the complex and volatile world of mid-Victorian publishing, generalisations of any kind are misleading.

Strahan (?1834–1918) was a very different kind of publisher from Routledge, but he was certainly his equal as an entrepreneur. He was a Scot who left the Free Church to join the Church of Scotland. Thus in religion he was a broad-minded evangelical, in politics a Gladstonian Liberal, and as regards literature, an avowed populist. Unlike Routledge, Strahan was a publisher of periodicals as well as of books, and he saw publishing in both forms as an opportunity to educate the masses and hence change society. He believed in making literature accessible to the widest possible audience by ensuring that it was cheap, of high quality, and understandable. His periodicals in particular were published in direct competition with those such as the *Cornhill* which he saw as 'exclusive … avowedly opponents, all fighting … for hostile views in religion and politics'.[31] By so conscious and so intelligent an approach to his public Strahan created a large and a wide readership for his productions. As Patricia Srebrnik has succinctly put it, Strahan achieved his high circulation figures 'by consciously amalgamating a variety of reading audiences – readers of fiction and readers of sermons, English readers and Scottish readers, readers from the middle classes and readers from the lower classes, Anglican readers and Nonconformist readers.'[32]

It is as a publisher of periodicals, several of which made extensive use of illustration, that Strahan was outstanding, and indeed some of the most notable books which he produced, such as those by George Macdonald with illustrations by Arthur Hughes, had their genesis in the pages of the magazines. Strahan was responsible for a variety of periodicals. In terms of fine illustration, the greatest of these aimed at adults was *Good Words* (206). Running a close second was the *Sunday Magazine* (218), and two others of interest, though not represented in the collection, were the *Argosy* and *St Paul's Magazine*. For children Strahan produced arguably one of the finest magazines ever aimed at youth: *Good Words for the Young* (207). Although it only maintained its superiority for some four years (1868–72) it was here that such classics as Macdonald's *At the Back of the North Wind* (190), with Hughes's celebrated and frequently reprinted drawings, made their first appearance.

Although all Strahan's magazines would repay study, it is *Good Words*, with its catholic mix of topics and extensive illustrations, which is the most useful to examine in the present context. It began in Edinburgh in January 1860 as a sixpenny monthly in direct competition with *The Cornhill Magazine*, which, edited by Thackeray at the beginning, just 'happened to publish its first number on the day when the first part of *Good Words* appeared'.[33] Although the *Cornhill* began with a staggering sale of 120,000 copies, by 1864, according to Strahan's own advertisements, *Good Words* was achieving 160,000 copies per month, which meant that it outsold not only its main rival but also every other monthly magazine in the English speaking world.[34] These magazines also circulated in America, where they were popular and influential.

If Routledge was aware of the commercial possibilities offered by illustration, Strahan saw its moral and educational value. Recalling popular illustration before he began *Good Words*, and maintaining that he always intended his productions to be illustrated, he wrote, 'Only in a most meagre and mean, or else in an utterly base, way did popular literature avail itself of the helps which I believed it could rightly obtain from Art for the purpose of adding to its own attractiveness and heightening its proper delights.'[35] Strahan was, in certain ways, revolutionary in feeling so strongly about the place of illustration in publishing, for there were those, with similar religious beliefs, who thought that it had no moral place there, and amounted to little more than frivolity.

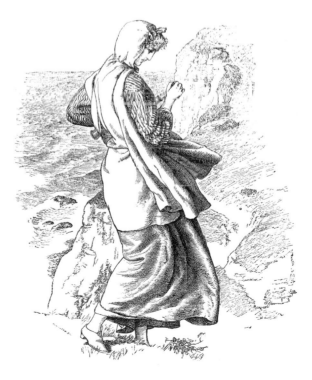

30. Hughes, 'Ev'n to the last dip of the vanishing sail', p. 24, Tennyson *Enoch Arden* 1866. 135 × 110mm. 1992–4–6–371

In 1862 Strahan moved his place of publication from Edinburgh to London, and it was also during this same year that *Good Words* reached its zenith as regards illustration. Its list of contributors reads like a roll call of the best artists of the period: Millais, J. D. Watson, Holman Hunt, Tenniel, Burne-Jones, Lawless, Thomas Morten, Simeon Solomon, Frederick Walker, Sandys, Houghton, Keene, Armstead, Whistler and Pettie. The literature was respectable rather than memorable. There were novels by Sarah Tytler (Henrietta Keddie), Dinah Mulock (Mrs Craik), as well as poems by other Strahan stalwarts, such as Dora Greenwell and Horace Moule. Thus in purely literary terms it could not compete with the weightier *Cornhill*. In 1862 this lofty journal was continuing Trollope's *Small House at Allington*, illustrated by Millais, and in July began to serialise *Romola* by George Eliot. It can scarcely be a coincidence that Leighton provided double the number of illustrations than was normal for the *Cornhill* at this time for this particular novel. In complete contrast, Strahan was not averse to adding to his dish a garnish of popular articles with intriguing titles such as 'Getting on' and 'Is he stingy?'

Strahan's great achievement as a publisher of periodicals was that he combined respectability with popularity and, in terms of his illustrations, a genuine distinction. As a publisher of illustrated books, Strahan's contribution is less easy to evaluate. His list was considerably smaller than that of Routledge and is, in many cases, heavily dependent on prior magazine publication. Several of the children's books came direct from *Good Words for the Young*; those by Macdonald illustrated by Hughes were almost invariably drawn from this rich source. There were others, however, such as the rather cloying offerings by William Brighty Rands, who wrote a series of *Lilliput Lectures* 1871 (302) under the pseudonym Matthew Browne, also illustrated by Hughes. For adults came two important gift books of illustrations both deriving largely from Strahan's magazines: *Touches of Nature* 1867 (385) and *Millais's Illustrations* 1866 (223). The latter is bibliographically more complex than it might at first appear, since it also contains designs by Millais from books and magazines published by rival firms, such as James Nisbet and Bradbury & Evans. Although many of Strahan's books were reprints, this was not the case of all of them. A particularly happy exception is *Wordsworth's Poems for the Young* 1863 (422), illustrated by Millais and Pettie.

It is neither possible nor indeed entirely fair to make a direct comparison between Routledge and Strahan. If anything, their very differences are a measure of the variety and complexity of illustrated publications at the time. Since Routledge clearly had a close relationship with his engravers, the Dalziels, it might perhaps be expected that Strahan's situation would have been broadly similar. While the Dalziels did most (though not all) of the work in *Good Words* and the *Sunday Magazine*, rivals such as Swain contributed to the *Argosy* and also to several of the books, suggesting that Strahan probably preferred not to put himself entirely in the hands of one firm. However, the Dalziels themselves were in no doubt about their dominant position in the field, and wrote, 'When Mr Alexander Strahan proposed that we should take the entire control of the art part of *Good*

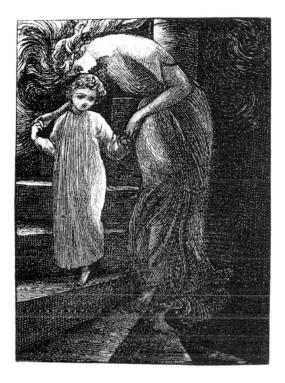

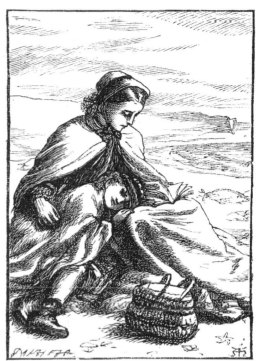

(*Above, left*) 31. Hughes, 'I am afraid of falling down there....', p. 80 George Macdonald *At the Back of the North Wind* 1871. 80 × 58mm.
1992-4-6-190

(*Above, right*) 32. Hughes, 'Dear boy! said his mother....', p. 133, George Macdonald *At the Back of the North Wind* 1871. 80 × 56mm.
1992-4-6-190

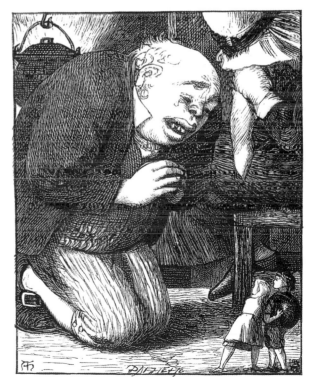

(*Right*) 33. Hughes, 'The Giant on his knees', facing p. 136, George Macdonald *Dealings with the Fairies* 1867. 94 × 75mm. 1992-4-6-191

Words, we asked all our most distinguished artist friends to make drawings for the journal.'[36]

The editors

Strahan did not become a great proprietor of illustrated periodicals single-handed. He had an innate ability to choose outstanding men to be his editors. For *Good Words* he appointed Norman Macleod, for *Good Words for the Young*, George Macdonald, and for the *Sunday Magazine*, Thomas Guthrie. His choices of two deeply religious men, Norman Macleod and Thomas Guthrie, to guide his flagship journals might have seemed unlikely to be successful, but as it happened, they were little less than inspired. Macleod (1812–72) was a Church of Scotland minister but a moderate in religion, and amazingly managed to steer a middle course between the Evangelicals and the Moderates. He saw the editing of *Good Words* as an entirely religious and solemn activity, and only accepted the post after agonising heart-searching. He wrote, 'The editorship of *Good Words* was given me. I did not suggest or ask the publication, and I refused the editorship for some time. On the principle, however, of trying to do what seems given me of God, I accepted it. May God use it for His glory.'[37] Although it is difficult to find evidence of exactly what Macleod felt about the role of illustration in his magazine, the manner in which he defended its judicious mix of the religious and secular suggests that he recognised its worth. He wrote bravely in the issue of December 1860 that he wished to blend the two contrasting elements 'to provide a periodical for *all the week*'. This was prompted by the reaction from the sternest believers that a not wholly religious journal was unsuitable fare for Sabbath reading. He never wavered in his beliefs and wrote with humble passion to Strahan, 'God bless you, and may He enable you and me, with honest, simple, believing, and true hearts, to do His will, and, come weal or woe, to make *Good Words* a means of doing real good to our fellow-men, and so pleasing our Master that, when time shall be no more, He will receive us as faithful servants. Amen.'[38] In addition, there is the evidence provided by the magazine itself. For several years, with Macleod at the helm, it was, with *Once a Week*, the most distinguished of the illustrated periodicals.

Thomas Guthrie (1803–73), who was editor of the *Sunday Magazine* from 1864 until his death, was another surprisingly successful appointment. He was a Free Church minister who, having been at one time opposed to Macleod, now became a friend and colleague. He contributed not only to his own journal but also to *Good Words*, thereby underlining the catholic nature of that magazine. While the *Sunday Magazine* was clearly aimed at a Sabbath readership, with essentially religious offerings, for some years it was an important vehicle for good illustration. A typical year was 1866, which contained Sarah Tytler's novel *The Huguenot Family in the English Village*, illustrated by Houghton, as well as further drawings by William Small, Pinwell, J. W. North and J. D. Watson.

Strahan's success could not last, however. All his magazines had declined in quality and in the number of their illustrations by the late 1860s, and although Macdonald was an excellent editor of *Good Words for the Young*, the financial writing was on the wall. In 1872 creditors seized both *Good Words* and the *Sunday Magazine* and Strahan was forced to retire from the business. *Good Words for the Young* struggled on for a few years but rapidly declined in quality and interest after 1872.

The only journal which was a genuine competitor – in terms of illustration – with those published by Strahan was *Once a Week* (212), which is arguably the greatest illustrated magazine of the entire period under discussion. Bradbury and Evans, the publishers of *Punch*, employed as editor Samuel Lucas (?1818–68), a sound literary critic who admired Thackeray more than Dickens. The magazine, which called itself 'A Miscellany of Literature, Art, Science and Popular Information', was started on 2 July 1859 as a direct challenge to Dickens's own organs, *All the Year Round* and *Household Words*, which were both unillustrated. Unlike *Good Words* or the *Sunday Magazine*, it had no special religious or reforming tasks to perform, and in contrast to the *Cornhill*, it never attracted writers of

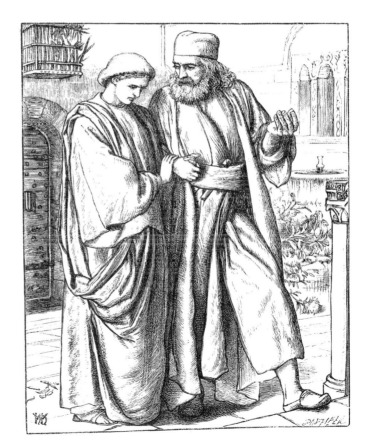

34. William Holman Hunt (1827–1910), 'The Lent Jewels', frontispiece, R.A.Willmott (ed.) *English Sacred Poetry* 1862.
126 × 102mm.
1992-4-6-399

53

exalted stature such as Trollope, George Eliot or Mrs Gaskell, who were the mainstays of that notable periodical. In the prospectus to the new magazine published in May 1859, the proprietors had distanced themselves still further from Dickens's zeal for social reform, stating categorically that it was 'neither a newspaper nor a Review' and said that they felt 'no obligation to support the views of any party or school'. Dickens had expressed his aims as the proprietor of *Household Words*, in a letter to Mrs Gaskell dated 31 January 1850, as being 'the raising up of those that are down, and the general improvement of our social condition.'[39] Hence *Once a Week* was determined to plough its own furrow, but it was one where illustration was to be of fundamental importance.

Lucas had a vital role to play in illustration, and had written reviews of illustrated books in the *Times* for several years. He was of an advanced turn of mind, for in all of them, he was concerned that the artists should actually illustrate the author's text, neither mistaking nor underestimating the meaning confided to them.[40] In reviews dated 31 October 1860 and 2 January 1865, Lucas praised Tenniel's designs for *Lalla Rookh* 1861 (231) and Shields's for *Bunyan's Pilgrim's Progress* originally 1864 (43) for being in close harmony with the texts. Lucas believed that the drawing should be so close in spirit and feeling to the text that its meaning could be ascertained even if the letterpress was removed.[41]

It is, therefore, hardly surprising that Lucas swiftly gathered around him a coterie of the best artists. Volume 1 of *Once a Week* contained 169 illustrations by, among others, Keene, Lawless, Millais, Tenniel, Leech and Hablot Browne (Phiz), while Holman Hunt and Frederick Walker contributed to the next volume. Later issues saw designs by Whistler, du Maurier, Sandys, Poynter and Pinwell. The writing also, at least in the first issues, was at an equally high level, with contributions from Tennyson, Charles Reade, George Meredith and Harriet Martineau. The magazine contained a mixture of work by the comic artists recruited from the pages of *Punch* and that of the newer men, whose illustrations were largely serious. It is not surprising, since it too came from Bradbury & Evans, that it even looked a little like *Punch*, with the illustrations printed in close conjunction with the text. The pages could not truthfully be described as 'designed'.

Lucas's involvement with the artists clearly went beyond mere critical comment. The collection contains a letter from Millais to Lucas which is of interest for the light it sheds on this editor's unusually close links with them. It seems to suggest that Lucas dealt with the artists over matters artistic, in a way that Routledge apparently did not. While the latter seems to have encouraged the Dalziels to negotiate with artists on his behalf, here the matter was evidently more in the hands of Lucas and his employers, Bradbury & Evans. Millais wrote from Perth on 19 July 1861, 'When Swain has cut the child on the swing let me have the proof as if you don't care to use it, I have no doubt it will come to be used some day ... I thought you wanted little sketches that came naturally ... I shall be back in a short time in Town when we will speak on the subject with B & E [Bradbury & Evans].'[42] The presence in the Bradbury & Evans Archive (*Punch* Archive, Lon-

35 Hunt, 'The Light of
Truth', facing p. 45, Mrs
Gatty *Parables from Nature*
1865. 98 × 129mm.
1992–4–6–110

don) of detailed accounts concerning the artists who worked for *Once a Week*
adds additional weight to the argument that, in the case of this particular pub-
lisher, the artists were probably handled directly and not through the intermediary
of the engraver.

The heyday of *Once a Week* was short-lived. By Volume 3 the number of
illustrations had dropped to 132, and by the time Volume 9 appeared (there were
usually two volumes per year) there were only 59. The reasons for this were almost
certainly financial. Not only were the major artists paid as much as six guineas a
drawing, but payments had also to be made to authors, engravers, and editorial
staff. On 6 January 1866 a 'New Series' began, with many fewer illustrations.
Although the advertisements boasted 'Extra illustrations by eminent artists,
printed separately on toned paper', the real result was that the magazine was
irrevocably altered. The laudable emphasis on fine, though fewer, illustrations,
better printed, hid the fact that heavily illustrated journals of this kind were
already doomed, even at this early date. None of the magazines contained in the
collection maintain their artistic interest much later than 1872, and the common
denominator in their demise was undoubtedly cost.

The engravers

The importance of the engravers in the whole area of illustration in the Sixties has
already been touched on in this chapter. The Dalziels were clearly the dominant
force and their contribution went far beyond engraving. In many cases, especially
as regards the gift books, the Dalziels were as responsible for the illustrations –

both artistically and financially – as the publishers and sometimes acted almost entirely on behalf of the publisher. They commissioned artists, negotiated with them often over periods of many years, and also paid them. The Dalziels undoubtedly saw themselves as the aristocrats of the engraving trade and even referred to themselves in the books like a publisher, calling themselves *The Camden Press*. Major gift books published by Routledge, such as *A Round of Days*, bear on their covers, the banner 'Dalziel Fine Art Gift Book'. The family became extremely wealthy and owned, among several homes, a grand property in Oppidans Road, Hampstead. Their mausoleum in Highgate Cemetery also bears eloquent witness to the lofty social position to which they rose in London life.

According to Percy Muir the Dalziels 'were not only the finest of the wood-engravers of this period, but also, in very large measure, its inspiring geniuses.'[43] The dynasty was started by George Dalziel (1815–1902), who was born at Wooler in Northumberland. Educated in Newcastle, he soon moved to London, where by 1840 he had set up an independent practice with his brother Edward (1817–1905). In the earliest years both men worked as 'outside engravers' for Ebenezer Landells (1808–60), a distinguished engraver, who had himself come from Newcastle. In due course several other members of the Dalziel family joined the enterprise. The Dalziels did not, however, have the field entirely to themselves, as Rodney Engen's exhaustive *Dictionary of Victorian Wood Engravers* 1985 makes clear. It should also be noted that these engravers ran workshops, which in certain cases must have provided employment for large numbers of jobbing craftsmen. Engen hints deftly at the numbers of people involved in the engraving trade, remarking that the big firms 'trained assistants or took on "outside" engravers who had trained under various trade school programmes; women wood engravers were especially popular as they could work at home and were generally reliable'.[44] In this connection, it is also revealing to read the humble words of Walter Hartright: 'I get my bread by drawing and engraving on wood for the cheap periodicals.'[45]

The chief rival to the Dalziels, in terms of amounts of work undertaken, was the shop run by Joseph Swain. It was Swain who dominated the engraving work in the *Cornhill*, *Once a Week* and *Punch* and he was also responsible for the engravings in numerous books. He seems to have lacked the grandiose empire-building ambition of the Dalziels, and was more content to concentrate on the engraving proper, rather than to act in their entrepreneurial manner. The result was that, in general, the Swain hallmark was the strength and clarity of his engravings, which were in many cases superior to those done by the Dalziels. His great skill lay in his ability to improve and strengthen a drawing for publication. This was recognised by Thackeray, who apparently once said to Swain, 'Why don't you engrave my drawings to come out like John Gilbert's – his work always looks so strong and mine so weak and scratchy?'[46] Thackeray's comment, far from being a veiled criticism of Swain's abilities, reflects instead an awareness of his own shortcomings as a draughtsman and the difficulties his insubstantial figures presented to the

engraver. In this connection it is worth noting that Thackeray handed over the work of illustrating his novel *The Adventures of Philip* in the *Cornhill Magazine* in 1861 to Frederick Walker, an artist whose designs were easier to transfer into wood-engraving on account of their greater strength and definition.

Two particularly happy examples of Swain's skills can be found in Jerrold's *Mrs Caudle's Curtain Lectures* 1866 (145), illustrated by Keene, and Coventry Patmore's *The Children's Garland from the best Poets* 1873 (250), with designs by John Lawson.

There were many other engravers active at the time, but the Dalziels and Swain were the most prolific. The position of the Dalziels was clearly a remarkable one and their importance cannot be over-estimated, even though as artists, and especially as 'book packagers', they were often deficient in taste and discrimination. The fact that the Dalziels produced or 'packaged' books for publishers goes some way towards explaining the criticism sometimes levelled at the Sixties books – namely that as coherent unities they are frequently unsatisfactory. Illustrated books required the combined skills of author, artist, publisher and engraver, but these crucial agents did not necessarily work harmoniously together. Despite the Dalziels's innate belief in their own talents and sensibilities, they were frequently

36. Hunt, 'The Ballad of Oriana', p. 51, Tennyson *Poems* 1857 (The Moxon Tennyson). 94 × 80mm. 1992-4-6-374

unable to differentiate between great and mediocre artists, and many of their books especially, as well as those from other sources, can be faulted for lacking a single guiding artistic intelligence. By contrast *Wayside Posies* 1867 (395) is an outstanding example, where the designs of Pinwell, North and Walker co-exist in genuine harmony within the elegant and ornate binding designed by Albert Warren.

The power and influence of the engravers over illustration also contributed to the disquiet and unhappiness of the artists concerning the interpretation of their designs. It seems that the artists were almost powerless to ensure that the engravers faithfully or successfully carried out their wishes. It was Rossetti who gave voice most memorably to a feeling which must have undermined any link between originator and interpreter: in 1856 he wrote to William Allingham, referring to the Moxon Tennyson, 'But these engravers! What ministers of wrath! Your drawing comes to them, like Agag, delicately, and is hewn in pieces before the Lord Harry. I took more pains with one block lately than I had with anything for a long while. It came back to me on paper the other day, with Dalziel performing his cannibal jig in the corner, and I have really felt like an invalid ever since. As yet I fare best with W. J. Linton. He keeps stomach aches for you, but Dalziel deals in fevers and agues.'[47] In a more celebrated outburst Rossetti resorted to doggerel to express his exasperation with the Dalziels

> Address to the D—l Brothers
> O woodman, spare that block
> O gash not anyhow;
> It took ten days by clock,
> I'd fain protect it now.

Chorus, wild laughter from Dalziel's workshop.[48]

The *Bible Gallery* 1881 (see Chapter 6), which was a commercial failure for the Dalziels, appeared to signal the death knell not only of their great influence, but also of wood-engraving as a whole as a potent medium for trade engraving. As Campbell Dodgson wrote in the year he became Keeper of the Department of Prints and Drawings, 'In the next decade the photo-mechanical processes were beginning to prevail in competition with the slower and more expensive methods of the wood-engraver. The Dalziels's energies were thenceforth more devoted to the business of printing and the production of illustrated newspapers, chiefly comic.'[49]

The entrepreneurs

Routledge, Strahan and the Dalziels were undoubtedly the outstanding entrepreneurs of this period of illustration, if we use the term in its broader sense. However, there are two further names which must be mentioned – Charles Mudie and W. H. Smith.

Throughout the nineteenth century Mudie, with his 'Select Library' headquar-

(*Above, left*) 37. Charles Samuel Keene,
untitled, p. 165, Douglas Jerrold
Mrs Caudle's Curtain Lectures, 1866.
88 × 95mm. 1992–4–6–145

(*Above, right*) 38. Keene (1823–1891),
untitled, p. 75, *Mrs Caudle's Curtain
Lectures*. 93 × 86mm. 1992–4–6–145

(*Right*) 39. Keene, 'The Waiting Room',
facing p. 71, Herbert Vaughan, *The
Cambridge Grisette*, 1862.
128 × 102mm. 1992–4–6–390

ters on the corner of New Oxford Street and Museum Street, was arguably the most powerful distributor of books through the subscription library system. His catalogue, dated January 1865, runs to 204 packed pages divided into two categories: History, Biography, Religion, Philosophy and Travel comprised the first (136 pages), while the remainder was devoted to fiction. The fiction was almost entirely of the unillustrated 'Three Decker' variety. The normal price of these volumes was high – 31s 6d. It was largely because Mudie could buy these expensive books new, and in large numbers, that this extortionate price remained almost unchallenged until the 1890s. Indeed, it suited Mudie that this should be so, since if the books had been more affordable for individuals his own circulating libraries would have lost business. There is no sign of illustrated books being available through Mudie, or indeed from the other subscription libraries, and this is borne out by the fact that so few of the illustrated books of the period bear the distinctive (and almost impossible to remove) circulating-library labels.

In general, then, the circulating libraries specialised in supplying new and chiefly unillustrated books to an eager public which could not afford to purchase them. On the other hand, the leading illustrated magazines were available through Mudie's, and his catalogue lists the *Cornhill*, *Good Words*, *London Society* (210, 211) and *Once a Week*. It states that 'An ample supply is provided of the leading Reviews and Magazines, in order that all Town Subscribers may have access to them as soon as published; and that all Subscribers residing in the Country may obtain them within the period stated in the terms of their Subscription. Each Periodical is counted as One Volume.' Thus it seems that illustrated books must have reached the public largely through retail sales from bookshops or direct from the publishers, rather than through the circulating libraries.

Smith not only dominated the railway bookstall market like Hachette in Paris, but also enjoyed a virtual monopoly of retail bookselling outside the capital. However, I have found almost no books either in this collection or in others with W. H. Smith labels. This in itself proves nothing conclusively, but it may point to other methods of distribution, especially for the expensive gift books. These were much advertised in the national press, especially in the run-up to Christmas, and they could be obtained either by post, or in person, direct from the publishers. It is, therefore, possible that many of the other illustrated books might have been purchased in just this way.

An analysis of booksellers' labels in the collection might yield useful evidence of distribution methods, but such information should always be treated with caution, since it would be difficult to be certain exactly when a label had been applied to a book. The lack of Smith's labels might suggest that the branches did not tend to carry illustrated books (especially of the expensive kind) as a matter of course. However, they may have acted as recipients of orders for books, addressed, via them, to publishers, and hence would not have affixed labels to books thus ordered.

CHAPTER FOUR

The Readership: Taste and Reading Habits

Where illustration was clearly so central a part of what was being published, it would be of interest to discover what kinds of reader were the intended recipients. Clues may be found in the publications and the illustrations themselves, or by an examination of ephemera, such as prize and presentation labels, publishers' announcements and advertisements, and independent reviews. Circulation figures and retail prices may also yield some answers, while more nebulous matters like tone, as well as the elaborate bindings and the methods used in the manufacture of the books, are also of relevance.

Circulation

The circulation figures of periodicals should be judged with caution. Nevertheless, they may be helpful. The figures for the main illustrated magazines, the *Cornhill*, *Once a Week* and *Good Words*, make a convenient starting point. As stated in the previous chapter, the *Cornhill* began at 120,000 a month, and by 1864 *Good Words* was claiming 160,000 a month. *Once a Week*, on the other hand, began at a meagre 22,000 each week in 1859 and then declined sharply.[50] A chart showing the 'Circulation of Periodicals and Newspapers' compiled by J. Pickering, the Secretary to the Leeds Mechanics' Institute, gives some idea of the sale of illustrated periodicals during May 1860, in one provincial centre. In this particular month, the *Cornhill* sold 700 copies, *Once a Week* 194, and *Good Words* 139.[51] These more specific figures tell us that the *Cornhill* began magnificently, while the other two started more slowly and diffidently. What is not suggested, however, is how swiftly *Good Words* became the dominant illustrated magazine of the time. Indeed, interesting though the figures are in themselves, they do not, to tell the truth, move us much closer to the readership.

Tone and price

Although awkward to measure, tone can also help us to identify readership. The *Cornhill* undoubtedly took off in such style, because it commanded the best writers of the day (Trollope, Mrs Gaskell, George Eliot, Ruskin, Charlotte Brontë, etc), and was edited by the much-loved figure of Thackeray. There were illustrations, but these were comparatively few in number (Volume 1, January–June 1860, had just twelve), and the artists were not identified. Thus it made its appeal, at its inception, entirely on account of its weighty and serious nature. *Once*

a Week appeared essentially as a serious version of *Punch*, and it clearly encountered a problem in finding an individual voice that would give it wide readership across the classes. It was a lightish magazine, poorly printed on cheap paper. *Good Words*, on the other hand, managed to fill the gap left between the *Cornhill* and *Once a Week* and to scoop up innumerable readers of various persuasions, both religious and literary. As in *Once a Week*, the artists were all named, but what eventually gave it the edge was its blend of the secular and religious, together with a low selling price. At *6d* a month, its motto taken from George Herbert, 'Good Words are worth much and cost little,' was entirely apt.

The *Cornhill* cost a shilling and declined rapidly in circulation because it failed to meet the criteria defined by Richard Altick: 'The formula for popular periodicals as it developed . . . was threefold: a price of *6d* or lower; plenty of light fiction and amusing non-fiction; and as many illustrations as possible.'[52] It was not surprising, then, that Strahan, with his various titles, controlled the circulation battlefield. There is also little doubt that nearly all his magazines were available at the Mechanics' Institutes, which flourished in many towns, and it must have been here that the width of his approach would have paid dividends. The other magazines could also have been read in such settings, but their appeal was to a far smaller and essentially middle-class audience. Thus the tone, coupled with the selling-price, defined the readership and indeed the circulation.

The proprietors of illustrated periodicals destined for readers further down the social and economic scale knew how crucial illustrations were in maintaining support among the less confident newly literate. The catalogues put out by publishers in the rear of the books provide some telling information. S. W. Partridge was a firm which specialised in illustrated books and periodicals and catered extensively for the poorer readers. In a catalogue of 1862 (private collection) we read that the *Band of Hope Review* was a 'Monthly Paper for the Young – One Halfpenny – Eight Hundred Engravings.' Quoted below the advertisement is a statement from the *Poole Herald*: 'The after-life of many a child who has perused its stories and lessons, and been delighted by its pictorial illustrations, will be better and nobler for it.' Partridge carefully neglects to mention the Temperance nature of the magazine. On another page is advertised *The British Workman, and Friend of Sons of Toil*, which is puffed as a 'Monthly Paper for Working Men – One Penny', which was 'illustrated by first-class artists' and 'issued by the Editor with the earnest desire of promoting the HEALTH, WEALTH, and HAPPINESS of the Industrial Classes'. Thus hard-headed publishers were well aware that illustrated publications which sold cheaply had a potentially large audience. Sadly the boast of the presence of 'first-class artists' in such periodicals is rarely upheld. If a distinguished artist was ever included, the numbers of contributions were invariably small.

Books were targetted at readers in a similarly planned and hard-headed way. Partridge's list identifies categories of amazing variety: 'For the Single and Mar-

40. Matthew James Lawless (1837–1864), drawing, 'Effie Gordon' *c.*1861. Pen and grey ink and wash over graphite (see fig. 41). 100 × 130mm. 1992–4–6–85

41. Lawless, engraving, 'Effie Gordon' p. 406, *Once a Week* 1861, later reprinted in Thornbury's *Historical and Legendary Ballads and Songs* 6 April 1876, p. 65, as 'The Night after Culloden'. 97 × 128mm. 1992–4–6–502(a)

ried, For Young Women, For Mechanics, For the Cottage and Kitchen, For Apprentices, For Servant Girls etc.' This publisher was catering for an audience which wanted illustration but could afford little for books. Hence the cheapest books on the list cost 1*d* and the dearest ('sumptuously illustrated') were only 5*s*. Even the penny books were illustrated, but these were closer in character and presentation to the illustrated handbills, which Partridge issued in shilling packets containing one hundred items.

The de Beaumont collection is, however, less concerned with the type of publication put out by such firms as Partridge. Instead it concentrates on finer and more expensive items. These books were out of the financial reach of the poor, and they were never cheap. An appendix of some of the prices is included at the end of this chapter. The main gift books cost a guinea; some of the children's books cost as little as 2*s* 6*d*. Notwithstanding the evidence that readers expected and obtained

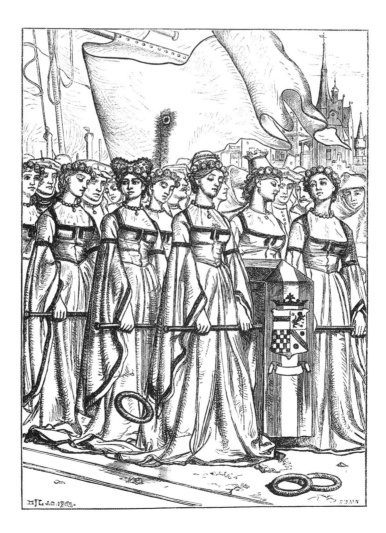

42. Lawless, 'Heinrich Frauenlob', p. 393, *Once a Week* October 3rd 1863, later reprinted in Thornbury's *Historical and Legendary Ballads and Songs* 1876, p. 41, as 'The Dead Bride'. 157 × 115mm. 1992-4-6-516

discounts from booksellers, this still meant that most of the books under discussion were aimed at a fairly well-off middle-class readership.

It is scarcely surprising that such books were costly. They were complex to manufacture, necessitating the involvement of a number of people in their design and production. Even if the book involved no author's fees, as in the case of *The Parables of Our Lord*, the artist, engraver, printer, cover designer and blockmaker all had to be paid. Living authors needed payment, and the more distinguished the author, and illustrator, the greater the fees. All such costs were reflected in the prices.

Some examples of what was paid to artists may serve to make the point. The Bradbury & Evans Archives of *Once a Week* (*Punch* Archive) reveal that throughout 1862 Charles Keene was paid £4 4s per drawing; his total earnings for drawings for the magazine between 1 July and 27 December amounted to £65 2s. On 8 February 1862 Keene received £30 for all eight of his full-page designs for Vaughan's *The Cambridge Grisette* (390). This, as it happened, was published by Tinsley and was merely printed by Bradbury & Evans. Presumably this sum also covered the vignettes at the opening of each chapter. Millais was paid at the higher rate of £6 per drawing at the same period, although some drawings warranted payments as high as £8 8s. Conversely, the young George du Maurier, then at the start of his career, was paid £3 3s per drawing in 1862, though this was increased by a further guinea per drawing in the following year.

The Bentley Papers in the British Library contain some of the records of *London Society* (210, 211) and these reveal that later in the Sixties prices were increasing at an alarming rate. Now du Maurier could command £10 10s a drawing, while Keene was receiving as much as £12 12s. A bill dated 15 June 1868 for payment which the Dalziel Brothers received from James Hogg (the proprietor of *London Society*) amounted to £15 19s 3d for their work for that month. The expenditure for issue no. 70, October 1867, was as follows:

Text and illustrations: £138 13s
Paper for text, advertisements, plates, tissue etc.: £244 5s 8d
Printing of 20,000 copies: £118 9s 9d
Binding of 19,000 copies: £43 4s 6d
Salaries for four staff: £62 16s (Hogg received £25)
Sundries: £10
Rent: £12 10s (£150 per annum)[53]

With a monthly production cost for a popular journal of over £500, it follows that luxurious books with high-quality paper, lavish bindings and greater attention to manufacture and printing could only be expensive. One example where relevant figures are known is the edition of Wordsworth's *Poems* 1859 (421). Illustrated by several artists, including Birket Foster and John Gilbert, and published by Routledge, the first two editions were printed in July and November 1858 in runs of 5000 and 3000 respectively. A third edition of 3000 copies appeared in August

1865. The elaborate binding design by Albert Warren cost £25, which included not only Warren's preliminary work, but the cutting of the brass block as well. The 100 engravings cost Routledge £1025, which presumably was paid to the Dalziel Brothers, who then must have paid the artists a proportion. I do not know exactly how these figures break down.[54] The usual selling-price for such a book was a guinea.

It is useful to compare prices of some other commodities, in order to put the prices of these books into some sort of perspective. The sum of £1 in 1860, was roughly equivalent to £35 in January 1993; 4 lb (1.8 kg) of bread cost about 8d in 1860 and today would be in the region of £1 50p.[55] In 1861 steak was 1s per lb (.45 kg), coffee 1s 3d per lb, broccoli 2d each and cucumbers 1d each.[56]

Clearly the market for these books was defined by cost. Only the very cheapest were aimed at the Mechanics' Institutes or the Reading Rooms. However, it is possible to find out more about the readership by examining some other elements.

Target audiences

Some ideas as to which members of a relatively comfortable audience were the intended recipients of the dearer books can be gleaned by examining the publishers' announcements, catalogues and advertisements. Then, as now, the favourite ploy of publishers was to quote favourable reviews of their wares, while omitting any less encouraging remarks. At the back of Volume 1 of Dalziel's *Arabian Nights Entertainments* 1865 (13) is a full-page advertisement by the publisher, Ward, Lock & Tyler, for another of their publications, also in the collection, Dalziel's *Illustrated Goldsmith* 1865 (115). Among the panegyrics is one from the *Sun*: 'Nobly-sized pages of delicately printed paper, with splendid typography and abundant illustrations. The latter are charming.' *The Spectator* is also quoted thus: 'Mr Pinwell may be congratulated on having really produced an illustrated Goldsmith, and not, after the fashion which has long obtained among us, certain pictures of more or less value to which the text of an established author is appended.' These puffs not only show the work in a favourable light, but, equally significantly, they point to the importance of the illustrations in stimulating sales. The book was rendered all the more attractive by being available in different bindings at various prices. As an ordinary volume it cost 7s 6d; in bevelled boards with 'full gilt sides and edges' it was 10s 6d; and bound in full morocco publishers' leather it was a guinea.

Strahan's advertisements for two of his gift books give some idea of his targets. In the rear of Ralston's *Krilof and his Fables* 1869 (301) are advertisements for the 'Fine Art Books' *Touches of Nature* 1867 (385) and *Millais's Illustrations* 1866 (223). The former is listed at a guinea and the latter at 16s. A review is quoted from the *Westminster Review* referring to *Touches of Nature* (an anthology of engravings reprinted from Strahan's magazines): 'the chief value of the work is the testimony, which most certainly it bears, to the soundness of English art in the

present day'. The quotation from the *Times* relating to the Millais volume is even more enthusiastic: 'here are his best illustrations collected together, separate from the text to which they belonged. They are works of art that need no letterpress – no comment.' The nature of these judiciously chosen comments shows that these books were intended above all for the educated art lover.

Prizes, presents and the drawing-room

Such books were, however, too pricey to be bought on impulse or casually. Their true position in the world of book purchasing can be discovered in other advertisements, especially those carried by the *Bookseller*. On 29 February 1864 James Hogg & Sons announced: 'The London Prize Catalogue of nearly one hundred choice illustrated books for Boys and Girls of an entertaining and instructive nature.' In the issue of 30 January of the same year Nimmo put out an advertisement for their poetry books which described them as being suitable for 'Presents, School Prizes or Rewards.' On 31 October the journal carried an announcement from Strahan for the Millais compilation just mentioned, which stated: 'This will be published in the ordinary drawing-room form.' These apparently simple

43. Frederic Leighton (1830–1896), 'Abram and the Angel', p. 13, *Art Pictures from the Old Testament* 1894. First published in Dalziel's Bible Gallery 1881. 213 × 153 mm. 1992-4-6-15

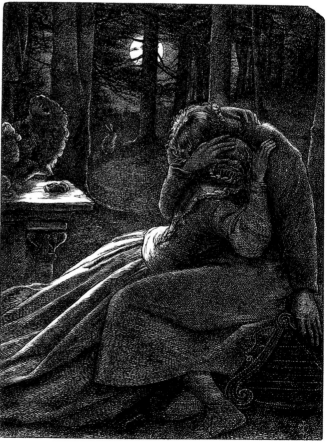

45. Millais, frontispiece, W. Wilkie Collins
Mr Wray's Cashbox, 1852. 126 × 72mm.
1992–4–6–67

(*Right*) 46. Millais, 'Love', p. 137, R.A.
Willmott (*ed.*) *The Poets of the Nineteenth
Century* 1857. 126 × 94mm.
1992–4–6–398

(*Facing page, top*)
44. John Everett Millais
(1829–1896), 'The Fireside
Story', facing p. 216, William
Allingham *The Music Master*
1855. 76 × 125mm.
1992–4–6–7

(*Right*)
47. Millais, 'The Hidden
Treasure', p. 6, *The Parables
of Our Lord* 1864.
140 × 108mm.
1992–4–6–244

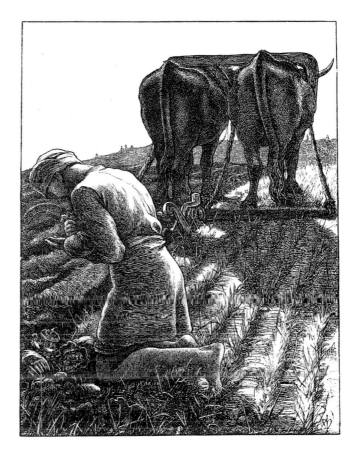

descriptions encapsulate the aim of most of the illustrated books under discussion
and the crucial words are prize, present, reward and drawing-room.

Prizes, almost invariably in the form of books, were common in the period, not
only in Public Schools, but also in other schools and especially the Sunday
Schools. Several books in the collection contain prize or presentation labels. In
The Pilgrim's Progress [1863] (42) we read an inscription by the editor,
Dr H. W. Dulcken, 'The First prize for arithmetic awarded to Miss Harriet
Wright'; and in *Don Quixote* 1866 (62) is a hand-written prize label, 'Testimonial
of High Merit (Grade 15th) awarded to Walter Barron (aged 14).'

In Victorian times, while the concept of the prize flourished at school, outside it,
and especially in the home, there were 'Rewards'. Again and again in the pub-
lishers' announcements, the word is used, reinforcing the idea that this was a
society which punished the bad child, but rewarded the good – be it for behaviour
or academic achievement.

Who gave which books to whom, is perhaps a more complex area to investigate.
It is not easy to discover much, based purely on the names of the donors and the
recipients, except where the presentation was made by an editor, author, illus-

trator or publisher. Suggestions on the suitability of a book as a prize or gift is occasionally found printed inside the volume itself. An example of this is found in Burns's *Poems and Songs* 1858 (46), published by Bell & Daldy, which reads: 'This selection from the Poetical Works of ROBERT BURNS includes such of his popular POEMS as may with propriety be given within a volume intended for the Drawing-room.' Another in *The Merchant of Venice* 1860 (355) from Sampson Low states, 'In offering an Illustrated Edition of one of Shakespeare's immortal plays as a Gift-book for Families, the Editor has considered it to be his duty to omit a few lines which, in the present age, might be thought objectionable.' These words of advice, faintly risible in the modern context, suggest that such books were chiefly intended for presentation by husbands to wives for dainty perusal in that female preserve, the drawing-room. A third note of a similar kind goes straight to the point about Gift Books. Appearing in *Poetry and Pictures* by Thomas Moore 1858 (232), it reads, 'The demand for Illustrated Books for Presents has led the Publishers to suppose that a selection from the Poems of THOMAS MOORE would be acceptable.'

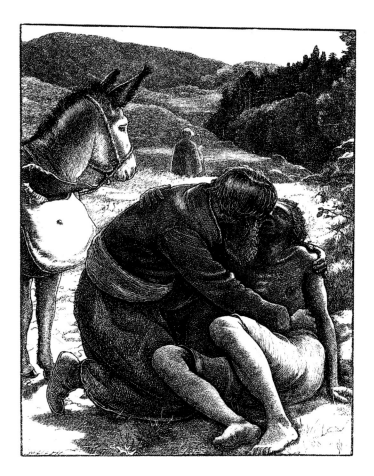

48. Millais, 'The Good Samaritan', p. 21, *The Parables of Our Lord* 1864. 140 × 108mm. 1992–4–6–244

These were the Victorian precursors of a now reviled genre – the 'coffee-table book'. Magnificent and frequently signed publishers' bindings were the appropriate apparel for such works, and the paradoxical nature of their manufacture helps to emphasise that these were items intended, almost exclusively, for gentle browsing. In the case of *Pictures of English Landscape* 1863 (259), illustrated by Birket Foster with an outstanding binding design by Owen Jones, the ostentatious luxury hides physical weakness. Although the printing is of high quality, the pages are made of thick but brittle and acidic card (of wood-pulp origin) which cannot bend without snapping. In addition, these too-heavy pages are held in the book without the traditional sewing for security. Instead, a kind of binding has been used which today is euphemistically called 'perfect binding'. To retain the pages the binders have used a material which the Victorians saw as a sort of miracle 'super glue'. This was *gutta percha*, an evaporated milky fluid or latex (rubber) obtained from trees, largely in Malaysia. In 1843 samples were sent to London by Dr William Montgomerie of Singapore and these were exhibited to acclaim at the Society (now Royal) of Arts. Up to the First World War it was used chiefly for

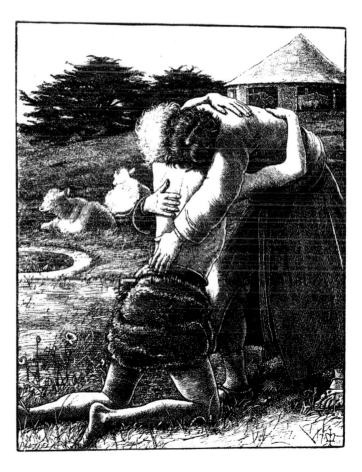

49. Millais, 'The Prodigal Son', p. 34, *The Parables of Our Lord*, 1864.
140 × 108mm.
1992-4-6-244

electrical insulation.[57] However, as a binding material *gutta percha* was little short of disastrous, as it perished over time; its indiscriminate use accounts for the disintegration of so many of the books. Even when copies of these scarce volumes so bound are found, they must be collated carefully, to ensure that no pages are missing. The Victorians must have been aware that such a method of binding could never be as permanent as the proper sewing of signatures or pages. It seems likely, therefore, that these books, by reason of their physical construction, were not intended for any kind of hard use or regular reading. In this they differed markedly from the Annuals, to which they are in some ways related.

The Annuals were yearly volumes, published as Christmas and New Year gift books. Containing poetry and illustrations, they reached the height of their popularity between the 1820s and the early 1850s. With titles such as *Friendship's Offering* and *The Recreation*, they were aimed especially at women, and they were generally tastefully bound, sometimes in luxurious materials, such as watered silk. Like many of the Sixties books which superseded them, 'they were not intended for serious reading but for intermittent perusal, yet because the receiver wished to be seen engaged in literary or pious pursuits, the covers were particularly important'.[58] The spines of the books were also important, as these would be visible on the library shelf. The spines of the Annuals were almost uniformly chaste in appearance, while Sixties spines generally were as showy as the covers. In the later volumes, the binding designer would often sign twice – on both covers and on the spine.

The Annuals were nearly all small in size, with relatively sober binding, and usually illustrated with steel engravings. They were also invariably soundly made and sewn. The later Victorians made their books much more flamboyant in appearance, but ironically, as already mentioned, manufactured them less carefully. It was a curious case of pretence on the one hand and cheapness on the other. The machine age and mass production were partly to blame, and it is a truism worth repeating that in the case of these once relatively common objects, 'The more there were, the less there are.' The deficiencies in the construction of these books mean that most of those in the collection are scarce and some are of extreme rarity.

In Victorian times, as today, publishers knew that when they published was almost as crucial as what they published. They shamelessly capitalised on the season of goodwill and concentrated their efforts, at least where illustrated books were concerned, on the Christmas trade. The mid-Victorian period saw an unprecedented growth in the importance of Christmas as a time of present-giving. Almost without exception books appearing in October or November actually bore the publication date of the following year. This meant that the canny publisher obtained two bites of the lucrative Christmas cherry, and the books retained their novelty, albeit somewhat spuriously, for at least two years.

In the period under discussion the emphasis on Christmas seemed even more intense than it is today. For example, the *Bookseller* of 10 December 1864 was a lavish and enormous double Christmas number running to over 200 pages. On its

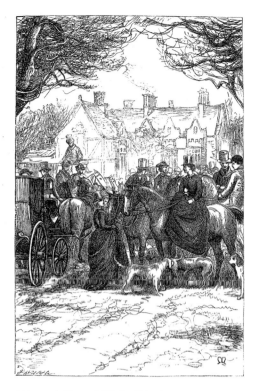

(*Above, left*) 50. Millais, 'Monkton Grange', facing p. 216, Anthony Trollope, *Orley Farm* vol. i 1862. 168 × 106mm. 1992–4–6–386

(*Above, right*) 51. Millais, 'Lady Mason going before the Magistrates', facing p. 97, Anthony Trollope *Orley Farm* vol. ii 1862. 172 × 108mm. 1992 4–6–386

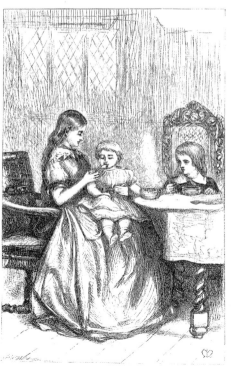

(*Right*) 52. Millais, 'Our Sister Grizel', facing p. 10, Sarah Tytler *Papers for Thoughtful Girls* 1862. 140 × 88mm. 1992–4–6–389

elaborate cover it proclaimed that it contained a 'complete list of illustrated and other Books suitable for Presents, School Prizes or Rewards with numerous specimens of the Illustrations'. Almost every book is represented by an illustration, together with an accompanying recommendation from the publisher. Several of the books in the collection are included. There were also reviews, which were usually generous, but occasionally less so. (Some of these reviews are discussed in Chapter 7.)

Throughout the Sixties, the *Bookseller* continued to produce these special issues. The excitement was not restricted to the trade papers, however. The *Examiner* newspaper, for example, published six reviews of gift books between 11 November and 30 December 1865. Similarly, journals such as the *Athenaeum* carried regular reviews, not always favourable, under the headings of 'Gift Books' or 'Fine Arts' and these invariably were longer and more detailed in November and December. The publishers also advertised their wares with a Christmas bias. One such was Strahan's announcement in the *Athenaeum* dated 22 November 1862 relating to Sarah Tytler's *Papers for Thoughtful Girls* 1863 (389): 'This

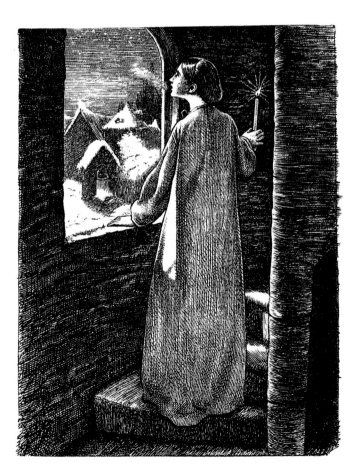

53. Millais, 'St. Agnes' Eve',
p. 309, Tennyson, *Poems*
1857 (The Moxon
Tennyson). 98 × 73mm.
1992–4–6–374

edition will be illustrated by Mr Millais and will be produced in an Elegant Style adapted for a Christmas Gift Book.'

The factors examined in this chapter point to a relatively small and generally comfortable readership, but one, nevertheless, that had to be carefully and energetically wooed by the publishers. Although impressive on the surface, many of these volumes were frequently shoddy and slipshod: they were produced just for the age in which they appeared. They were certainly never 'built to last' – a point true also of so many other commodities in a developed capitalist economy.

Appendix to Chapter 4: selected prices

These prices are organised according to publisher and divided into two categories. The first comprises retail prices of books from several publishers obtained from various sources, notably publishers' announcements and advertisements, either in the books themselves or in contemporary newspapers or journals. The second is devoted to Routledge material, and this includes both the wholesale and the retail prices. Prices are also given in the *English Catalogue of Books* (compiled by Sampson Low) for the relevant years. However, the plethora of book issues can make the accurate retrieval of prices of particular editions a lengthy process.

These prices should be treated with some caution. For publishers other than Routledge, it must be assumed that the prices given are those in operation at the date of publication. In general these appear to have held for some years. Sometimes cheaper editions were available, while on the other hand special editions in publishers' leather could double or even treble the normal price of an ordinary copy.

The Routledge prices are compiled from a stock catalogue dated December 1865 (University College Library, Routledge Archive). This catalogue, which runs to 89 pages, shows what was being charged at that time for both new stock and backlist items. Major Routledge items such as *The Parables of Our Lord* and *A Round of Days* in special leather bindings cost between 24s and 35s.

A note on the pre-decimal currency
A pound was divided into 20 shillings, and there were 12 pennies in a shilling. A guinea was 21 shillings. Guineas were frequently used: five guineas equalled £5 5s, eight guineas £8 8s and so on.

BRADBURY & EVANS

Mrs Caudle's Curtain Lectures 1866 (145)	10s 6d
The Story of a Feather 1867 (147)	10s 6d

LONGMANS

The Life of Man 1866 (161)	42s
Lyra Germanica 1868 (403)	21s

JOHN MURRAY

Hymns in Prose 1864 (18) 7s 6d

WILLIAM NIMMO

The Blade and the Ear ?1866 *(22)* 2s
Roses and Holly 1867 (341) 10s 6d

RELIGIOUS TRACT SOCIETY

Our Life Illustrated by Pen and Pencil [1865] (240) 10s 6d
The Months Illustrated by Pen and Pencil [1864] (229) 10s 6d
English Sacred Poetry of the Olden Time [1864] (101) 10s 6d

ALEXANDER STRAHAN

Lilliput Lectures 1871 (302) 5s
The Gold Thread 1861 (198) 3s 6d
At the Back of the North Wind 1871 (190) 7s 6d
Dealings with the Fairies 1867 (191) 2s 6d
The Boy in Grey 1871 (154) 3s 6d
Wordsworth's Poems for the Young 1863 (422) 6s

WARD & LOCK

Dalziel's *Arabian Nights' Entertainments* 1864–5 (12)
 Weekly numbers 1d
 Monthly parts 6d

WARNE

The Spirit of Praise [1866] (364) 21s
Don Quixote 1866 (62) 7s 6d

ROUTLEDGE	Wholesale	Retail
Balderscourt 1866 (1)	2s 6d	3s 6d
What the Moon saw 1866 (11)	3s 7d	5s
Eliza Cook's Poems 1861 (68)	15s	21s
English Sacred Poetry 1862 (400)	15s	21s
Pictures of English Landscape 1863 (259)	15s	21s
The Home Affections 1858 (193)	9s	12s 6d
Home Thoughts and Home Scenes 1865 (127)	15s	21s
The Parables of Our Lord 1864 (244)	15s	21s
A Round of Days 1866 (346)	15s	21s
What Men have said about Woman 1865 (363)	3s 7d	5s

The Artists

It is convenient to begin this chapter with the Pre-Raphaelites because they are seen traditionally as the dominant force in illustration of the period. Their influence was certainly important, especially in the very earliest years, but it would be dangerously unbalanced to see Sixties illustration as having been, in some way, 'created' by them. Instead it is fairer to set against their contributions, notable though they are, the productions of those artists who went in different directions. In doing so, it is necessary to look with care at the subject matter and its choice and treatment, as well as at the development of various artists – or indeed their lack of development or decline in powers. Another important issue is the extent to which the artists genuinely illustrated the texts, or were merely content, as Rossetti suggested he might have been, to 'allegorize on one's own hook on the subject of the poem, without killing, for oneself, and everyone, a distinctive idea of the poet's'.[59]

The Pre-Raphaelites

Two volumes traditionally and correctly mark the start of a new kind of illustration that evolved during the late 1850s. The first is *The Music Master ... and Two Series of Day and Night Songs* 1855 (7) by William Allingham, illustrated by Dante Gabriel Rossetti, Millais and Arthur Hughes and published by Routledge. The book must have sold fairly well since it warranted later editions, but the first is now exceptionally scarce in the first issue binding. 'The Maids of Elfen-Mere', Rossetti's sole contribution, was to prove immensely influential, especially on the other Pre-Raphaelites. Burne-Jones wrote of it, shortly after its publication, 'it is I think the most beautiful drawing for an illustration I have ever seen, the weird faces of the maids of Elfinmere [sic], the musical timed movement of their arms together as they sing, the face of the man, above all, are such as only a great artist could conceive'.[60] Few would quarrel with so cogent an appreciation, and this drawing makes all the more powerful an impression when compared to the designs by Hughes, which seem temperamentally more in keeping with the previous decade and artists such as Maclise. Stylistically this drawing is of crucial importance, since it employs a favourite Pre-Raphaelite device: the placing of a figure in the extreme foreground. This was to be much used in the second book, Tennyson's *Poems* 1857 (374), usually known as the Moxon Tennyson after the publisher. This book, though published two years later than *The Music Master*, is arguably the more significant, but paradoxically the less coherent. It contains

(*Left*) 54. Thomas Morten (1836–1866), 'The Merchant and the Genie', p. 13, Dalziel's *Arabian Nights* vol. i 1865. 175 × 135mm. 1992-4-6-13

(*Right*) 55. Morten, 'A new set of ghosts', p. 237, Jonathan Swift, *Gulliver's Travels*, 1865. 219 × 140mm. 1992-4-6-367

illustrations by Millais (eighteen), Holman Hunt (seven), and Rossetti (five) but also several by non-Pre-Raphaelites, Maclise, Creswick, Mulready and J. C. Horsley. The Pre-Raphaelite designs are bolder and more strongly defined than those of their counterparts, and in almost all of them emphasis has been placed on large, central figures. In many of them there is a sense of fantasy and dream which is not present in the work of the other contributors. By comparison, the latter artists' efforts appear more generalised and conventional, and hence less powerful, with a tendency either to depict additional non-essential characters or to elaborate on other extraneous detail. Even where a Pre-Raphaelite design only loosely interprets the text, there is never any doubt as to the assured commitment of the artist to the narrative element in the poem. Hunt's 'The Ballad of Oriana' and Rossetti's 'The Palace of Art', for example, score in both weight and strength over any of the contributions of the earlier school. This is not to say that the work done by Horsley or Mulready is in some way 'bad', but rather that its presence only

serves to highlight the great differences between the two styles. The various points of departure have been explored in some detail by Joel M. Hoffman, who remarks that the figures of the older artists 'show less expression and contortion than do their Pre-Raphaelite counterparts'.[61]

This book, remarkable though it is, can be faulted because text and image are not always carefully linked and there is a good deal of 'allegorizing on own hooks'. The mix of several artists who do not happily fit together, produces a disconcerting, almost staccato effect.

Of equivalent significance to the stylistic developments made by the Pre-Raphaelites was the intellectual force which they inevitably brought to bear on the whole subject of illustration itself. As they were essentially literary artists, they saw illustration as the proper medium through which they might marry word and image and fully realise their narrative intentions. Unlike many artists who saw oil painting as the summit of their aims, the Pre-Raphaelites, at least at this particular moment, placed illustration in a more central position – what Professor Fredeman has called 'an integral part of the Pre-Raphaelite innovation'.[62] As

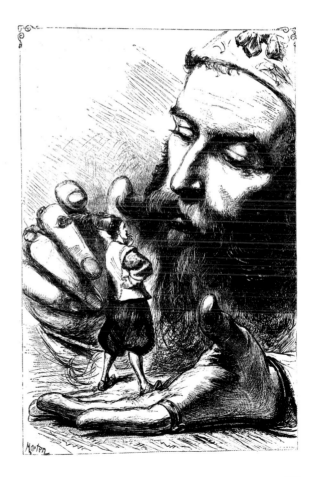

56. Morten, 'My Little Friend Grildrig', p. 153, Jonathan Swift *Gulliver's Travels* 1865. 218 × 142mm. 1992-4-6-367

telling a story was so significant a part of Pre-Raphaelite painting, it followed naturally that illustration should appeal to these artists. The growth of narrative art in general goes back to the 1830s and 1840s with artists such as Mulready and Maclise, and the Pre-Raphaelites were working from the background of an established tradition.

From this auspicious beginning, it might perhaps have been expected that a flood of highly imaginative illustrated books would have appeared, dominated by Pre-Raphaelite artists. However, although the Moxon Tennyson and *The Music Master* were important in bringing Pre-Raphaelite illustrations before the public, they were probably more significant because they drew attention to illustration as a subject, making it attractive to more people and new artists. In the event, Rossetti, Burne-Jones, Brown and Hunt made a small number of scattered, though admittedly extremely rewarding, designs, and it was only Millais who went on to produce a large and varied corpus of illustrations for both prose and verse well after the Sixties. (I do not include Burne-Jones's work for the Kelmscott Press in the 1890s, which seems entirely other in character to his work in the Sixties. This

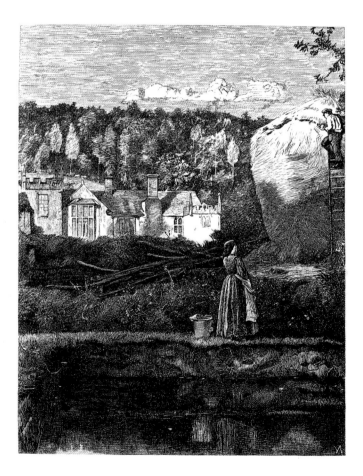

57. John William North (1842–1924), 'The Home Pond', p. 15, *A Round of Days* 1866. 178 × 135mm. 1992–4–6–346

is chiefly because it was done for an essentially private press and presumably in a conscious reaction to the execrable standards of much of the trade illustration of the 1880s.)

Rossetti, in addition to his drawings for *The Music Master* and the Moxon Tennyson, illustrated with a frontispiece and a title-page two books of poems by his sister, Christina. The first was *Goblin Market* 1862 (342) and the second *The Prince's Progress* 1866 (344). As already mentioned in Chapter 1, Rossetti also provided highly original binding designs for both books, which still appear striking today in their understated simplicity. In these two works Rossetti manages, perhaps more successfully than elsewhere, genuinely to 'illustrate' the poems, rather than merely use the poetry as a starting point for his own fantasy. As one critic has written, 'A close examination of these designs reveals that they succeed as richly developed interpretative illustrations of Christina's poems.'[63] It might also be mentioned that these illustrations rank as some of the most frankly sensual, not only of this period, but indeed of all British book illustration.

Burne-Jones's illustrations at this time are as few in number as Rossetti's, and perhaps more scattered. He made two contributions to *Good Words* in 1862 and 1863 and in the case of the latter, 'The Summer Snow', the artist is oddly named in the index 'Christopher Jones'. A curious book to which he gave a frontispiece, title-page and a tail-piece is *The Fairy Family* 1857 (195), written anonymously by Archibald Maclaren. These, his earliest illustrations, possess a gauche charm far removed from the gravitas present in so many Pre-Raphaelite designs. Indeed, Burne-Jones never acknowledged that they were his work.

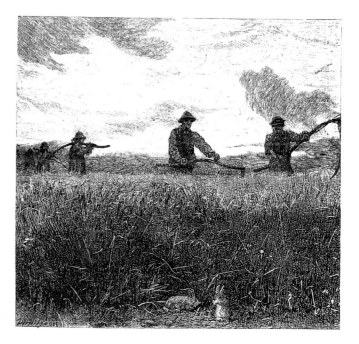

58. North, 'Reaping', p. 30,
Wayside Posies 1867.
119 × 125mm.
1992-4-6-395

Ford Madox Brown also made very few drawings for book illustration. One of the most powerful is 'The Prisoner of Chillon' in *Poets of the Nineteenth Century* 1857 (398), an important work which ghoulishly but accurately mirrors the sense of the text. Brown's diary is illuminating on his painstaking dedication to his task, and the length of time he gave to it. He records at one point that he had devoted twenty-eight hours to the work and, notwithstanding the possibility of exaggeration, the numerous entries reveal an investment of time which, although praiseworthy, was scarcely commercial. The diary also shows something of the control which the Dalziels exercised over the illustrators, when Brown writes, 'Called on Dalziel who had sent me a check for the £8 found that he wished me to put a slashed sleeve on the arm of the Prisoner to give him a more mediavel look.'[64] In 1870 Brown returned to Byron in a series of designs for an edition of the poems, to which his son Oliver also contributed, published by Moxon (not in the collection, but in the British Museum Department of Prints and Drawings, 166* *c.43*).

Holman Hunt made a few designs for magazine illustrations, in *Once a Week* in 1860 and in *Good Words* in 1862 and 1878. However, his most sustained

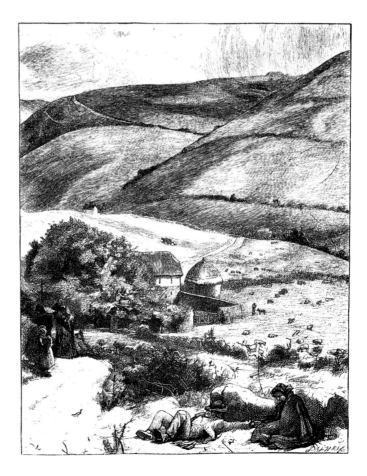

59. North, 'Glen Oona',
p. 45, *Wayside Posies*, 1867.
164 × 125mm.
1992-4-6-395

60. North, drawing,
'Requiescat in Pace', c.1867.
Pen, Indian ink and grey wash
extensively heightened with
white on buff coloured card.
126 × 101mm. 1992–4–6–86.
Engraved version, p. 39,
Jean Ingelow, *Poems* 1867.

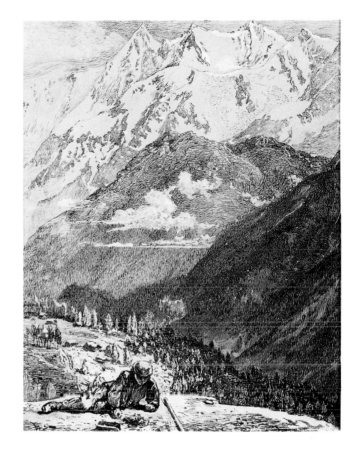

achievement was in the Moxon Tennyson, acclaimed by one commentator in the following terms: 'Of the Pre-Raphaelite contributions to the Moxon Tennyson, Hunt's designs are the most conscientiously executed in accordance with the text.'[65] Hunt also provided a notable frontispiece, 'The Lent Jewels', for Willmott's *English Sacred Poetry* 1862 (399).

Brown, Burne-Jones and Hunt also contributed to the Dalziel's *Bible Gallery* (21). Although published in 1881, this huge project belongs in spirit to the Sixties, and nearly all the designs are datable in the period.

Millais alone merits the position of most distinguished Pre-Raphaelite illustrator for a body of work which combines quality and variety with quantity. He is notable on many accounts, but there are two overwhelming characteristics which marked him out from the other Pre-Raphaelites. First, he was able to work quickly and could meet deadlines. Thus he could be reliably employed by periodicals, which had to have the drawing in time to be engraved for publication. Secondly, he was never limited in the subject matter he could undertake and is, on the evidence of what he produced, the most versatile of these artists.

The first point, concerning speed of work, is an important one. It has already

been noted how long Brown anguished over 'The Prisoner of Chillon'. Despite the excellence of the result, the Dalziels and the publishers were businessmen who had to turn a profit. It may not be entirely coincidental that Moxon himself died the year after the expensive and time-consuming Tennyson *Poems* appeared, and it has often been suggested that the worry over this book hastened his end. Rossetti and his closest associates were not temperamentally suited to be regular or long-term producers of illustrations, not simply because they wished to be known primarily as painters or poets, but equally significantly because they could not produce what was needed regularly or quickly. Although Millais agonised over, and worked slowly on *The Parables of Our Lord*, in general he drew swiftly enough to work for periodicals.

Millais' variety extends not only to his subject matter but also to his style. He was as happy with prose as with poetry, unlike most of the other Pre-Raphaelites who, with one or two exceptions, found poetry more suitable for their art. Only Hughes and Shields tackled prose to any appreciable extent, but neither approached Millais in range. Millais could produce images of haunting poetic intensity, such as 'Love' in Willmott's *Poets of the Nineteenth Century* 1857 (398), as well as equally memorable designs for Trollope's prose in *Orley Farm* 1862 (386). *The Parables of Our Lord* showed that he could bring dignity and grandeur, without bombast, to the Bible, and *Little Songs for Me to Sing* [1865] (165) revealed his ability to be tender and not cloying when illustrating for children. In *Once a Week* in 1862 he amply demonstrated his versatility by producing designs both for ballads translated from the Breton by Tom Taylor (later reprinted in book form in 1865 (369)) and for *Sister Anna's Probation*, a story by Harriet Martineau.

It was in his style, however, that Millais showed an unique strength. He could alternate between two different styles, which for convenience might be termed 'Ancient and Modern'. This distinction is far more complex than the mere differentiation of dress, according to the historical setting of what was being illustrated. It was, rather, his ability to deal with a Parable with an appropriate sense of monumentality, while consciously reducing the scale and increasing the intimacy. This is seen in, for example, his earliest illustration, the frontispiece to Wilkie Collins' *Mr Wray's Cashbox* 1852 (67). The directness and immediacy of his illustrations were especially suited to the Trollope novels, dealing as they frequently do with a volatile blend of politics, domestic life and the Church. For his own library Trollope had bound a set of artist's proofs of Millais' designs for *Orley Farm*, and in the album he wrote, 'I have never known a set of illustrations so carefully true, as are these, to the conception of the writer of the book illustrated.'[66]

Millais' style was never static and he continued to develop. As late as 1879, when he illustrated an edition of Thackeray's *Barry Lyndon*, he drew with a powerful sparsity and originality, while remaining true to the spirit and period of the work.

There were several other artists working in the Pre-Raphaelite milieu who are

well represented in the de Beaumont collection. Among the most important are Arthur Hughes, Frederick Sandys and Frederic Shields. Hughes, like Millais, tackled both prose and verse and has become best known for his illustrations for children's books. He made numerous designs for the works of George Macdonald, most notably *At the Back of the North Wind* 1871 (190) and *Dealings with the Fairies* 1867 (191). His illustrations for *Tom Brown's Schooldays* 1869 (134) are also justly celebrated. Although Hughes can sometimes be guilty of repetition and sentimentality, in all three of these works he is at his best. As a recent critic has noticed, it is the timeless quality of his drawings that makes them so memorable. She acutely sees that 'In his depictions of sexuality, of sentimental melancholy, of apprehensions of undefinable, incomprehensible, and unfriendly powers, Hughes can be seen to interrelate intimately with a variety of contemporary forms of anxiety.'[67] Hughes's major achievement for adults is *Enoch Arden* 1866 (371), one of those rare books of the period where a genuinely outstanding work of literature finds, in its illustrator, an equally sympathetic partner. It is all of a piece, unlike the Moxon Tennyson which, in the final analysis and despite its virtues, is diluted by the incongruities already discussed.

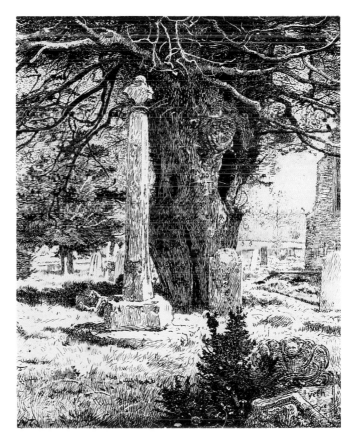

61. North, drawing, 'The Four Bridges', *c.*1867. Pen, Indian ink and grey wash extensively heightened with white on buff coloured card. 125 x 101mm. 1992–4–6–87. Engraved version, p.253, Jean Ingelow, *Poems* 1867.

Frederick Sandys was one of the most powerful illustrators in the outer Pre-Raphaelite circle. Greatly influenced by German art, especially Dürer and Rethel (see Chapter 6), he expressed many of the mid-Victorian obsessions with sex, death, despair and yearning passion in his few (less than thirty) highly wrought and febrile illustrations. His work as an illustrator is awkward to examine, since it was nearly all published in the magazines. He made a contribution to Dalziel's *Bible Gallery* and two to Willmott's *English Sacred Poetry* 1862. His finest illustration, 'Amor Mundi', appeared in the short-lived *Shilling Magazine* (217) in 1865; it contains a macabre comment on the transitory nature of joy as the two lovers stroll, oblivious, towards a putrefying corpse, typically placed in the lower foreground. Stylistically this design may be compared with Brown's 'The Prisoner of Chillon' (see above) made some eight years previously.

Frederic Shields made even fewer illustrations than Sandys and his best are connected with two works of prose. He made six small drawings for Defoe's *The History of the Plague of London* [1863] (78), a book of great rarity in the true first edition. The following year he made nineteen designs which appeared without

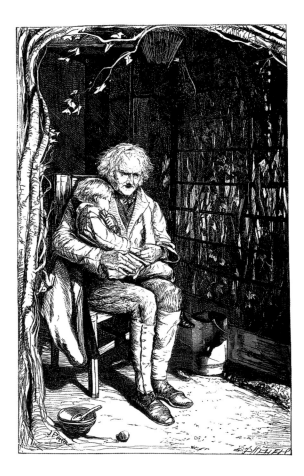

62. John Pettie (1839–1893), 'The Passion Flowers of Life', opp. p.141, *Good Words* 1863. 176 × 112mm. 1992-4-6-546

86

letterpress as *Illustrations to Bunyan's Pilgrim's Progress*. The copy of the work contained in the de Beaumont collection is a later edition of 1875 (43), but the collection also includes one of Shields' original drawings for the head in 'Mercy fainting at the Gates' (92). Shields and Sandys can be linked stylistically, though the latter is arguably a more varied and poetic artist. The former's almost unrelieved grimness can prove wearying.

Lawless and Armstead were two further artists of interest who inhabited this Pre-Raphaelite circle. Regrettably, Armstead made so few designs that it is difficult to assess his achievement. However, on the evidence of 'The Trysting Place' contained in Eliza Cook's *Poems* 1861 (68), he was a powerful performer with a well-developed interest in Mediaevalism – a subject which appealed to so many of these artists. Evidence of Lawless's fondness for mediaeval themes can be seen in the way that he often designed his monogram like that of Dürer or other German Renaissance artists. Some of his finest work was for *Once a Week*, notably 'Heinrich Frauenlob' and 'The Betrayed'. He died at the age of twenty-nine before his style could fully mature, but he remains an illustrator of some stature who warrants serious examination.

Three other artists whose works clearly reveal a Pre-Raphaelite influence should now be mentioned. Simeon Solomon concentrated almost exclusively on Jewish themes and his most impressive achievement was *Illustrations of Jewish Customs*, a series of ten small designs contained in *The Leisure Hour* 1866 (209). Despite indifferent engraving and printing on poor paper, these remain works of genuine feeling and power. Two women artists who also worked in a Pre-Raphaelite vein were Jane Benham (later Hay) and Eleanor Vere Boyle (EVB). The former contributed some fine designs, especially those for editions of Longfellow in 1852 and 1854 (176, 179, 180), which reveal debts to her training in Germany with Kaulbach. EVB illustrated at least two works alone – Tennyson's *The May Queen* 1861 (373) and her own *Child's Play* [1852] (30) – and both provide convincing evidence that she was an artist of genuine originality.

The Idyllic school

Several other artists of this period have, for convenience, been described as belonging to the 'Idyllic' or 'Open Air' school. The term may well have stemmed from a rare anthology of designs culled from *The Quiver*. Entitled *Idyllic Pictures* 1867 (136), it contains work by Pinwell, Houghton, Robert Barnes, William Small, Sandys, Mary Ellen Edwards and John Lawson, among others. Forrest Reid seems to have been the first to use the description, and under it he also includes Frederick Walker and J. W. North. Of the former, when speaking of his designs for *Denis Duval* Reid wrote, 'he may clothe his figures in the costume of a bygone age, but the drawings themselves breathe precisely the same idyllic Victorian spirit as his modern illustrations'.[68] A further clue to the exact meaning when applied to these illustrations is offered in the introduction to *A Round of*

Days 1866 (346), a work sometimes considered archetypally Idyllic in spirit. Here we read, 'As life consists of "a round of days" that title has been chosen to designate a collection of Poems and Pictures representing everyday scenes, occurrences and incidents in various phases of existence.'

Houghton, du Maurier and Pinwell were all artists whose work falls into this category. Houghton is perhaps the most important, because he was the most prolific and varied. Despite his short life, he worked to a very high standard up to his death, and, unlike du Maurier, his work did not degenerate into saccharine sentimentality. He contributed widely to magazines, notably *Good Words*, *London Society*, *Churchman's Family Magazine*, *Good Words for the Young*, *The Quiver*, *The Argosy* and *The Graphic* 1869–71 (208). In these he seems equally at home with verse or prose aimed either at children or adults. He was just as varied in the types of books which he illustrated and among these may be discerned his several styles. A favourite was his oriental style, which he used to great effect in the Dalziel's *Arabian Nights*. He illustrated this virtually single-handed and it ranks as one of his most sustained achievements. Another could be termed his domestic style, which was based almost exclusively on his own family. It reached a peak of intensity in *Home Thoughts and Home Scenes* 1865. This innocuous title disguises a book of designs which reveal juvenile passions and disquiet, as powerful and intense as anything produced by Sandys. His books aimed exclusively at children are often of less interest, but in what might be called his journalistic style, he produced for *The Graphic* a potently truthful series entitled *Graphic America*. These numerous designs are of such variety that they would make an interesting and valuable exhibition in themselves. His use of wood-engraving for reportage had a parallel in America, where artists such as Winslow Homer employed it similarly. The entombment of these images in the cumbersome *Graphic* volumes means, however, that they are unjustifiably little known.

Du Maurier, so often thought of merely as a consummate artist for *Punch* in the 1870s and 1880s, was during this period a prolific contributor to magazines and books of a more serious nature. In *Once a Week* he was confined in the main to thrillers with titles such as *The Notting Hill Mystery* 1862–3 and *The Veiled Portrait* 1864, but his letters at the time show that he had his sights set on higher things. To his mother he wrote prophetically in April 1861, 'I am very anxious to be kept on O. A. W [*Once a Week*] as it is the swellest thing out and gets one known, and the more carefully I draw the better it will be for me in the end, as a day is coming when illustrating for the million (swinish multitude) à la Phiz and à la Gilbert will give place to real art, more expensive to print and engrave and therefore only within the means of more educated classes, who will appreciate more.'[69]

Du Maurier soon had his chance, and some of his noblest Idyllic compositions appeared in the *Cornhill* 1864–5 for Mrs Gaskell's *Wives and Daughters*. Expertly engraved by Swain, these designs are of a quality which du Maurier was unable to sustain. Instead of developing further, he soon slipped into a sub-*Punch*

type of prettiness, which begins in a work such as Owen Meredith's *Lucile* 1868 (222) and is virtually complete by the time he came to illustrate Florence Montgomery's *Misunderstood* 1874. A rare survival of his Idyllic style was 'Under the Elm' which appeared in *Good Words* as late as 1872.

Even as a humorous artist du Maurier was at his most incisive in the Sixties. His outstanding achievement in this vein appears in Douglas Jerrold's *The Story of a Feather* 1867 (147), where he excelled in inventiveness, not only in the full-page designs, but especially in the numerous vignette initial letters which head each chapter.

G. J. Pinwell, while more limited in subject matter than Houghton, and less accomplished a draughtsman than du Maurier, was arguably, within his narrow compass, the most intensely poetic of the Idyllic artists. Some of his best work appears in *Wayside Posies* 1867 (395). Designs such as 'Shadow and Substance' and 'The Island Bee' reveal Pinwell's ability to produce haunting and sometimes disturbing images which nevertheless have an air of mystery about them. Very few of his figures look directly out of the designs, while many hide their features with a

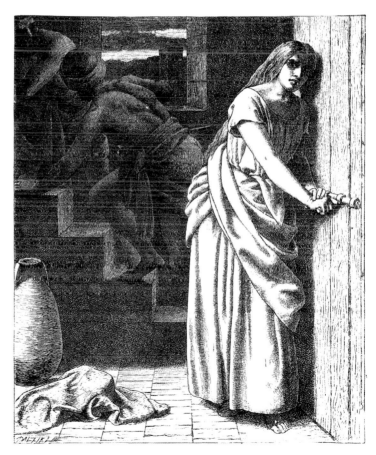

63. Frederick Richard Pickersgill (1820–1900), 'Rahab and the Spies', p. 115, *Art Pictures from the Old Testament* 1894, first published in Dalziel's *Bible Gallery* 1881. 215 × 178mm. 1992–4–6–15

hat. As a draughtsman Pinwell is not usually impressive, but his idiosyncratic designs improve markedly when cut on a block and can possess great strength. He illustrated few books alone, and his one major individual commission – for Dalziel's *Illustrated Goldsmith* 1865 (114), which was a costume piece – did not suit him. He was most at home designing for works where he could allow full rein to his fragile talent for depicting figures in the open air. A striking example of this skill can be seen in his work for 'High Tide on the Coast of Lincolnshire' in Jean Ingelow's *Poems* 1867 (137).

Another artist who shared a measure of Pinwell's poetic sense was J. W. North. This little-known artist is important because he was the only genuine landscape artist of the Idyllic group and indeed one of very few of the entire period. Unlike Pinwell, his figures are invariably subservient to the landscape element, and he is more interested in the overall design than in dealing with human feeling or emotion. In a design such as 'Reaping' in *Wayside Posies* he seems more concerned with a harmonious grouping of the figures than in making any social comment.

If Houghton, du Maurier, Pinwell and North exemplify the central Idyllic group, there were, in addition, several other artists working in the same general area who deserve some comment. Frederick Walker, though a better-known artist than either Pinwell or North, seems, on the evidence of his illustrations, to be a less interesting one. Various studies were devoted to him shortly after his tragically early death, but on the basis solely of what remains, he had relatively little to say. A fine design such as 'Broken Victuals' in *A Round of Days*, though accomplished and pleasing, remains little more than a good composition. Walker's work as an illustrator is essentially competent but conventional. However, it might be well to remember the high regard in which he was held by his contemporaries. Du Maurier, for example, probably thinking of the designs for Thackeray's *Philip* which brought Walker to prominence when the novel was serialised in the *Cornhill* during 1861–2, wrote in *The Magazine of Art* in August 1890, 'he was the first to understand, in their "inner significance", the boot, the hat, the coat-sleeve, the terrible trousers, and, most difficult of all, the masculine evening suit. Even Millais and Leech, who knew the modern world so well, could not beat him at these.'

Two little-known Scottish artists, William Small and John Dawson Watson both worked in an Idyllic style, often with real originality. As with Pinwell, Small's drawings improve in strength when cut on the wood-block, but his work is little documented. Many of his best designs were for children's books, such as *Little Lays for Little Folks* 1867 (394), but for adults he excelled especially in his drawings for Milton's *Ode on the Morning of Christ's Nativity* 1868 (225). Here he produced images which were not only appropriate to the text but were also imaginative and lively in composition. Small developed as an artist and changed his style, and he was one of the few Sixties artists who continued to illustrate in the period when wood-engraving was gradually being replaced by photo-mechanical methods of reproduction. In the 1870s and 1880s he tried to adapt his style to the new possibilities offered by photography, moving away from the Sixties stress on

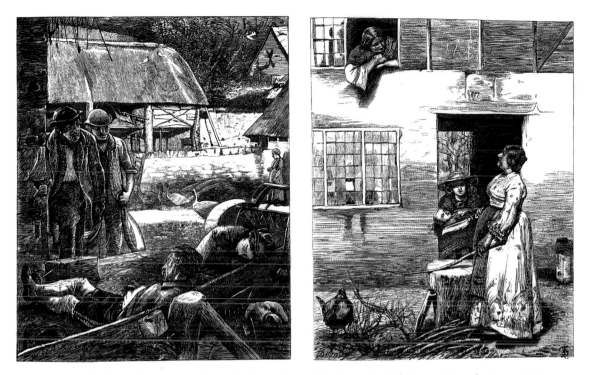

(*Left*) 64. George John Pinwell (1842–1875), 'The Journey's End', p. 28, *Wayside Posies* 1867. 159 × 125mm. 1992-4-6-395

(*Right*) 65. Pinwell, 'At the threshold', p. 7, *A Round of Days* 1866. 165 × 129mm. 1992-4-6-346

purity of line towards an increased use of wash. His later work, although interesting from a technical point of view, unfortunately lost much of its earlier power when reproduced photomechanically.

Watson is a more difficult artist to evaluate. He is at his best in designs of simplicity and power, such as 'Ash Wednesday' in *London Society* 1862 (211a), and in those which he made for *English Sacred Poetry* 1862 (399), or in his charming drawings for children, such as the ones in *The Golden Harp* 1864 (94). His one major project was his complete *Pilgrim's Progress* 1861 (40), but, fine though many of the designs are, he, like Pinwell, was clearly happier to make contributions to a volume rather than undertake the entire responsibility for it.

An ubiquitous artist who had an undeniable tendency towards the sentimental was Robert Barnes. His most important work is *Pictures of English Life* 1865 (260), which shows him as a highly competent if not particularly inspired draughtsman. However, the book is entirely Idyllic in feeling and can be seen as an almost archetypical example. A further point is that the wood-engravings it contains are among the largest of the period.

There were many other artists who worked in an Idyllic way, such as John

Pettie, who only produced a handful of designs. One of the Dalziel family, Edward, on occasion could produce a memorable drawing. Much of his best work appears in Bryant's Poems 1854?(33). This book (Appleton, New York) is undated on the title-page. However, the information 'Entered 1854' appears on the title verso. An English edition was published in 1858 by Sampson Low. Mary Ellen Edwards produced many competent designs in a similar vein, and John Lawson's neglected work is frequently of great character and interest.

Other styles

The Pre-Raphaelites and the Idyllic School provide the two main stylistic strands to illustration at this period, but they were by no means the only ones – nor indeed are these classifications in any way watertight. The Sixties were rich and complex enough to allow artists who worked in other ways to flourish.

Three who fall into no neat category are Charles Keene, Whistler and Thomas

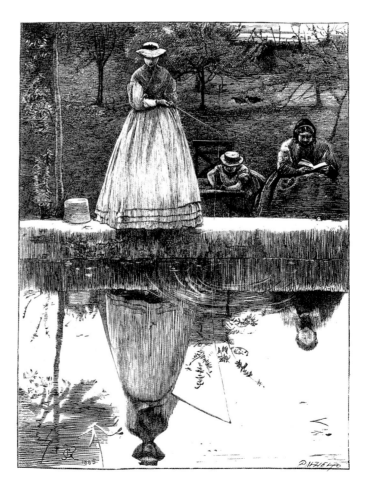

66. Pinwell, 'Shadow and Substance', p. 8, *Wayside Posies* 1867. 169 × 125mm. 1992-4-6-395

Morten. Keene has two outstanding books in the collection. The first is Douglas Jerrold's *Mrs Caudle's Curtain Lectures* 1866 (145, 146) and the other is Herbert Vaughan's *The Cambridge Grisette* 1862 (390). The former is rightly seen as Keene's best book and the designs remain genuinely comic, even though the text has dated. Keene was not, however, restricted to comic work. In the first year (1859) of *Once a Week* he illustrated Charles Reade's *A Good Fight* in what might be termed a mediaeval swashbuckling style, and in the following year in the same magazine showed his adaptability by turning his attention to George Meredith's novel *Evan Harrington*.

Whistler's six wood-engraved illustrations are to be found in the collection. All appeared in 1862, two in *Good Words* and four in *Once a Week*. Typically they are impossible to classify and are best summed up by Forrest Reid, who wrote, 'They do not display all his qualities, of course, but they display his poetic imagination, his feeling for decoration, his beauty of line, his sense of composition, and that impeccable taste which in him, as Arthur Symons has said, was

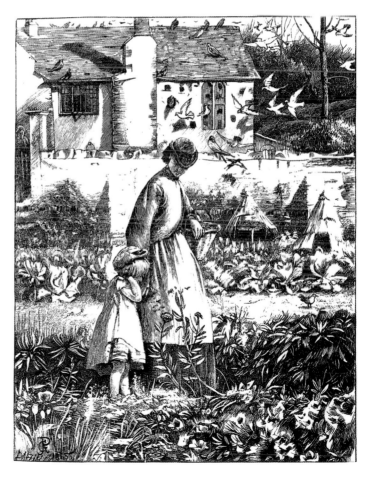

67. Pinwell, 'The Island Bee', p. 47, *Wayside Posies* 1867. 160 × 124mm. 1992–4–6–395

carried to the point of genius.'[70] In addition the collection also includes the two etchings which Whistler contributed to *Passages from Modern English Poets* 1862 (248).

Thomas Morten, who committed suicide in September 1866, aged only thirty, produced a remarkable edition of *Gulliver's Travels* 1865 (367). Professor Life has acutely pointed out that Morten's fatal flaw was plagiarism, and that in this instance, his source was another illustrator who had tackled the same work, John Gordon Thompson: 'That Thompson's designs often function as studies for Morten's more elaborate and accomplished works does not diminish the tragic implications of a mature artist's reliance upon an amateur's imagination.'[71] True as this may be, there is a long tradition of professional artists building on the ideas of amateurs. Gillray and Rowlandson, for example, both made many drawings based on designs supplied by amateur friends. The point in Morten's case was that he clearly borrowed without permission. Despite Life's strictures, Morten's edition of Swift's classic remains a wonderfully concerted effort and cannot be ignored.

Poynter, Frederick Leighton and G. F. Watts were occasional illustrators who worked in their own classically inspired 'High Victorian' style. All three contributed monumental designs to Dalziel's *Bible Gallery*, but Leighton also produced an impressive series of drawings for George Eliot's *Romola*. These appeared in the *Cornhill* between July 1862 and August 1863.

F. R. Pickersgill, who also contributed to the *Bible Gallery*, was an illustrator whose spare neo-classical style remained little changed throughout the period. He continued to work up to the 1870s in exactly the same style as he had used in the 1840s. An impressive example of his work, published as late as 1870, but which might have been made at least thirty years earlier, is *The Lord's Prayer* 1870 (6). However, it must be remembered that religious subject matter tended to be treated by artists in an archaic style.

Like Pickersgill, there are other important artists who continued to illustrate throughout the period with little stylistic change or development. Among these should be included Birket Foster, Tenniel and John Gilbert. Up to the late 1850s Foster was the most prolific of artists, and few books escaped the inclusion of one or two of his refined landscape vignettes. His most distinguished achievement here is *Pictures of English Landscape* 1863 (259), in which his large designs, well engraved, show a sure grasp of his subject. Foster virtually gave up designing for books after this date but his illustrations were reprinted countless times until the

(*Facing page, top left*) 68. Pinwell, drawing, self portrait. n.d. Graphite. 138 × 122mm. 1992-4-6-89

(*Facing page, top right*) 69. Pinwell, 'An English Eclogue', p. 65, Robert Buchanan *North Coast and other poems* 1868. 125 × 100mm. 1992-4-6-35

(*Facing page, below*) 70 (*left*) and 71 (*right*) Pinwell, two illustrations for 'High Tide on the Coast of Lincolnshire' p. 163 and 169, Jean Ingelow *Poems* 1867, p. 163 (*left*): 127 × 100mm. p. 169 (*right*): 128 × 101mm. 1992-4-6-137

1880s and beyond. His work was produced very much to a formula and, although initially charming, its lack of inventiveness can become numbing.

Gilbert's star, so high in the Victorian firmament, has also fallen in this century. His most considerable achievement is probably a huge edition of the works of Shakespeare, but in this collection he is seen at his best in Longfellow's *Poetical Works* 1856 (181). His work has great facility but, perhaps because he apparently never drew from life, to a modern reader many of his illustrations have a rather mechanical feel.

While Tenniel made numerous contributions to books and magazines of the period (notably *Lalla Rookh* 1861 (231), which he illustrated alone), his heart lay more with *Punch* and with *Alice in Wonderland*, which both lie outside the scope of this collection. As a recent critic has remarked of his designs made prior to *Alice*, 'while most of these books were competently conceived and admirable examples of Sixties School illustration, the true test of his abilities lay with a fastidious, infuriatingly tiresome Oxford don and his inimitable childish fantasies'.[72]

Appendix to Chapter 5

Alphabetical list of the chief artists mentioned in this chapter with their dates.

ARMSTEAD, Henry Hugh (1828–1905)

BARNES, Robert (1840–95)

BENHAM (later HAY), Jane (*fl.* 1850–62)

BOYLE, Eleanor Vere (EVB) (1825–1916)

BROWN, Ford Madox (1821–93)

BURNE-JONES, Edward (1837–98)

CRESWICK, Thomas (1811–69)

DALZIEL, Edward (1817–1905)

DU MAURIER, George (1834–96)

EDWARDS, Mary Ellen (later FREER, then STAPLES) (1839–*c*.1910)

FOSTER, Myles Birket (1825–99)

GILBERT, John (1817–97)

HORSLEY, John Callcott (1817–1903)

HOUGHTON, Arthur Boyd (1837–75)

HUGHES, Arthur (1832–1915)

HUNT, William Holman (1827–1910)

KEENE, Charles Samuel (1823–91)

LAWLESS, Matthew James (1837–64)

LAWSON, John (*fl.* 1865–1909)

LEIGHTON, Frederic (1830–96)

MACLISE, Daniel (1806–70)

MILLAIS, John Everett (1829–96)

MORTEN, Thomas (1836–66)

MULREADY, William (1786–63)

NORTH, John William (1842–1924)

PETTIE, John (1839–93)

PICKERSGILL, Frederick Richard (1820–1900)

PINWELL, George John (1842–75)

POYNTER, Edward John (1836–1919)

ROSSETTI, Dante Gabriel (1828–82)

SANDYS, Frederick Augustus (1832–1904)

SHIELDS, Frederic (1833–1911)

SMALL, William (1843–1929)

SOLOMON, Simeon (1840–1905)

TENNIEL, John (1820–1914)

WALKER, Frederick (1840–75)

WATSON, John Dawson (1832–92)

WATTS, George Frederick (1817–1904)

WHISTLER, James Abbott McNeil (1834–1903)

Foreign Influences

'I said that, had Tenniel been rightly trained, there might have been the making of a Holbein, or nearly a Holbein, in him.'[73] Ruskin's remark, made in 1872, reveals an admiration for German art which was espoused not only by him but also by several of the artists with whom we are concerned. It is a revealing exercise to investigate which German artists were genuinely appreciated in England at this period, and how far their ideas were accepted and adapted for the English reader. Influences from other countries on English artists are also discussed briefly in this chapter.

The year 1828 marked the three hundredth anniversary of the death of Dürer and was duly celebrated in Germany, but the revival of interest in his art dates from some years earlier. On 1 September 1817 Rudolph Ackermann published in London a series of lithographs after Dürer's designs for the *Prayer Book* of Maximilian of Bavaria. This was an early example of a lithographed book in England. Printed in colour, these designs had enormous influence on German and English illustration, not merely because of the style of the drawing, but also because of the way in which the images surrounded the text, instead of being encased within the letterpress. These drawings were not vignettes tossed into a sea of words, but were important and dominant in their own right. As if to stress the separate nature of the designs, the texts were isolated from them by ruled borders. A major book which followed this pattern was S. C. Hall's *Book of British Ballads* 1842 and 1844 (124). The second series of 1844 bore a dedication to Ludwig, King of Bavaria, in which Hall wrote that the volume was 'suggested by the Works of German Artists'. In terms of design, few books in the collection similarly ape the manner in which the drawings are placed, but Hall's book is otherwise important because it brought together a number of English artists who were to continue to work in a Germanic manner throughout the Sixties, notably Paton, Tenniel, Pickersgill and Gilbert. Significantly, these were the very illustrators whose styles throughout the period were only marginally affected by what the Pre-Raphaelites or the Idyllic artists were doing. However, as we shall see, it was not Dürer alone who influenced them.

F. A. M. Retzsch

The greatest and clearest influence on an artist such as Pickersgill was F. A. M. Retzsch (1779–1857). It is perhaps difficult today to comprehend just how popular and influential the 'outline' style of this artist was in the England of

the first half of the nineteenth century. As late as 1893 his illustrations to Goethe's *Faust* were still being republished in London, some seventy years after their first appearance in Germany.[74] Retzsch was admired by writers such as Byron and Shelley as well as by Flaxman, Maclise, Rossetti and Millais. Retzsch's appeal to the English seemed to lie in the clarity of his narrative message, coupled with a strict economy of line. Above all, Retzsch was a genuine illustrator because he explained the text in an unambiguous manner. As one English reviewer remarked, 'We have heard Germans say that we Englishmen cannot comprehend Faust. With that we have nothing to do here. We understand Retzsch, very much to the honour of the poet he illustrates, very much to his own honour, and very much to our own gratification.'[75]

Retzsch's interpretation of *Faust* reached England as early as 1819, and within two years large sales were being achieved by an English version with engravings by Henry Moses made after Retzsch's designs. In 1824 Moses produced another set of engravings after Retzsch, this time accompanying a translation of Schiller entitled *Fridolin, or the Road to the Iron Foundry*. As the years went by, Retzsch aimed his work increasingly at the English market, and in 1828, 1836 and 1838 his outline illustrations to Shakespeare were published in Leipzig and in London with accompanying text in English. In 1840 his etched illustrations to Bürger's *Ballads* were also published in this country. As Vaughan points out, Retzsch remained popular in England long after any vogue which he might have enjoyed in his native country had faded: 'Retzsch, by retaining outline to depict the varied subjects of modern literature in an anecdotal and detailed manner, became an anomaly in the Germany of Richter, Rethel and the Munich illustrators.'[76] Although Retzsch clearly had an effect on Tenniel, Paton and Forties artists such as Franklin and O'Neill, in the context of this study it is Pickersgill who will be the main focus of our attention.

One of the first commissions given by the Dalziels to a single artist was to Pickersgill. In 1850 they entrusted him with a grandiose project – an illustrated *Life of Christ*, which never reached completion. They wrote that, at this date, they were 'desiring to follow the example of Rethel's "Dance of Death" which had just been published in Germany at a very small price . . . Our attempt to produce high class art at what was then thought to be a nominal price was not responded to.'[77] In the manner in which the engravings were published, using large images devoid of text, the Dalziels were quite right to compare their project with Rethel's. However, in terms of narrative style and outline execution, the comparison should surely have been made with Retzsch, and Pickersgill was undoubtedly the truest and most devoted Retzschian illustrator at work during the Sixties. He was given a few commissions to complete alone, but in general, his slow and deliberate methods meant that he was happier to make occasional contributions to volumes illustrated by others.

As already mentioned, Pickersgill produced some designs for the second series of Hall's *Book of British Ballads* in 1844 and in the same year he illustrated

Massinger's *The Virgin Martyr* (219) in a similar vein. Virtually every book illustrated by Pickersgill is contained in the de Beaumont collection. His designs in, for example, Thomas Moore's *Poetry and Pictures* (first published 1858) (232) or Montgomery's *Poems* 1860 (227), show that, while remaining true to Retzsch in inspiration, he produced work which is consistently softened. While Retzsch is cold and hard in outline, Pickersgill's forms are invariably rounder, more lively and, in the final analysis, warmer in atmosphere.

Adolph Menzel

While Pickersgill represents those artists who were affected by this 'outline' German style, so Charles Keene is the epitome of those most influenced by another German artist, Adolph Menzel (1815–1905). Menzel, though comparatively little known in Britain, has a place in German esteem which is similar to that of Hogarth in Britain. During his lifetime, which spanned the nineteenth century, Menzel was prolific as painter, draughtsman and illustrator. In 1838 he began work as a designer for book illustrations with sixteen drawings for *Peter Schlemihl*. His next project, a considerably larger one, was a commission to illustrate Kugler's *Life of Frederick the Great* (see fig. 7). Some five hundred of the designs appeared in an English edition in 1844, and it was this work which was to exert so great an

72. Edward John Poynter (1836–1919), 'Miriam', p. 73, *Art Pictures from the Old Testament* 1894, first published in Dalziel's *Bible Gallery* 1881. 228 × 169mm. 1992–4–6–15

influence on Keene. He first saw Menzel's work in the early 1850s and also came into contact with the drawings, by seeing them in the collection of a friend, the collector J. P. Heseltine, and through him began a correspondence with Menzel.[78] What Keene no doubt admired in Menzel was his ability to draw accurately, simply and yet with vivacity, within a small space. Menzel was a master of the understated, pregnant vignette and something of his influence can be seen in Dulcken's *The Book of German Songs* 1856 (93), and to even greater effect in *Mrs Caudle's Curtain Lectures* 1866.

Du Maurier also was influenced by Menzel, as his lifelong friend, Tom Armstrong, recalled: 'Du Maurier used to practise methods of execution about this time with pen and brush, and I remember his careful copy of a portion of one of Rethel's famous woodcuts, *Death the Friend*, and also portions of Menzel's work in the life of Frederick the Great. This book, of which Charles Keene was the first among us to own a copy, impressed English draughtsmen on wood very much.'[79] The time referred to was probably autumn 1861, when a drawing done by du Maurier for *Once a Week* was rejected. Instead, the commission went to Frederick Sandys and, although disappointed, du Maurier exclaimed with generosity in a letter, datable September 1861, to his mother, 'Wasn't Fred Sandys's drawing exquisite? That was the poem that I illustrated, and which they refused on account of its being so elaborate.'[80] The drawing in question was 'From

73. Dante Gabriel Rossetti
(1828–82), 'Sir Galahad',
p. 305, Tennyson *Poems* 1857
(The Moxon Tennyson).
95 × 80mm. 1992–4–6–374

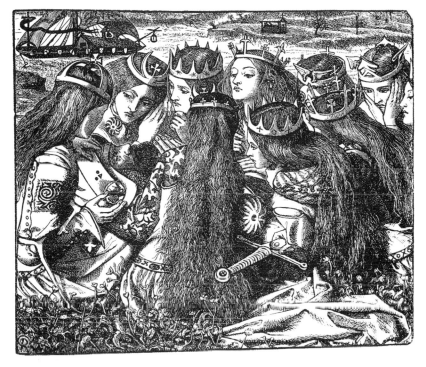

/4. Rossetti, 'The Palace of Art', p. 119, Tennyson *Poems* 1857 (The Moxon Tennyson). 80 × 94mm. 1992–4–6–374

my Window', which appeared in the magazine on 24 August 1861. Du Maurier so admired Sandys that he even emulated him, especially in a very Rethel-like composition, 'A Time to Dance', which was published in *Good Words* in October 1861. However, in du Maurier's case, it would be a mistake to stress Rethel's influence above that of Menzel, or indeed other illustrators such as Ludwig Richter. Du Maurier did little work in Sandys's style, but the influence of Menzel is clearly apparent in, for example, the vignettes in *The Story of a Feather* 1867. Du Maurier's depictions of women, especially in the works of Mrs Gaskell, owe far more to Menzel than to Sandys. Like those of Millais, they have an elegance and a sweetness which is absent in the more tortured and sensual designs of Sandys.

Du Maurier also found the work of Ludwig Richter of interest, both stylistically and commercially. In a letter to his mother, datable September 1864, he wrote, 'I wish you would find out how Richter manages with his publishers, for nearly all his drawings have been illustrations to a periodical which have afterwards appeared in a separate form as "Album-Richter".'[81] Du Maurier was to have his wishes somewhat satisfied by the publication in 1880 of some sixty-three of his designs for *Punch* in a folio volume entitled *English Society at Home*.

The influence of Menzel on Millais is less easy to calculate. Millais's illustrations seem to owe little directly to the German artist's book designs, but by comparing Menzel's paintings with Millais's magazine and book designs the link

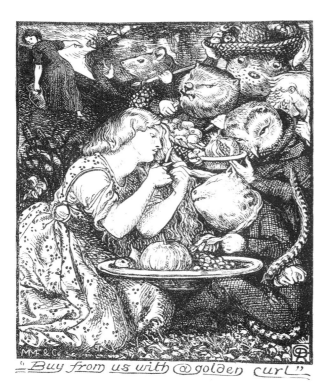

becomes more obvious. Two major exhibitions of German and Austrian paintings were held in London in 1861 and 1862. The latter, which was part of the International Exhibition at South Kensington, was probably the largest display of German nineteenth-century art ever held in Britain.[82] It is possible that Millais may have seen these exhibitions, for although no formal evidence exists to prove this, several of his designs for Trollope in particular bear more than a superficial resemblance to paintings by Menzel. Stylistically his knowledge of Menzel's work, conjectural though it is, must date from before these exhibitions, given his designs for *Framley Parsonage*. These appeared in the *Cornhill* in 1860 and one of the most celebrated, 'Was it not a lie?', which shows Lucy weeping on her bed, is uncannily close in composition and feeling to Menzel's painting of his sister, Emily, of 1848 (Hamburg, Kunsthalle). Naturally one must be ever wary in comparisons of this kind, but it is fair at least to suggest that Millais saw and admired Menzel as a painter.

Alfred Rethel

Alfred Rethel (1816–59) was perhaps the German artist whose influence is the most apparent to a modern viewer. Even more than Retszch, Rethel affected British illustrators not merely stylistically, but also emotionally. His woodcuts,

which were obsessively concerned with death in a mediaeval setting, found a ready echo in the sensibilities of certain mid-Victorian artists, into whose preoccupations such ideas fitted naturally. His influence is most clearly seen in the work of Sandys, Lawless and Shields.

In 1840 Rethel illustrated *Das Nibelunglied*, whose mediaeval designs suggest Paton's drawings for Aytoun's *Lays of the Scottish Cavaliers*, which did not appear until 1863. More significant were the six large woodcuts which he made for *Auch ein Totentanz* (Another Dance of Death), which were published in Dresden in 1849, the year after the Revolutions of 1848 which these designs commemorate. Rethel managed to combine a backward glance at treatments of the subject by Holbein and Deutsch with an entirely contemporary and populist approach. These woodcuts, printed on tinted paper, with minimal text in Gothic script by R. Reinick, were clearly influential on Shields in his *Illustrations to Bunyan's Pilgrim's Progress*, first published in 1864 (43). Not only is there here a conscious Germanising in the use of a similar script, but the large figures, heavily shadowed, and the device of steep precipices dropping away in the foreground, also reveal an enormous debt to the German artist. This influence can also be seen to a lesser extent in Shields's powerful but smaller designs for Defoe's *History of*

76. Rossetti, 'You should have wept her yesterday', frontispiece, Christina Rossetti *The Prince's Progress*, 1866. 150×97mm.
1992-4-6-344

You should have wept her yesterday

the Plague, first published in 1863 (78). Rethel made three further woodcuts on the themes of Death as Friend, Slaughterer and Servant, and these grimly powerful designs were widely circulated (see fig. 9). Made before the onset of Rethel's insanity in 1853, they are a direct mirror of the woodcuts of Dürer, and hence would have appealed to so ardent a mediaevalist as Sandys. Engraved by J. Jungtow after Rethel, 'Der Tod als Freund' (Death the Friend) 1851 shows a hooded skeleton tolling a bell in a medieval room with an old man in a chair behind – an archetypical Rethel concept. Some of Sandys's most powerful images, such as 'Until her Death' and 'Rosamund, Queen of the Lombards', contain elements clearly derived from Rethel. In the former, which appeared in *Good Words* in October 1862, the use of the clothed skeleton looks straight back to Rethel, as does the placing of the figures in the latter (*Once a Week*, 30 November 1861). However, Sandys's interest in brooding sexuality, sometimes but not always coupled with comments on death, looks beyond Rethel, especially to German artists of the sixteenth century such as Sebald Beham. One of Sandys's most potent images in this manner is 'Amor Mundi', which appeared in the *Shilling Magazine* in 1865. In 'If' (*Argosy*, March 1866) the figure is reminiscent, not only of that in

77. Frederick Augustus Sandys (1832–1904), 'From my window', p.238, *Once a Week* August 24th 1861. 128 × 85mm. 1992–4–6–582

78. Sandys, 'Until her death', p.312, *Good Words* 1862. 102 × 125mm. 1992–4–6–578

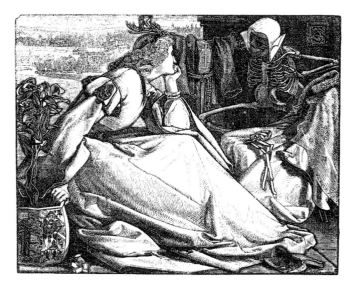

'Until her Death', but also of Dürer's 'Melencolia' (1514). The element added by Sandys is the highly distracted and suggestive manner in which the woman is drawing a strand of her own hair through her teeth.

In view of the widespread knowledge and appreciation of Rethel's designs in Britain, it is not so surprising that an engraving after 'Death the Friend' appeared in the *Sunday Magazine*, with no attribution, in May 1871.

Johann Schnorr

The *Bible in Pictures*, with illustrations by Johann Schnorr von Carolsfeld (1794–1872), which finally appeared in Germany in 1851, was published in an English edition in 1860. Several further English editions followed swiftly, and there is no doubt that both the idea of an illustrated Bible, and the linear and economic style of Schnorr's designs, had an influence over the production of the Dalziel's *Bible Gallery* 1881 (21). The popularity of this book in England can be gauged by the double-page advertisement taken by the Paris publisher Schulger in the *Bookseller* of 10 December 1864: no fewer than six variant editions were available, ranging in price from 40 to 110 francs. Schnorr's work, which owed something to Retzsch, also looked back in stylistic terms to the Renaissance and especially to Raphael.

Like the Dalziels, Joseph Cundall had also decided to commission artists for an illustrated Bible in the early Sixties, but on 7 September 1863 Cundall wrote to his rivals, handing his project over to them: 'I find that it is quite impossible for me to carry on my project for an Illustrated Bible without in some degree clashing with yours. We go to the same artists – we are getting drawings of the same size ... I will hand over to you four drawings by Cope, Dyce, Tenniel and F. Leighton ...

Millais, Hunt and Watts have each promised me drawings which they have in hand – you can take these also if you wish.'[83] With Cundall safely out of the way, the Dalziels could proceed on their own Bible without the fear of a strong competitor. However, the project was delayed and did not appear until its grandiose publication of 1881 (21). The designs were republished in a book for children entitled *Art Pictures from the Old Testament* 1894 (15), but the Dalziels themselves acknowledged that the project had proved a disaster. 'Our *Bible* commercially speaking, was a dead failure. It was carefully printed on India Paper, and issued partly in portfolio and partly in book form, but the British public did not respond, some two hundred copies being all that were sold. The balance of the number printed were disposed of at prices which we will not here record. Thus ended a work, begun with the highest aims, over which we spent many years of careful, patient labour, and several thousands of pounds.'[84] The work failed for many reasons, but one of the most obvious was that by 1881 it was out of its time. Conceived and almost entirely illustrated in the Sixties, by this late date it was no longer a production that could expect a real public. Unlike Schnorr's work, it had been handed to numerous artists who could not be persuaded to complete their drawings on time. In the end the New Testament drawings were never even properly begun, but when the 1894 volume was reprinted finally in 1905, Millais' drawings for *The Parables of Our Lord* were added to provide at least a New Testament element.

The importance of Schnorr's influence on the English artists commissioned for the *Bible Gallery* has been clearly identified by Keith Andrews: 'Designs such as Frederick Sandys's *Jacob Hears the Voice of the Lord*, or F. R. Pickersgill's *Moses' Hands Held Up*, but especially Leighton's boldly simplified *Samson Carrying the Gates* could hardly have been conceived without Schnorr's example.'[85] Overbeck, as one of the leading Nazarene artists, was likewise influential, especially on nineteenth-century popular religious imagery.

Influences from France and elsewhere

German artistic influence on the illustrators of the Sixties is, in many cases, clear and obvious. Any influence from France is rather less easy to identify. Although British engravers were active in France, especially in the 1840s and 1850s, this did not mean necessarily that the illustrations which they engraved were equally appreciated in artistic circles in England. For example, a book of the first importance was Curmer's edition of *Paul et Virginie*, which appeared in Paris in 1838, and this was followed by an English edition published by W. S. Orr the following year. The dominant artist was Tony Johannot, and although the engravers involved were almost exclusively English, the book is quintessentially French in feeling. It was admired and popular in England. Its delicate vignettes suggest something of Mulready's designs in *The Vicar of Wakefield* 1843 (117), and George Thomas's somewhat anachronistic drawings for the 1855 edition of the

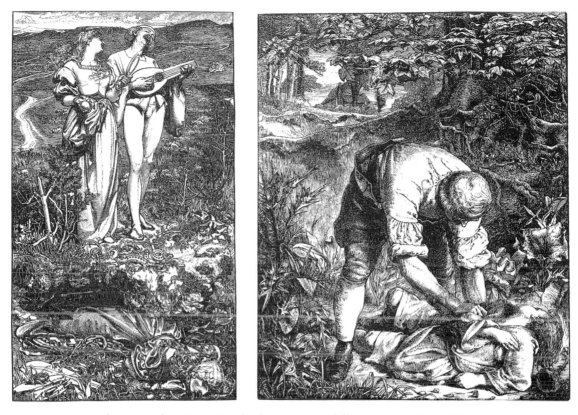

(*Right*) 79. Sandys, 'Amor Mundi', facing p. 193, *Shilling Magazine* June 1865. 173 × 98mm. 1992–4–6–217 (a)

(*Left*) 80. Sandys, 'Life's Journey', p. 60, R.A.Willmott (ed.) *English Sacred Poetry*, 1862. 127 × 102mm. 1992 4 6–592

same book, published by Cundall for Sampson Low (118). Gavarni's designs for Sue's *Le juif errant* 1845 look forward slightly to the vigour of Houghton's *Don Quixote* 1866 (62, 63), and Gustave Brion's use of shadow in Hugo's *Les misérables* 1865 could well have influenced Solomon's drawings of Jewish life which appeared in the *Leisure Hour* the following year. Doré seems to have succeeded in an unique vacuum. Although lionised in England, his massive volumes now seem not only awkward to come to terms with for modern readers, but also to have little to do with the Sixties. Arguably his greatest achievement, *London*, appeared in 1872, at the tail end of the period in question.

If it is difficult to be certain of genuine French influence, it is even more uncertain whether artists from other countries were in any way significant. An artist whose work would bear detailed examination in this connection was the Dane, Vilhelm Pedersen, whose designs for Caroline Peachey's translation of Hans Andersen appeared in London in 1853 as *Danish Fairy Legends and Stories*.

Whatever the case, it is important to understand that the trade in books was an international one, as is demonstrated by the large numbers of editions and translations which became available during the period. It was, therefore, inevitable that, with the increase in mechanisation in book production coupled with better communications, books travelled from country to country and from hand to hand in enormous numbers, in a way that had never been possible previously.

In general, however, it seems that the works of the Sixties illustrators were not exported to the continent, nor produced in translation, in any appreciable number. In contrast, the books and periodicals were well known in America. Many were produced in almost simultaneous editions. *Orley Farm*, for instance, was published in a single volume by Harper & Brothers in New York in 1862, the same year as the two-volume edition appeared from Chapman & Hall (386). However, the American version, despite including most of Millais's designs, was less well printed on far cheaper paper. A more distinguished example, at least from the point of view of production, was *Lucile* 1868 (222) (du Maurier). The edition by Ticknor & Fields of Boston, which also appeared the same year as the Chapman & Hall publication, is equal in almost every way to its English counterpart.

81. Sandys, 'The Waiting Time', facing p. 91, *Churchman's Family Magazine*, vol. 2 July 1863. 177 × 114 mm. 1992–4–6–201 (b)

The History of Criticism

Note. Many of the reference books mentioned in this chapter will be found listed in tabulated form in the Select Bibliography.

The widespread admiration for the pioneering accounts by Gleeson White *English Illustration: 'The Sixties' 1855–70* 1897 and Forrest Reid *Illustrators of the Sixties* 1928, has perhaps led to a belief that serious criticism of the illustrations only began with these writers. An examination of some contemporary criticism reveals instead that, at least in some quarters, the books and their artists had attracted interest and reasoned comment well in advance of White and Reid.

Ruskin was one of earliest to react to the Moxon Tennyson and his comment (see Introduction, p. 13), although harsh on the engravers, conveys vividly something of the shock engendered by the new Pre-Raphaelite illustrations at the time. He brings home to a modern reader just how different these designs must have appeared to contemporaries.

In 1861 Henry Bohn added a chapter to Jackson and Chatto's *A Treatise on Wood Engraving*, which had first appeared in 1839. Entitled 'Artists and Engravers of the Present Day', Bohn's text concentrated on the more traditional and established artists by including illustrations by Tenniel, Gilbert, Maclise, Creswick, Doyle and Leech among others. Holman Hunt, Millais, and Pickersgill were relegated to an unillustrated list of 'Painters who occasionally Draw on Wood' while Keene, Lawless and J. D. Watson were described, equally summarily, as 'Professional Draughtsmen on Wood'.[86] It is interesting that Bohn, who must have been well aware of what was going on, manages by his omissions to suggest that public taste, at least by 1861, had been little affected by Pre-Raphaelite illustration.

The *Bookseller*

It is in periodicals that some of the most telling comment is to be found. The *Bookseller*, being essentially a trade journal, tended to err on the side of generosity, especially since it depended for its success and circulation largely on the advertisements taken by the publishers. Many of the unsigned reviews were complimentary almost to the point of being gushing. For example, the issue for 12 December 1865 carried this tribute to John Leighton's *The Life of Man* 1866 (160): 'One of the most original, curious and beautiful books produced since the days of Caxton.' It is, therefore, surprising to find in the same issue a far less

(*Left*) 82. Shields, frontispiece, 'Decision of Faith'. Daniel Defoe *History of the Plague* [1863]. 104 × 78mm. 1992–4–6–78

(*Below, left*) 83. Frederic Shields (1833–1911), drawing of head in 'Mercy fainting at the Gates', *c.* 1864. Graphite. (See fig. 84.) 92 × 78mm. 1992–4–6–92

(*Below, right*) 84. Shields, engraving, 'Mercy fainting at the Gates', p. unnumbered, John Bunyan *Illustrations to Bunyan's Pilgrim's Progress* 1875 (First published 1864.) 149 × 100mm. 1992–4–6–43

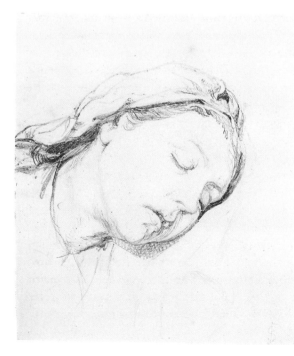

appreciative notice on Millais' *Illustrations* 1866, which contains the following paragraph: 'The engravers have only partially succeeded – many of them [the illustrations] look hard and scratchy. The lines are intensely black, and the absence of half tints or middle tones produces a not very agreeable effect of light and shade.' Far more usual for the pages of the *Bookseller* was a variety of pallid and non-committal review, epitomised by that (contained in the same issue) of Houghton's *Don Quixote* 1866: 'Numerous artists – especially Gustave Doré and Tony Johannot have attempted the delineation of the characters in Cervantes' admirable book; and it is satisfactory to find that the illustrator is by no means the least successful of the throng.'

Doré's popularity in England justified a long and appreciative essay on him in this same issue of the *Bookseller*, which managed to contain an implicitly adverse comment on English wood-engraving as practised by the likes of the Dalziels: 'The prevailing fashion is to give to wood engravings the character of pen and ink drawings, so that at first sight they appear like lithographs.' Since at this date Doré's work was invariably engraved by French engravers, notably Pisan, it seems almost certain that the Dalziels were the intended recipients of this snipe.

The *Athenaeum*

Far weightier critical fare was on offer in a more august journal, with no particular trade connection, the *Athenaeum*. Here, from the early years of the Sixties, there are regular and always learned, though unsigned, reviews of many of the books with which this study is concerned. Although I have been unable to identify the authors of individual reviews, the journal at this time included among its art critics Walter Thornbury, George Scharf (later director of the National Portrait Gallery) and F. G. Stephens. Late in 1862 came a long and detailed notice on *Pictures of English Landscape* 1863 (259), and Birket Foster came under a barely veiled attack. 'In general too, we notice even more strongly than in successive years at the Exhibitions, a sameness of composition pervading the drawings which the monotony of handling does nothing to relieve.' On a slightly more positive note, however, the review also states that the designs exhibit a 'fidelity which if prosaic is always agreeable.'[87] The date of this notice points up the fact that most newly-published books bore the date of the following year, and also shows that review copies were clearly sent to journals and newspapers in good time for mentions to catch the eye of readers in search of Christmas presents.

The following week brought this comment under the general heading of 'Books for Children': 'The "Children's gift-book season" has again arrived ... brilliant in crimson and gold and coming, like the cold weather, rather before the proper time, the books for the young are as numerous and attractive as ever.' This gentle quip was matched by a far harsher one published at about the same time the following year, under the heading of 'Gift Books': 'Book draughtsmen appeal to a class which demands mere luxury in illustration, high finish, and subtleties of

85. William Small
(1843–1929), 'The
Trumpet spake not . . .',
p. 17, John Milton *Ode
on the Morning of
Christ's Nativity* 1868.
95 × 95mm.
1992–4–6–225

engraving, in place of thought, fine design and manly style . . . the law seems to be that Art shall be a pretty plaything, used to decorate trivial books, costly but low in flight and narrow in scope.'[88] Despite so carping a comment, only a short time later Mrs Barbauld's *Hymns in Prose for Children* 1864 (18) was lauded on account of the 'Good deal of taste and spirit in the drawings which accompany the new edition.' In the following week's issue *The Golden Harp* (94) was similarly welcomed: 'We have not seen so nice a little book as this for many a day; all the artists have done well.'[89] It is worth noting that both these children's books were reviewed under the general heading of 'Fine Arts'.

The issue of 26 December 1863 carried a considerably longer and more serious review of Millais's *Parables of Our Lord* 1864, arguably one of the most important books of the entire period. The interest here is chiefly in the balance and cogency of what was said. On the positive side the commentator wrote, 'The majority [of the designs] possess high qualities of Art . . . The delivery of the unmerciful servant unto the tormentors is one of the best designs we have had from Mr Millais's hands – a very noble composition.' On the other hand Millais was taken to task for not having approached the project as a unified whole and in this

connection the critic stated, 'In the most important element of design these works are of unequal value.'

Similar reviews of major illustrated books continued to appear in the pages of the *Athenaeum* throughout the following years. They are significant because they provide disinterested criticism and offer some of the best contemporary notices. Two further reviews warrant mention here. The first appeared on 12 November 1864 and dealt with the Dalziel's *Arabian Nights* 1865 (12, 13). An admiration of foreign illustration is made transparently clear: 'We believe the issue of a book in this manner marks an era of importance in the history of its class and that the employment of genuine artistic ability ... is what is required to bring English book-illustrating to the level of the practice of our German and French neighbours.' The second, just over a year later, looked in detail at one of the very few books of the period for which it can be said honestly that the text and the illustrations are almost wholly at one: *Enoch Arden* 1866 (371). This review is of value because it recognises a special quality in Hughes's illustrations. 'Enoch Arden and Mr Hughes were made for each other so far as the brighter, more genial and purely elegant qualities of the poem are concerned ... it is because they are faithful and, without weakness, extreme in refinement that these compositions are so potent.' The piece concluded by remarking that the book was 'a remarkable and valuable example of aptitude on the part of an artist to illustrate a particular poem'.[90]

Other criticism

The value of what was published on the subject in the *Athenaeum* is thrown into high relief by comparison with that carried by other organs. On the one hand are the relatively bland comments in such journals as the *Bookseller*, which have already been mentioned, while on the other are more virulent views such as these, which appeared in a popular newspaper, the *Examiner*. Here Millais was blamed for having spawned a school of followers who produced illustrations which 'show us a gentleman talking to a lady, or a lady talking to a gentleman', which the anonymous reviewer castigated as being 'expressionless, meaningless, affected shams of art, unutterably dreary'.[91]

After the Sixties had faded into history, the illustrations themselves also slipped somewhat from critical attention. It was not until the end of the 1880s that the wood-engraver W. J. Linton answered Bohn, by taking him to task over his additional chapter on contemporary wood-engraving published in 1861. Barely mentioning Dalziel or Swain, Linton, who had been a rival of both firms, wrote: 'But I am bound by the purpose of my book: the recognition of only the Best. Though I could point out good cuts ... I find few above the unartistic monotony of book-illustration after the first edition of the *Treatise* in 1839, nothing entitling the doers to rank as Masters, teachers of our Art.'[92] After so virulent an attack, it was not surprising that an opposition to such a view began to emerge. A series of

articles, some written by Joseph Swain, appeared in *Good Words* from 1888 to 1889 on various illustrators, notably Pinwell and Frederick Walker. In 1891 these articles were edited and reprinted with others by Henry Ewart, in a book somewhat appropriately entitled *Toilers in Art*. Although this may appear today as little more than a period piece, it is interesting for the selection of artists included by Ewart, and for whom he clearly felt a sympathy. In addition to those already mentioned, there are chapters on Tenniel and C. H. Bennett, as well as on almost forgotten names such as Frederick Eltze and George Tinworth. The book also contains a brief autobiographical chapter by Frederic Shields and pieces on notable foreign contemporaries such as Lhermitte, Lalanne and Oskar Pletsch. Ewart appears to have been Swain's chief engraver at *Once a Week*, as is made clear in this passage (pp. 240–1) in the chapter on Eltze, where Ewart wrote concerning the magazine, 'I was fortunate in having a good staff of assistants, who took delight in working with me to preserve the special characteristic of each artist's drawing; and without their aid it would have been impossible to do justice to so

86. Frederick Walker (1840–1875), 'Broken Victuals', p. 3, *A Round of Days* 1866. 157 × 119mm. 1992–4–6–346

much work in the time. I consider the greatest compliment ever paid me was by Eltze, who one day said to me, "How is it you are able to preserve the character of each artist's drawing in the way you do? When I look over any engravings I can generally tell who the engraver is, but when I look at your work I can see at once who the artist is."'

Books of criticism

In 1894 came the first book to aim at a more critical and analytical approach to some of the illustrators of the period. This was George Somes Layard's *Tennyson and his Pre-Raphaelite Illustrators* (325). Individual chapters were devoted to Millais, Rossetti and Hunt, and the author named in his acknowledgements Christina Rossetti, W. M. Rossetti and the ageing Hunt himself. Interesting though this work is, its value was restricted because it dealt exclusively with just one book, the Moxon Tennyson (1857), and was limited in its impact by the fact

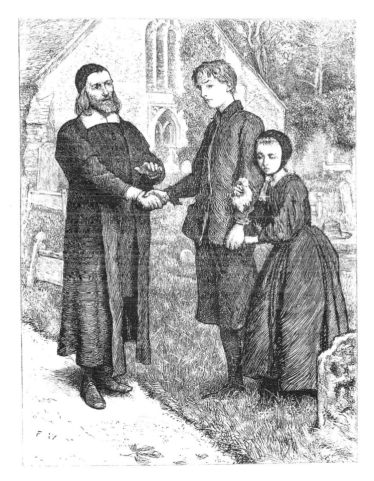

87. Walker, 'A Teacher's knowledge and a Saviour's love', facing p. 184, *English Sacred Poetry of the Olden Time* 1864. 137 × 103mm. 1992–4–6–101

that it was produced in an edition of only 750 copies. Two years earlier Layard had produced *The Life and Letters of Charles Keene*. In 1896 came a further book, similarly organised, also devoted to an individual artist of the period: J. G. Marks's *Life and Letters of Frederick Walker A.R.A.* Neither book, however, discussed in real depth, the illustrations of these artists. The following year saw the publication of one of the earliest bibliographies of the illustrations of a single artist. This was compiled by W. H. Chesson and it appeared in Joseph Pennell's *The Work of Charles Keene*. The same author had also written a well-illustrated and still provocative general survey, *Modern Illustration* 1895, which looked not only at England, but also at France and Germany. A similar book of a general nature was *Of the Decorative Illustration of Books Old and New* by Walter Crane, who saw the Sixties as part of a long tradition to which he himself belonged .[93]

It fell to a fellow illustrator, Laurence Housman, to write the first book devoted to one of the foremost illustrators of the Idyllic school. Housman saw that the

88. John Dawson
Watson (1832–1892),
'Death of Giant Grim',
p. 269 John Bunyan
The Pilgrim's Progress
1861. 150 × 114mm.
1992-4-6-40

work of Arthur Boyd Houghton was distinguished on account of 'its imaginative force and vitality as an illustration of its subject'.[94] The book is also significant because most of Houghton's designs were reproduced from the original blocks and Housman also included an attempt at a bibliography of the illustrations. In more recent years several critics have discussed the undoubted influence which Houghton's work exerted over the illustrators of the 1890s.[95]

In 1897 Gleeson White published his major study (already mentioned) which was the first to recognise clearly the Sixties as a period which was uniquely interesting in the history of British book illustration.[96] White attempted an all-inclusive approach which was encyclopaedic, even if occasionally he proved inaccurate, especially over dates. The work remains important because of the wealth of information it contains as well as for its numerous illustrations.

In 1900 G. C. Williamson produced *George J. Pinwell and his Works*, which was neither accurate nor informative on Pinwell as an illustrator. One point of interest, however, was that Williamson reproduced Pinwell's one contribution to *Punch* of 6 June 1861.

Two works which seem to have been sparked off by White's book were published in 1901. The first was the Dalziels's own account of their activities (already mentioned). Much play has been made over the inaccuracy of this work, especially

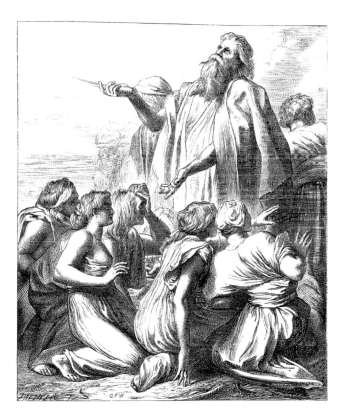

89. George Frederick Watts (1817–1904), 'Noah's Sacrifice', p. 7 *Art Pictures from the Old Testament* 1894. First published in Dalziel's *Bible Gallery* 1881. 213 × 175mm. 1992-4-6-15

the fact that the Dalziels frequently misdate their own publications. Nevertheless, judiciously used, this book has much to offer, notably on their relations with the various artists. The copy held by the British Museum Department of Prints and Drawings bears an inscription, dated December 1901, to the then Keeper, Professor (later) Sir Sidney Colvin, signed by the authors, George and Edward Dalziel. The second work was the catalogue of *Modern Illustration* which accompanied the largest exhibition (at the Victoria & Albert Museum) of such material ever held. It was not, however, confined to the Sixties but covered the whole period 1860 to 1900, not only in Britain, but also in Europe, Scandinavia, America, Russia and Japan. The catalogue ran to 1644 entries, even including the printing presses shown at the exhibition. All the main Sixties artists were exhibited, and the catalogue contained an informative introduction by Henry B. Wheatley. The material in the exhibition was borrowed, which suggests that, at this date, there was little of importance in the national collections. For example, George Murray Smith (Smith, Elder 1881–90) lent an entire collection of material relating to *The Cornhill Magazine*, while the Dalziels lent a series of works by Millais, many of which were touched proofs of the engravings. By 1908, however, the collection of Millais illustrations at the Victoria & Albert Museum was of such importance that Martin Hardie produced a catalogue of *Wood Engravings after Sir John Everett Millais* contained in the Museum. This was followed by the *Catalogue of Modern Wood-Engravings*, also compiled by Hardie, which included all the works acquired by the Museum up to 1914. Delayed by the First World War, the catalogue did not appear until 1919. The list of donors and bequests contained many notable names of engravers, collectors and relations of the artists.

In 1912 Ernestine Mills edited *The Life and Letters of Frederic Shields*, in which the artist's illustrations were accorded their proper importance, and this, together with Hardie's Victoria & Albert Museum catalogues, must have paved the way for the important exhibition of Sixties illustrations held at the National Gallery, Millbank (now the Tate Gallery) in 1923. (For a discussion of this exhibition and its catalogue see 'Collector's Progress' by Robin de Beaumont.)

In 1928 the Irish novelist, Forrest Reid (1875–1947), published his book *Illustrators of the Sixties* which remains unsurpassed for both its wisdom and its accuracy. At the end Reid included a checklist of the relevant books with their illustrators, which is still essential reading for scholars and, indeed, was the basis on which the de Beaumont collection was formed.

In 1937 Basil Gray in *The English Print*, produced one of the most concise and balanced analyses of the Sixties and subtitled his chapter, 'The Successful Print'. Two years later Harold Hartley, the notable collector, wrote of his enthusiasm for the Sixties in a delightful, if hardly an academic, manner. He claimed that he was the first collector of such material and that a direct result of the 1901 exhibition (he acted on the Executive Committee) was the creation of the Department of Illustration at the Victoria & Albert Museum.[97]

The late 1940s saw the launch by the publishers Arts and Technics Limited of a series of books entitled *English Masters of Black and White*. Two of the most useful were those devoted to Tenniel, by Frances Sarzano, and to du Maurier, by D. P. Whiteley, which were both published in 1948. The latter remains outstandingly useful for du Maurier's illustrations, notwithstanding the important study by Leonée Ormond, *George Du Maurier 1969*.

Ruari McLean showed, in a pioneering book first published in 1963, that there were many factors to be taken into account in any discussion of Victorian books, and that it was no longer acceptable to separate the illustrations from the books themselves.[98] He followed this with a work devoted to the bindings of the period and this in turn stimulated Douglas Ball to provide his meticulous enquiry into the same subject.[99]

If McLean and Ball showed that the design and the exteriors of the books were all part of a journey towards greater understanding of the contents, so other

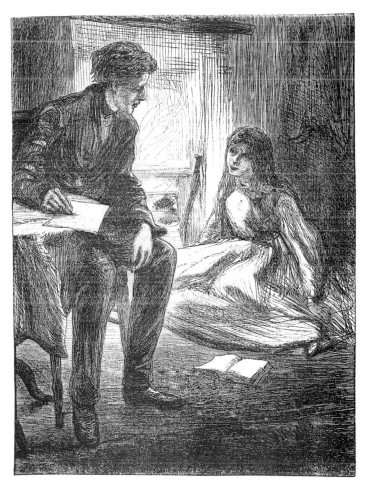

90. James Abbot McNeil
Whistler (1834–1903),
'The Trial Sermon', p. 585,
Good Words 1862.
152 × 113mm.
1992-4-5-206 (b)

scholars returned to the illustrations themselves. Professor W. E. Fredeman, in a book concerned mainly with the literature of the Pre-Raphaelites, provided an indispensable *Bibliography of Pre-Raphaelite Illustrations*, while Percy Muir, some six years later, published his *Victorian Illustrated Books*, which remains a shining example of 'scholarship worn lightly'.[100]

In 1976 the Arts Council of Northern Ireland mounted an exhibition of Sixties illustration in honour of the centenary of Forrest Reid's birth. The catalogue, though brief, contained an interesting essay on Reid by Michael Longley. This appears to have been the most recent institutional exhibition of such material in Great Britain. However, ten years later an exhibition of proof wood-engravings was held at a commercial gallery in London. The catalogue was compiled by Rodney Engen, who also contributed the introductory essay.[101]

Simon Houfe's *Dictionary of British Book Illustrators and Caricaturists 1800–1914* was published in 1978. Although a general study covering a long time-span and a wide subject area, it contains essential reference information as well as stimulating introductory chapters on the period in question. The works of Houfe, Reid and White, with the addition of Rodney Engen's *Dictionary of Victorian Wood Engravers* 1985, are the four chief books on the subject which no student should be without.

Another more general and well-illustrated study is *The Victorian Woodblock Illustrators* 1980 by Eric de Maré, while an easily overlooked, though impressive, catalogue which covered some of the same ground, accompanied an exhibition held in Germany in 1985.[102] In 1991 an exhibition devoted to the illustrations of the Pre-Raphaelites was held in New Haven, at the Yale Center for British Art. Entitled 'Pocket Cathedrals', it was accompanied by a catalogue similarly titled.

Three of the major artists have been the subject of studies in recent years. Paul Hogarth wrote *Arthur Boyd Houghton* in 1980, which was an enlarged sequel to his catalogue which accompanied an exhibition devoted to the artist held at the Victoria & Albert Museum in 1975. The latter contains an exhaustive checklist of the illustrations. Jan Reynolds's devoted work *Birket Foster* was published in 1984, and in 1991 came Rodney Engen's *Sir John Tenniel: Alice's White Knight*. Significant gaps remain: there is nothing up to date or reliable on Pinwell, and several artists of note, such as Lawless, North, Small, Watson and Barnes, have received almost no critical attention since Reid in 1928.

Finally, there should be mention of a small number of works of interest devoted to particular aspects. Mary Lutyens wrote a cogent introduction to a new edition of Millais's *The Parables of Our Lord* published in 1975, and N. John Hall's *Trollope and his Illustrators* (again useful for Millais) appeared in 1980.

Few books have been devoted solely to the children's illustrators of the Sixties, but Muir (1954) together with Whalley and Chester (1988) are helpful[103], while the technical aspects of the period are well summarised by Geoffrey Wakeman in *Victorian Book Illustration – The Technical Revolution* 1973.

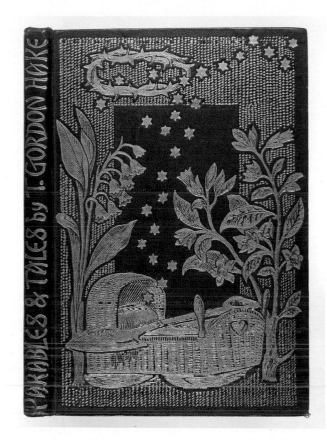

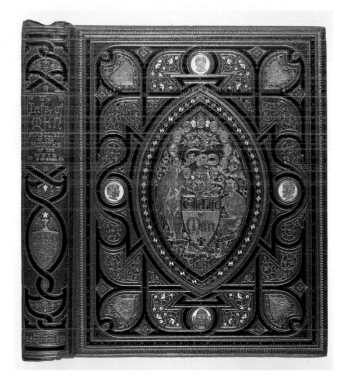

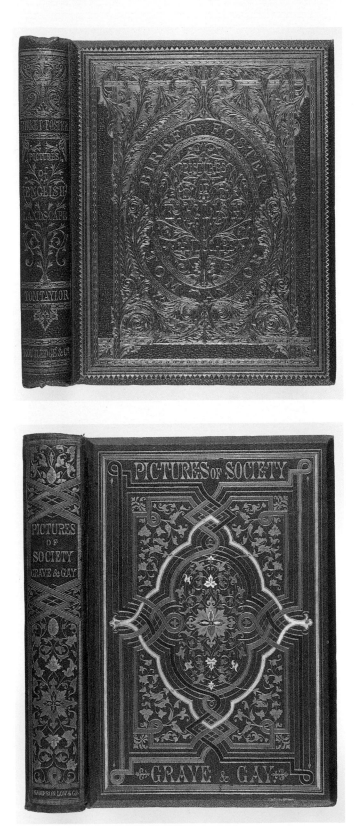

PLATE 3
*Pictures of English
Landscape* 1863.
Designed by Owen Jones.
1992-4-6-259

PLATE 4
*Pictures of Society Grave
and Gay* 1866.
Unsigned design, hand-
stencilled in watercolours.
1992-4-6-261

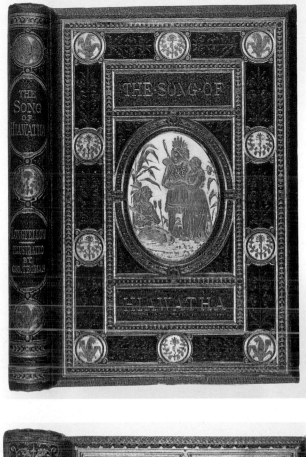

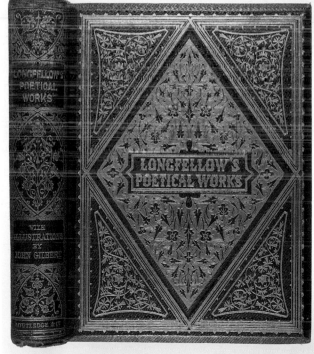

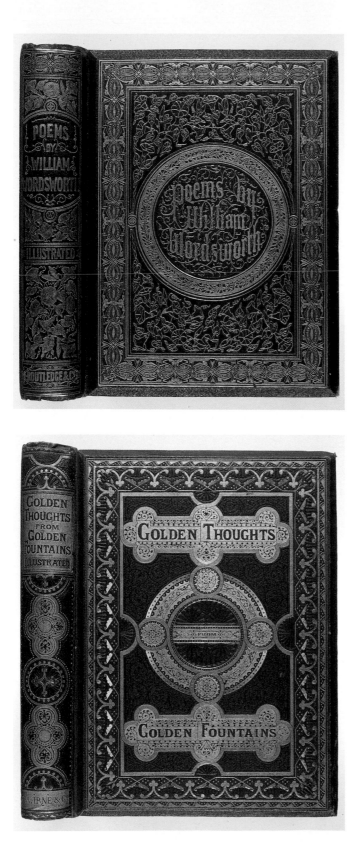

PLATE 7
William Wordsworth
Poems 1859.
Designed by Albert
Warren.
1992–4–6–421

PLATE 8
*Golden Thoughts from
Golden Fountains* 1867.
Designed by William
Harry Rogers.
1992–4–6–113

Notes

1 Robin de Beaumont, 'Some new light on the 1843 Vicar of Wakefield', *The Private Library*, Fourth Series Volume 5:1, Spring 1992, p. 15.

2 John Ruskin, *The Elements of Drawing*, Second edition, 1857, Appendix ii, p. 352.

3 Edward Hodnett, *Five Centuries of English Book Illustration*, 1988, p. 144.

4 Percy Muir, *Victorian Illustrated Books*, 1971, p. 139.

5 Gleeson White, *English Illustration – 'The Sixties'*, 1897, p. 7.

6 *Good Words for The Young*, November 1868–April 1869; continued June–September 1869; continued November 1869–October 1870.

7 Alastair Grieve, 'Rossetti's Applied Art Designs – 2. Book-Bindings', *The Burlington Magazine*, no 839, vol. cxv, February 1973, p. 84.

8 Ibid. p. 83.

9 *Orley Farm* was published in parts by Chapman & Hall from March 1861 to October 1862. *Framley Parsonage* was published in sixteen instalments in the *Cornhill Magazine* from January 1860 to April 1861.

10 Robin de Beaumont, Catalogue 10, Autumn 1986, p. 34 no. 189.

11 Maurice J. Quinlan, *Victorian Prelude: A History of English Manners 1700–1830*, 1941, p. 124.; Mayhew, London Labour and the London Poor, ?1861, iv, xxiii.

12 W. O. B. Allen and Edmund McLure, *Two Hundred Years: The History of the Society for Promoting Christian Knowledge, 1698–1898*, 1898, p. 198.

13 Richard Altick, *The English Common Reader*, 1957, p. 157.

14 S. J. Curtis, *History of Education in Great Britain*, 1948, pp. 149–50.

15 Matthew Arnold, *Reports on Elementary Schools*, 1871, pp 129, 157.

16 Edward Bulwer-Lytton, *Pelham*, 1828, Chapter 2.

17 John Chapman, 'The Commerce of Literature', *Westminster Review*, n.s., 1 (1852), pp. 511–54.

18 Altick, op. cit., p. 305.

19 Charles L. Graves, *Life and Letters of Alexander Macmillan*, 1910, p. 286.

20 Leone Levi, *Wages and Earnings of the Working Classes*, 1885, p. 53.

21 Altick, op. cit., p. 306.

22 George and Edward Dalziel, *The Brothers Dalziel – A Record*, 1901, p. 82.

23 Martin Hardie on Edmund Evans, *Dictionary of National Biography*, Second Supplement, vol. 1, 1912, p. 633.

24 Geoffrey Wakeman, *Victorian Book Illustration – The Technical Revolution*, 1973, p. 75 and plate 22.

25 Ibid. p. 76.

26 John Jackson and W. Chatto, *A Treatise on Wood Engraving*, second edition, with a new chapter by Henry G. Bohn, 1861, p. 577*.

27 Altick, op. cit., p. 299.

28 Full letter contained in de Beaumont no. 32: [Rev. Henry Ramsden Bramley], *Christmas Carols, New and Old*, 1871.

29 British Library, Dept of MSS, Add. 38974, f.194, 195.

30 Dalziel, op. cit., pp 31–2.

31 Alexander Strahan, 'Twenty Years of a Publisher's Life', *Day of Rest*, n.s. 3, (1881), pp. 15–16.

32 Patricia Thomas Srebrnik, *Alexander Strahan – Victorian Publisher*, Ann Arbor, 1986, p. 2.

33 Strahan, op. cit., p. 17.

34 Strahan, op. cit., p. 69. Srebrnik, op. cit., p. 64.

35 Strahan, op. cit., p. 15.

36 Dalziel, op. cit., p. 162.

37 Donald Macleod, *Memoir of Norman Macleod*, D. D. 1876, p. 98. Quotation from Norman Macleod's Journal, 1 January 1861.

38 Macleod, op. cit., p. 177. Letter from Macleod to Strahan dated Midnight 31 December 1864/1 January 1865.

39 'Letters of Charles Dickens', New York, 1879, i, 250. William E. Buckler, *Publications of the Modern Language Association of America*, lxvii, December 1952, no. 7, p. 926. footnote 8.

40 Review of 'Illustrated Books' in *The Times*, 24 December 1858.

41 Buckler, op. cit., p. 929.

42 De Beaumont no. 170. Millais refers to an illustration entitled 'Swing Song' which was published in *Once a Week* on 12 October 1861, p. 434.

43 Percy Muir, *English Children's Books 1600–1900*, 1954, p. 181.

44 Rodney Engen, *Dictionary of Victorian Wood Engravers*, Cambridge, 1985, p. vii.

45 Wilkie Collins, *The Woman in White*, Penguin Classics Edition, 1987, p. 433. First published in *All The Year Round* 1859–60.

46 Engen, op. cit., p. 252. Dalziel, op. cit., p. 44.

47 Oswald Doughty and John Robert Wahl (eds.), *Letters of Dante Gabriel Rossetti* Oxford, 1965, vol. 1, 1835–60, p. 310. Letter undated but postmarked 18 December 1856. The 'cannibal jig' referred to may be a reference to the prominent Dalziel signature invariably included in their blocks.

48 Doughty and Wahl, op. cit., p. 318. Letter to William Bell Scott, February (no day) 1857.

49 *Dictionary of National Biography*, Second Supplement, vol. 1, 1912, p. 465.

50 Buckler, op. cit., pp. 938–9. Altick, op. cit., p. 395.

51 James Hole, *The Working Classes of Leeds* 1863, p. 149.

52 Altick, op. cit., p. 363.

53 British Library, Bentley Papers, Add. MSS 46, f. 666.

54 Douglas Ball, *Victorian Publishers' Bindings*, 1985, p. 68. Information from Routledge Archive, vol. 3, f. 1.

55 Information kindly provided by Virginia Hewitt of the Department of Coins and Medals, April 1993.

56 Mrs Beeton *Book of Household Management*, 1861 edition. Average prices given throughout book in recipes.

57 *Encyclopaedia Britannica*, Eleventh Edition, vol. xii, 1910–11, p. 743.

58 Eleanore Jamieson, 'The Binding Styles of the Gift Books and Annuals', p. 15 of a supplementary essay in Frederick W. Faxon *Literary Annuals and Gift Books*, reprint of the original 1912 edition, Pinner, 1973.

59 Doughty and Wahl, op. cit., p. 239. Letter to William Allingham, 23 January 1855.

60 *Oxford and Cambridge Magazine*, 1856, no. 6.

61 Joel M. Hoffman, 'What is Pre-Raphaelitism Really? In Pursuit of Identity through *The Germ* and the Moxon Tennyson' in Susan P. Casteras, *Pocket Cathedrals – Pre-Raphaelite Book Illustration*, Yale Center for British Art, New Haven, 1991, p. 49.

62 W. E. Fredeman, *Pre-Raphaelitism – A Bibliocritical Study* Cambridge, Mass., 1965, p. 275.

63 Gail Lynn Goldberg, 'Dante Gabriel Rossetti's 'Revising Hand' : His illustrations for Christina Rossetti's Poems.'

64 Virginia Surtees (ed.), *The Diary of Ford Madox Brown*, 1981. Entries dated between 20 and 26 of April 1856, pp. 169–171.

65 Fredeman, op. cit., p. 288.

66 This quotation is taken from a volume in the Robert H. Taylor Collection, Princeton University Library. It was quoted by N. John Hall by courtesy of Mr Taylor in *Trollope and his Illustrators*, 1981, p. 27.

67 Kate Flint, 'Arthur Hughes as Illustrator for Children' in Gillian Avery and Julia Briggs (eds.) *Children and Their Books*, Oxford, 1989, p. 219.

68 Forrest Reid, *Illustrators of the Sixties*, 1928, p. 134.

69 Daphne du Maurier (ed.), *The Young George du Maurier – A Selection of his letters*, 1860–67, 1951, p. 36.

70 Reid, op. cit., p. 108.

71 Allan R. Life, 'That Unfortunate Young Man Morten' in *Bulletin* of the John Rylands Library, Manchester, vol. 55, 1972–3, p. 383.

72 Rodney Engen, *Sir John Tenniel – Alice's White Knight*, 1991, p. 66.

73 John Ruskin, *Ariadne Florentina*, 1872, Lecture iii, p. 98. Quoted from an edition published in 1890.

74 William Vaughan, *German Romanticism and English Art*, 1979, p. 123.

75 Vaughan, op. cit., p. 126. *Foreign Quarterly Review*, 1837, xviii, p. 63.

76 Vaughan, op. cit., p. 128.

77 Dalziel, op. cit., p. 52.

78 Simon Houfe, 'Charles Keene and the Artists' in exhibition Catalogue, *Charles Keene, The Artists' Artist*, Christie's, London, 1991, p. 24.

79 Thomas Armstrong, 'Reminiscences of George du Maurier' in *Thomas Armstrong C. B. A Memoir*, edited by L. M. Lamont, 1912, pp. 159–60.

80 Du Maurier, op. cit., p. 65–6. Also cited by Leonée Ormond, *George du Maurier*, 1969, p. 126.

81 Du Maurier, op. cit., p. 243.

82 Vaughan, op. cit., p. 248.

83 British Library, Department of Manuscripts, Add. 39, f. 168.

84 Dalziel, op. cit., p. 256.

85 Keith Andrews, *The Nazarenes*, Oxford, 1964, p. 66.

86 Jackson and Chatto, op. cit., pp. 598*–600*.

87 *Athenaeum*, 22 November 1862.

88 *Athenaeum*, 28 November 1863.

89 *Athenaeum*, 12 December and 19 December 1863.

90 *Athenaeum*, 23 December 1865.

91 *Examiner*, 23 December 1865. Unsigned review of Millais's *Illustrations* 1866 (223).

92 W. J. Linton, *The Masters of Wood Engraving*, 1889, p. 202.

93 This book was reprinted in 1972 and again in 1979 by Bell & Hyman.

94 Laurence Housman, *Arthur Boyd Houghton – A Selection from his work in Black and White . . .*, 1896, p. 21.

95 Two of the most important studies are John Russell Taylor, *The Art Nouveau Book in Britain*, 1966; and Simon Houfe, *Fin de Siècle*, 1992.

96 A facsimile reprint was published by Kingsmead Reprints, Bath, in 1970.

97 Harold Hartley, *Eighty–Eight Not Out*, 1939 (320), p. 222.

98 Ruari McLean, *Victorian Book Design and Colour Printing*, 1963. Second edition, enlarged and revised, 1972.

99 Ruari McLean, *Victorian Publishers' Book-bindings in Cloth and Leather*, 1974; Douglas Ball *Victorian Publishers' Bindings*, 1985.

100 Fredeman, 1965, op. cit., pp. 275–302. Muir, 1971, op. cit.

101 Exhibition catalogue, Christopher Mendez Gallery, London: *Proof Wood Engravings*, 11–22 November 1986. Ian Hodgkins & Co. Ltd.

102 Exhibition catalogue, Herzog August Bibliothek, Wolfenbüttel, *The Art of Illustration – Englische illustrierte Bücher des 19. Jahrhunderts*, 1 December 1984 – 21 April 1985.

103 Muir, 1954, op. cit. Joyce Irene Whalley and Tessa Rose Chester, *A History of Children's Book Illustration*, 1988.

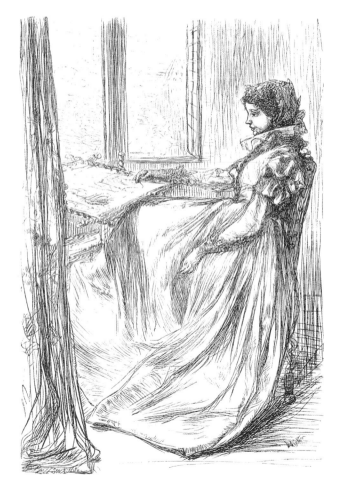

91. Whistler, 'The Morning before the Massacre of St. Bartholomew', p. 210, *Once a Week* vol. vii, 16 August 1862. Reprinted in Walter Thornbury *Historical and Legendary Ballads and Songs* 1876, p. 129, as 'Lady Mabel's lovers'. 133 × 102mm. 1992–4–6–382

Select Bibliography

Publication dates and names of authors enclosed by square brackets denote that this information is not given anywhere in the book, but is known from external evidence.

Books referred to, both in the text and in the notes (including reference books), are published in London, unless stated otherwise.

ALTICK, Richard, *The English Common Reader – A Social History of the Mass Reading Public*, Chicago, 1957.

BALL, Douglas, *Victorian Publishers' Bindings*, 1985.

BARR, John, *Illustrated Children's Books*, 1986.

BARWICK, G. F., 'The Magazines of the Nineteenth Century', *Transactions of the Bibliographical Society*, xi, 1909–11, pp. 237–249.

BUCKLER, W. E., 'Once a Week, under Samuel Lucas 1859–1865', *Publications of the Modern Language Association of America*, 1952, pp. 924–41.

CASSIDY, John A., *Robert W. Buchanan*, New York, 1973.

CHRISTIAN, John, 'Early German Sources for Pre-Raphaelite Designs', *Art Quarterly*, Vol. xxxvi, 1973, pp. 56–83.

CRUSE, Amy A., *The Victorians and their Books*, 1935.

DALZIEL, George and Edward, *The Brothers Dalziel – a Record of Fifty Years Work*, 1901.

DANIELS, Morna, *Victorian Book Illustration*, 1988.

DARTON, F. J. Harvey, *Children's Books in England – Five Centuries of Social Life*, 3rd edition revised by Brian Alderson, 1982.

DE MARÉ, Eric, *The Victorian Woodblock Illustrators*, 1980.

EGOFF, Sheila A., *Children's Periodicals of the Nineteenth Century*, 1951.

ELLEGARD, Alvar, 'The Readership of the Periodical Press in Mid-Victorian Britain', *Göteborgs Universitets Arsskrift*, vol. 63, no. 3, *Acta Universitatis Gothoburgensis*, Göteborg, 1957.

ENGEN, Rodney, *Dictionary of Victorian Wood Engravers*, Cambridge, 1985.

ENGEN, Rodney, *Sir John Tenniel: Alice's White Knight*, Aldershot, 1991.

EWART, Henry C. (ed.), *Toilers in Art*, 1891.

FEATHER, John, *A History of British Publishing*, 1988.

FILDES, Paul, 'Phototransfer of Drawings in Wood-block Engraving', *Journal of the Printing Historical Society*, no. 5, 1969, pp. 87–97.

FREDEMAN, W. E., *Pre-Raphaelitism – A Bibliocritical Study*, Cambridge, Mass., 1965.

GRAY, Basil, *The English Print*, 1937.

GRIEST, Guinevere L., *Mudie's Circulating Library and the Victorian Novel*, 1970.

HALL, N. John, *Trollope and his Illustrators*, 1980.

HARDIE, Martin, *Wood Engravings after Sir John Everett Millais in the Victoria and Albert Museum*, 1908.

HARDIE, Martin, *Catalogue of Modern Wood-Engravings – Victoria and Albert Museum*, 1919.

HARVEY, J. R., *Victorian Novelists and their Illustrators*, 1970. (This deals primarily with the earlier illustrators.)

HODNETT, Edward, *Five Centuries of English Book Illustration*, 1988.

HOGARTH, Paul, *Arthur Boyd Houghton*, 1980.

HOLE, James, *The Working Classes of Leeds*, 2nd edition, 1863.

HOUFE, Simon, 'The Dalziel Brothers' – Introduction to sale catalogue, Sotheby's Belgravia, 16 May 1978.

HOUFE, Simon, *The Dictionary of British Book Illustrators and Caricaturists 1800–1914*, 1978.

HOUFE, Simon, *Fin de Siècle – The Illustrators of the Nineties*, 1992.

HUXLEY, Leonard, *The House of Smith Elder* (privately printed) 1923.

JACKSON, John and CHATTO, W. A. (with an additional chapter by BOHN, Henry G.), *A Treatise on Wood Engraving*, 2nd edition, 1861.

JAMES, Elizabeth, 'An Insight into the management of railway bookstalls in the 1850s', *Publishing History*, 10, 1981, pp. 65–9.

JAY, Harriet, *Robert Buchanan: Some Account of his Life, his Life's Work and his literary Friendships*, 1903.

LAYARD, George Somes, *Tennyson and his Pre-Raphaelite Illustrators*, 1894.

LERNER, Lawrence (ed.), *The Victorians*, 1978.

LIFE, Allan Roy, *Art and Poetry: A Study of the Illustrations of two Pre-Raphaelite Artists, William Holman Hunt and John Everett Millais*, unpublished doctoral thesis, University of British Columbia, 1974.

LUTYENS, Mary (intr.), *The Parables of Our Lord*, New York, 1975.

MACLEOD, Donald, *Memoirs of Norman Macleod*, 1876.

McLEAN, Ruari (ed.), *The Reminiscences of Edmund Evans – wood-engraver and colour-printer 1826–1905*, Oxford, 1967.

McLEAN, Ruari, *Victorian Book Design and Colour Printing*, 2nd edition, 1972.

MANTEUFFEL, Kurt Zoege von, *Alfred Rethel*, Hamburg, 1926.

MARCHAND, Leslie A., *The Athenaeum – A Mirror of Victorian Culture*, Chapel Hill, North Carolina, 1941.

MARSH, Jan, '"Hoping you will not think me too fastidious": Pre-Raphaelite Artists and the Moxon Tennyson', *Journal of Pre-Raphaelite and Aesthetic Studies*, Spring 1989, pp. 11–15.

MUIR, Percy, *English Children's Books 1600–1900*, 1954.

MUIR, Percy, *Victorian Illustrated Books*, 1971.

ORMOND, Leonée and Richard, *Lord Leighton*, 1975.

RAY, Gordon N., *The Illustrator and the Book in England from 1790 1914*, New York and Oxford, 1976.

RAY, Gordon N., *The Art of the French Illustrated Book 1700–1914*, New York and London, 1982.

REID, Forrest, *Illustrators of the Sixties*, 1928.

REYNOLDS, Jan, *Birket Foster*, 1984.

ROBBINS, Michael, *The Railway Age*, 1962.

RUSKIN, John, *The Elements of Drawing*, 2nd edition, 1857.

SREBRNIK, Patricia T., *Alexander Strahan – Victorian Publisher*, Ann Arbor, Michigan, 1986.

STEEGMAN, John, *Victorian Taste*, 1970.

SULLIVAN, Alvin (ed.), *British Literary Magazines – The Victorian and Edwardian Age 1837–1913*, 1984.

SUTHERLAND, J.A., *Victorian Novelists and their Publishers*, 1976.

TAYLOR, John Russell, *The Art Nouveau Book in Britain*, 1966.

VAUGHAN, William, *German Romanticism and English Art*, 1979.

Victorian Poetry, (various contributors), Morgantown, West Virginia University, vol. 20, no. 4, Winter 1982.

VIZETELLY, Henry, *Glances back through Seventy Years*, 1893.

WAKEMAN, Geoffrey, *Victorian Book Illustration – The Technical Revolution*, Newton Abbott, 1973.

WHALLEY, Joyce and CHESTER, Tessa, *A History of Children's Book Illustration*, 1988.

WHITE, Gleeson, *English Illustration – 'The Sixties': 1855–70*, 1897.

WHITE, Gleeson, 'In Memorian – Matthew James Lawless', in *The Quarto*, no. 4, 1898, pp. 45–59.

WILSON, Charles, *First with the News: The History of W.H. Smith 1792 1972*, 1985.

Exhibition catalogues

BELFAST, Arts Council Gallery (and elsewhere), *Illustrations of the Eighteen Sixties*, 1976.

BOLTON, Museum and Art Gallery (and elsewhere) *The Drawings of John Everett Millais*, 1979 (Arts Council).

BRIGHTON, Museum and Art Gallery, *Frederick Sandys 1829 1904*, 1974.

LIVERPOOL, Walker Art Gallery and London, Victoria & Albert Museum, *William Holman Hunt*, 1969.

LONDON, Christie's, *Charles Keene – The Artists' Artist 1823 1891*, 1991.

LONDON, Christopher Mendez Gallery, *Proof Wood Engravings 1840 – 1880*, 1986.

LONDON, Hayward Gallery (and elsewhere), *Burne-Jones*, 1975–6.

LONDON, Royal Academy of Arts, *Millais*, 1967.

LONDON, Victoria and Albert Museum, *Catalogue of the Loan Exhibition of Modern Illustration*, 1901.

NEW HAVEN, Yale Center for British Art, *Pocket Cathedrals – Pre-Raphaelite Book Illustration*, 1991.

OTTAWA, National Gallery of Canada, *High Victorian Design*, 1974.

WOLFENBÜTTEL, Zeughaus der Herzog August Bibliothek, *The Art of Illustration – Englische illustrierte Bücher des 19. Jahrhunderts*, 1984–5.

WOLFENBÜTTEL, Zeughaus der Herzog August Bibliothek, *L'Art d'Illustration – Französische Buchillustration des 19. Jahrhunderts*, 1985–6.

WOLFENBÜTTEL, Zeughaus der Herzog August Bibliothek, *Die Kunst der Illustration – Deutsche Buchillustration des 19. Jahrhunderts*, 1986–7.

Checklist of the de Beaumont Collection

This list is arranged in alphabetical order under author's name, and information is given in the following fashion. The checklist number (the same as the last digits in the British Museum register number) is followed by the name of the book's author. The title of the work is in italics, followed by the publisher and date of publication and the British Museum register number. The names of the chief illustrators of the volume appear at the end of each entry, in italic type.

Books which have no author are listed alphabetically under the title. All books are published in London unless otherwise stated. Dates and authors' names enclosed in square brackets are not to be found in the books themselves, but are known from external sources.

Miscellaneous items are listed under their category (bookplates, catalogues, drawings, photographs, reference, woodblocks, etc.).

Numbers 426 to 592 are loose engravings, mainly removed in the past from periodicals, and are listed alphabetically under the illustrator's name.

1 ADAMS, Rev. H.C., *Balderscourt*, Routledge 1866. 1992-4-6-1 *A.B. Houghton*

2 ADAMS, Rev. William, *Sacred Allegories*, Rivingtons 1856. 1992-4-6-2 *Foster, G.E. Hicks, Samuel Palmer, Horsley, Cope, Macquoid*

3 AESOP, *Fables*, Strahan 1872. 1992-4-6-3 *Wolf, Zwecker, T. Dalziel*

4 AIKIN, Dr and BARBAULD, Mrs (Anne Laetitia Aikin), *Evenings at Home*, Warne 1867. 1992-4-6-4 *Walter Crane*

5 ALBUM of mounted sheets of engravings from magazines and books. See register nos 1992-4-6-426-592 for complete listing.

6 ALFORD, Dean, *The Lord's Prayer*, Longman 1870. 1992-4-6-6 *Pickersgill*

7 ALLINGHAM, William, *The Music Master*, Routledge 1855. 1992-4-6-7 *Arthur Hughes, Rossetti, Millais*

8 ALLINGHAM, William, *Day and Night Songs and The Music Master*, Bell & Daldy 1860. 1992-4-6-8 *Arthur Hughes, Rossetti, Millais.*

9 ALLINGHAM, William, *Flower Pieces*, Longmans 1893. 1992-4-6-9 *Rossetti*

10 A.L.O.E. (pseud. of TUCKER, Charlotte Maria), *Exiles in Babylon*, T. Nelson and Sons 1868. 1992-4-6-10 *William Small*

11 ANDERSEN, Hans C., *What the Moon saw*, Routledge 1866. 1992-4-6-11 *A.W. Bayes*

12 *Arabian Nights*, Dalziel's, Ward & Lock Jan 1864–Sept 1865 (21 original parts). 1992-4-6-12 *Millais, Houghton, Tenniel, T. Dalziel, Pinwell*

13 *Arabian Nights' Entertainments*, Dalziel's, Ward & Lock 1865 (two vols). 1992-4-6-13 *Artists as no. 12*

14 *Arabian Nights' Entertainments*, Warne 1869. 1992-4-6-14 *Houghton, T. Dalziel*

15 *Art Pictures from the Old Testament*, Society for Promoting Christian Knowledge 1894. 1992-4-6-15 *Leighton, Burne-Jones, Poynter, G.F. Watts, F.M. Brown, Simeon Solomon, Holman Hunt, T. Dalziel, H.H. Armstead, Pickersgill, Houghton*

16 *Ballads: Scottish and English*, Nimmo 1878. 1992-4-6-16 *John Lawson*

17 *Ballads: Scottish and English*, Nimmo [1867]. 1992-4-6-17 *John Lawson*

18 BARBAULD, Mrs (Anne Laetitia Aikin), *Hymns in Prose for Children*, John Murray 1864. 1992-4-6-18 *Robert Barnes, Wimperis, Coleman, Kennedy*

19 [BARHAM, R.H.], *The Ingoldsby Legends*, Richard Bentley 1864. 1992-4-6-19 *George Cruikshank, Leech, Tenniel*

20 BAYNES, Rev. Robert (ed.), *The Illustrated Book of Sacred Poems*, Cassell, Petter & Galpin [1867]. 1992-4-6-20 *J.D. Watson, William Small, North, Macquoid*

21 *Bible Gallery*, Dalziel's, Routledge 1881. 1992-4-6-21 *Leighton, Poynter, H.H. Armstead, F.M. Brown, Simeon Solomon, Sandys, E. Dalziel, Small, Houghton, G.F. Watts, Burne-Jones, Walker, Holman Hunt*

22 *Blade and the Ear, The*, Nimmo [?1866]. 1992-4-6-22 *John Lawson*

23 BLAIR, Robert, *The Grave*, Adam & Charles Black 1858. 1992-4-6-23 *Birket Foster, Tenniel, J.R. Clayton*

24 BLOOMFIELD, Robert, *The Farmer's Boy*, Sampson Low 1857. 1992-4-6-24 *Birket Foster, Harrison Weir, G.E. Hicks*

25 *Book of Job, The*, Nisbet 1857. 1992–4–6–25
John Gilbert

26 *Book of Job, The*, Nisbet 1857 (contains letter from
Gilbert to Edward Dalziel). 1992–4–6–26 *John Gilbert*

27 BOOKPLATE: Millais' only bookplate for
Christopher Sykes. 1992–4–6–27 *Millais.*

28 BOOKPLATE: Proof of Solomon's only bookplate.
1992–4–6–28 *Simeon Solomon*

29 BOWMAN, Anne, *The Boy Pilgrims*, Routledge
[? c.1870]. 1992–4–6–29 *Houghton*

30 BOYLE, Eleanor Vere, *Child's Play*, Addey & Co. [1852]
1992–4–6–30 *E. V. Boyle*

31 BOYLE, Eleanor Vere, *A New Child's Play*, Sampson Low
1877. 1992–4–6–31 *E. V. Boyle*

32 [BRAMLEY, Rev. Henry Ramsden], *Christmas Carols,
New and Old*, Routledge 1871 (contains letter from
Effie Millais to Edward Dalziel). 1992–4–6–32
Arthur Hughes, E. G. Dalziel

33 BRYANT, William Cullen, *Poems*, D. Appleton & Co.
(New York) [1854?]. 1992–4–6–33 *T. Dalziel,
Birket Foster, Tenniel, Pickersgill*

34 BUCHANAN, Robert, *Ballad Stories of the Affections*,
Routledge [1866] (contains letter from author to the Dalziel
Brothers). 1992–4–6–34 *Pinwell, Small, J. D. Watson,
Houghton*

35 BUCHANAN, Robert, *North Coast and other Poems*,
Routledge 1868 (contains two letters from author to the
Dalziel Brothers). 1992–4–6–35 *Houghton, Pinwell, Small*

36 BUCHANAN, Robert, *Saint Abe and his Seven Wives*,
Robert Buchanan 1896. 1992–4–6–36 *Houghton*

37 [BUNYAN, John], *Pilgrim's Progress*, A. Fullarton & Co.
[?1851]. 1992–4–6–37 *David Scott*

38 BUNYAN, John, *The Pilgrim's Progress*, A. Fullarton &
Co [?1860]. 1992–4–6–38 *David Scott,
William Bell Scott*

39 BUNYAN, John, *Pilgrim's Progress*, Longmans 1860.
1992–4–6–39 *C. H. Bennett*

40 BUNYAN, John, *Pilgrim's Progress*, Routledge 1861.
1992–4–6–40 *J. D. Watson*

41 BUNYAN, John, *Pilgrim's Progress*, Macmillan 1862.
1992–4–6–41 *Holman Hunt*

42 BUNYAN, John, *The Pilgrim's Progress*, Ward, Lock &
Tyler [1863]. 1992–4–6–42 *T. Dalziel*

43 BUNYAN, John, *Illustrations to Bunyan's Pilgrim's
Progress*, Simpkin Marshall & Co. 1875. 1992–4–6–43
Frederic Shields

44 BURNAND, F. C., *Mokeanna!*, Bradbury, Agnew & Co.
1873. 1992–4–6–44 *Millais, du Maurier*

45 BURNAND, F. C., *The New History of Sanford and
Merton*, Bradbury, Evans & Co. 1872. 1992–4–6–45
Linley Sambourne

46 BURNS, Robert, *Poems and Songs*, Bell & Daldy 1858.
1992–4–6–46 *Birket Foster, Harrison Weir, J. C. Horsley,
G. Thomas*

47 BURNS, Robert, *Poems and Songs*, Nimmo 1868.
1992–4–6–47 *John Lawson*

48 BYRON, Lord, *Childe Harold's Pilgrimage*, John Murray
1859. 1992–4–6–48 *Skelton, Lear*

49 BYRON, Lord, *Poetical Works*, Warne [c.1878].
1992–4–6–49 *Houghton, F. M. Brown, Birket Foster*

50 CAMPBELL, Thomas, *The Pleasures of Hope*,
Sampson Low & Son 1855. 1992–4–6–50 *Birket Foster,
Harrison Weir, G. Thomas*

51 CAMPBELL, Thomas, *Gertrude of Wyoming*, Routledge
1857. 1992–4–6–51 *Birket Foster, T. Dalziel,
Harrison Weir.*

52 CATALOGUE, Birmingham City Museum 1924, *Book
Illustration of the Sixties*, 1992–4–6–52.

53 CATALOGUE, Glasgow Art Gallery 1925, *Book
Illustration of the Sixties*, 1992–4–6–53

54 CATALOGUE, Victoria and Albert Museum, London
1919, *Modern Wood-Engravings* by Martin Hardie.
1992–4–6–54

55 CATALOGUE, Victoria and Albert Museum, London
1969, *William Holman Hunt*. 1992–4–6–55

56 CATALOGUE, Royal Academy, London 1967, *Millais*.
1992–4–6–56

57 CATALOGUE, National Gallery of British Art, Millbank
(now Tate Gallery), London 1923, *Book Illustration of the
Sixties* 1992–4–6–57

58 CATALOGUE, *George Pinwell and George Mason* 1895
by Harry Quilter. 1992–4–6–58

59 CATALOGUE, *George Pinwell and George Mason* 1895
by Harry Quilter (de luxe version). 1992–4–6–59

60 CATALOGUE, Art Gallery of Toronto 1956, *Book
Illustrators of the 1860s*. 1992–4–6–60

61 CATALOGUE, Whitechapel Art Gallery 1924, *Book
Illustration of the Sixties*. 1992–4–6–61

62 CERVANTES, Miguel de, *Adventures of Don Quixote*,
Warne 1866. 1992–4–6–62 *Houghton*

63 CERVANTES, Miguel de, *Adventures of Don Quixote*, as
no. 62 but in a variant (? second issue) binding.
1992–4–6–63

64 *Children of Blessing, The*, Routledge [?1869].
1992–4–6–64 *John Lawson*

65 COLERIDGE, Samuel Taylor, *The Rime of the Ancient
Mariner*, Sampson Low 1857. 1992–4–6–65 *Birket Foster,
Wehnert, Duncan*

66 COLLINS, Charles Allston, *A Cruise upon Wheels*, Routledge 1863. 1992–4–6–66 *?Collins*

67 COLLINS, W. Wilkie, *Mr Wray's Cash Box*, Richard Bentley 1852. 1992–4–6–67 *Millais*

68 COOK, Eliza, *Poems*, Routledge 1861. 1992–4–6–68 *John Gilbert, Watson, Zwecker, Armstead*

69 *Cornhill Gallery, The*, Smith Elder & Co. 1865. 1992–4–6–69 *Leighton, Millais, du Maurier, Paton, Sandys, W. M. Thackeray, Walker*

70 CORNWALL, Barry (pseud. of Bryan Weller Procter), *Dramatic Scenes*, Chapman & Hall 1857. 1992–4–6–70 *Tenniel, Birket Foster, J. R. Clayton, T. Dalziel, E. Dalziel*

71 COWPER, William, *The Task*, Nisbet 1855. 1992–4–6–71 *Birket Foster*

72 DALE, Thomas Pelham, *A Life's Motto*, James Hogg [1869]. 1992–4–6–71 *J. D. Watson*

73 DALTON, Henry, *The Book of Drawing Room Plays*, James Hogg [1861]. 1992–4–6–73 *du Maurier, Corbould*

74 *Days of Old*, Macmillan 1859. 1992–4–6–74 *Holman Hunt*

75 [DEFOE, Daniel], *Robinson Crusoe*, Edward Lumley [?1853]. 1992–4–6–75 *Keene*

76 DEFOE, Daniel, *The Life and Adventures of Robinson Crusoe*, Routledge 1864. 1992–4–6–76 *J. D. Watson*

77 [DEFOE, Daniel], *Robinson Crusoe*, Macmillan 1866. 1992–4–6–77 *Millais*

78 DEFOE, Daniel, *History of the Plague of London*, Thomas Laurie [?1880s]. 1992–4–6–78 *Frederic Shields*

79 DICKENS, Charles, *The Uncommercial Traveller*, Chapman & Hall [1874]. 1992–4–6–79 *Pinwell*

80 DOCUMENT: Pinwell Pension. Application for Civil List Pension for Pinwell's widow. 1992–4–6–80

81 DRAWING, G. E. Hicks, 'With Joy she views her plenteous reeking store' for p. 11 *The Farmer's Boy* (Bloomfield) 1857 (no. 24). 1992–4–6–81

82 DRAWING, Charles Keene, Sheet of studies for *Robinson Crusoe* 1847 (see no. 75 for a later edition of this book). 1992–4–6–82

83 DRAWING, Charles Keene, Sketch of hands of principal figure holding a musket in 'The March of Arthur' in *Once a Week* 11 April 1863. 1992–4–6–83. Reprinted in *Ballads and Songs of Brittany* 1865 (369)

84 DRAWING, Matthew James Lawless, 'The Cradle Song of the Poor'. 1992–4–6–84

85 DRAWING, Matthew James Lawless, 'The Night after Culloden', for p. 65 in Walter Thornbury, *Historical and Legendary Ballads* 1876 (no. 382). This originally appeared as an illustration for 'Effie Gordon' in *Once a Week* 1861 p. 406. 1992–4–6–85

86 DRAWING, J. W. North, 'Requiescat in Pace' for p. 39 in Jean Ingelow, *Poems* 1867 (no. 137). 1992–4–6–86

87 DRAWING, J. W. North, 'The Four Bridges' for p. 253 in Jean Ingelow, *Poems* 1867 (no. 137). 1992–4–6–87

88 DRAWING, J. W. North, 'Glorious things of thee are spoken' for p. 235 in *Spirit of Praise* c.1866 (no. 364). 1992–4–6–88

89 DRAWING, G. J. Pinwell, Self portrait. 1992–4–6–89

90 DRAWING, G. J. Pinwell – for p. 25 in *Dalziel's Illustrated Goldsmith* (see no. 114). 1992–4–6–90

91 DRAWING, Frederick Sandys, 'The Spirit of the Storm'. 1992–4–6–91

92 DRAWING, Frederic Shields – for the head of 'Mercy fainting at the gates' in *Illustrations to Bunyan's Pilgrim's Progress* 1864 (see no. 43 for later edition of the same book). 1992–4–6–92

93 DULCKEN, H. W. (ed.), *The Book of German Songs*, Ward & Lock 1856. 1992–4–6–93 *Keene*

94 DULCKEN, H. W. (ed.), *The Golden Harp*, Routledge 1864. 1992–4–6–94 *Watson, T. Dalziel, Wolf*

95 DULCKEN, H. W., *Old Friends and New Friends*, Warne [1867]. 1992–4–6–95 *Watson, T. Dalziel, Gilbert, Zwecker, Harrison Weir, Houghton*

96 DULCKEN, H. W., *Happy Day Stories for the Young*, Routledge [1874]. 1992–4–6–96 *Houghton*

97 EDGAR, John G., *Sea Kings and Naval Heroes*, Bell & Daldy 1861. 1992–4–6–97 *Keene*

98 EILOART, Mrs, *The Boys of Beechwood*, Routledge 1868. 1992–4–6–98 *Houghton*

99 EILOART, Mrs, *Ernie Elton*, Routledge 1867. 1992–4–6–99 *Houghton*

100 ELWES, Alfred, *Swift and Sure*, Griffith & Farran 1873. 1992–4–6–100 *John Lawson*

101 *English Sacred Poetry of the Olden Time*, Religious Tract Society 1864. 1992–4–6–101 *du Maurier, North, Watson, Walker*

102 ENGRAVING Millais, 'Ursula March' frontispiece from Dinah Mulock (Mrs Craik), *John Halifax, Gentleman*, Hurst and Blackett [1861]. 1992–4–6–102

103 ENGRAVING Millais, 'A Reverie' from *Magazine of Art*. 1992–4–6–103

104 FALCONER, William, *The Shipwreck*, Adam and Charles Black 1858. 1992–4–6–104 *Birket Foster*

105 *Favourite English Poems*, Sampson Low 1862. 1992–4–6–105 *Birket Foster, Creswick, Cope, Hicks, etc.*

106 FOXE, John, *The Book of Martyrs*, Cassell, Petter & Galpin [1866]. 1992–4–6–106 *du Maurier, Watson, Houghton, Small, Barnes, Morten*

107 GASKELL, Mrs Elizabeth, *Sylvia's Lovers*, Smith Elder 1863. 1992-4-6-107 *du Maurier*

108 GASKELL, Mrs Elizabeth, *Cranford*, Smith Elder 1864. 1992-4-6-108 *du Maurier*

109 GATTY, Mrs Alfred, *Parables from Nature*, Bell & Daldy 1861. 1992-4-6-109 *Cope, Holman Hunt, G. Thomas*

110 GATTY, Mrs Alfred, *Parables from Nature*, Bell & Daldy, 1865. 1992-4-6-110 *Holman Hunt, G. Thomas, W. B. Scott, Burne-Jones, Tenniel*

111 [GILBERT, Sir John], *Pictures by Sir John Gilbert at Guildhall*, Blades, East and Blades 1893. 1992-4-6-111 *Gilbert*

112 GILLIES, Mary, *The Voyage of the Constance*, Sampson Low 1867. 1992-4-6-112 *Keene*

113 *Golden Thoughts from Golden Fountains*, Warne [1867]. 1992-4-6-113 *Houghton, E. & T. Dalziel, Lawson, Small, Pinwell*

114 GOLDSMITH, Oliver, *Dalziel's Illustrated Goldsmith*, Ward & Lock 1865. 1992-4-6-114 *Pinwell*

115 GOLDSMITH, Oliver, *Dalziel's Illustrated Goldsmith*, Ward & Lock n.d. 1992-4-6-115 *Pinwell*

116 GOLDSMITH, Oliver, *The Traveller*, David Bogue [1858]. 1992-4-6-116 *Birket Foster*

117 GOLDSMITH, Oliver, *The Vicar of Wakefield*, John van Voorst 1843. 1992-4-6-117 *Mulready*

118 GOLDSMITH, Oliver, *The Vicar of Wakefield*, Joseph Cundall for Sampson Low 1855 1992-4-6-118 *G. Thomas*

119 GRAHAME, James, *The Sabbath*, James Nisbet 1857. 1992-4-6-119 *Birket Foster*

120 GRANT, Alexander H., *Half-Hours with the Sacred Poets*, James Blackwood [1871]. 1992-4-6-120 *H. S. Marks*

121 GRAY, Thomas, *An Elegy written in a Country Churchyard*, Joseph Cundall 1855. 1992-4-6-121 *Foster, EVB (Eleanor Vere Boyle), G. Thomas*

122 GREY, Heraclitus (pseud. of MARSHALL, Charles), *King Gab's Story Bag*, Cassell, Petter & Galpin [1869]. 1992-4-6-122 *Walter Crane*

123 HAKE, Thomas Gordon, *Parables and Tales*, Chapman & Hall 1872. 1992-4-6-123 *Arthur Hughes*

124 HALL, Samuel Carter (ed.), *The Book of British Ballads*, Jeremiah How 1st series 1842, 2nd series 1844. 1992-4-6-124 *Tenniel, Gilbert, Paton, Pickersgill, Courbould, Richard Dadd, W. B. Scott, Franklin*

125 HERBERT, George, *The Poetical Works*, James Nisbet 1856. 1992-4-6-125 *Foster, Clayton*

126 HEY, F. (correctly Wilhelm), *Picture Fables*, Routledge 1858. 1992-4-6-126 *Otto Speckter*

127 *Home Thoughts and Home Scenes*, Routledge 1865. 1992-4-6-127 *Houghton*

128 HOOD, Tom (ed.), *Cassell's Penny Readings*, Cassell, Petter & Galpin [1867]. 1992-4-6-128 *Walker, Green, Houghton, Small, Watson, Paul Gray*

129 HOOD, Tom, *Jingles and Jokes for Little Folks*, Cassell, Petter & Galpin [1865]. 1992-4-6-129 *C. H. Bennett, Morten*

130 *Horace Hazelwood*, Johnstone, Hunter & Co. 1866. 1992-4-6-130 *Small*

131 [HORSBURGH, Matilda], *Jottings from the Diary of the Sun*, Johnstone, Hunter & Co. [1868]. 1992-4-6-131 *Lawson*

132 *Household Song*, W. Kent & Co. 1861. 1992-4-6-132 *Foster, G. Thomas, Samuel Palmer*

133 HUGHES, Thomas, *The Scouring of the White Horse*, Macmillan 1859. 1992-4-6-133 *Richard Doyle*

134 [HUGHES, Thomas], *Tom Brown's School Days*, Macmillan 1869. 1992-4-6-134 *Arthur Hughes, Prior Hall*

135 HUGO, Victor, *Les Miserables*, Hurst & Blackett [1864]. 1992-4-6-135 *Millais*

136 *Idyllic Pictures*, Cassell, Petter & Galpin 1867. 1992-4-6-136 *Gray, Barnes, Pinwell, Small, Sandys, Morten, Houghton, G. Thomas, Lawson*

137 INGELOW, Jean, *Poems*, Longmans 1867. 1992-4-6-137 *Pinwell, Poynter, North, Houghton, Small*

138 INGELOW, Jean, *The Shepherd Lady*, Roberts Bros (Boston) 1876. 1992-4-6-138 *Arthur Hughes*

139 INGELOW, Jean, *Songs of Seven*, Roberts Bros (Boston) 1866. 1992-4-6-139 *North*

140 [INGELOW, Jean], *Stories Told to a Child*, Strahan [1865]. 1992-4-6-140 *Lawson, Houghton*

141 [INGELOW, Jean], *Studies for Stories*, Strahan 1866. 1992-4-6-141 *Millais, Small, Barnes, Houghton*

142 *The Story of Jack and the Giants*, Cundall & Addey 1851. 1992-4-6-142 *Richard Doyle*

143 JACKSON, Richard C., *The Risen Life*, R. Elkins & Co. n.d. 1992-4-6-143 *Rossetti*

144 JAMES, Rev. Thomas (ed.), *Aesop's Fables*, John Murray 1848. 1992-4-6-144 *Tenniel*

145 JERROLD, Douglas, *Mrs Caudle's Curtain Lectures*, Bradbury, Evans 1866 (first issue). 1992-4-6-145 *Keene*

146 JERROLD, Douglas, *Mrs Caudle's Curtain Lectures*, Bradbury, Evans 1866 (second issue). 1992-4-6-146 *Keene*

147 JERROLD, Douglas, *The Story of a Feather*, Bradbury, Evans 1867. 1992-4-6-147 *du Maurier*

148 J.M., *Historical Tales*, Routledge ?1864. 1992-4-6-148 *G. Thomas*

149 JONES, M., *Stories of the Olden Time*, Cassell, Petter & Galpin 1870. 1992-4-6-149 *Crane*

150 JUDKIN, Rev. J. T., *By-Gone Moods*, Longman. 1992-4-6-150 *Pickersgill, Gilbert, Mulready, Clayton*

151 KEARY, E., *The Magic Valley or Patient Antoine*, Macmillan 1877. 1992-4-6-151 *EVB (Eleanor Vere Boyle)*

152 KEATS, John, *The Eve of St. Agnes*, Cundall 1856. 1992-4-6-152 *Wehnert*

153 *Kind Words for Boys and Girls*, Henry Hall 1868. 1992-4-6-153 *Pinwell, Gray, Small, E. Dalziel*

154 KINGSLEY, Henry, *The Boy in Grey*, Strahan 1871. 1992-4-6-154 *Arthur Hughes*

155 KRUMMACHER, Frederick Adolphus, *The Parables of Frederick Adolphus Krummacher*, Nathaniel Cooke 1854. 1992-4-6-155 *J. R. Clayton*

156 *Lays of the Holy Land*, James Nisbet 1858. Black morocco leather binding. 1992-4-6-156 *Foster, Pickersgill, Millais*

157 *Lays of the Holy Land*, James Nisbet 1858. As no. 156 but in decorative gilt cloth binding. 1992-4-6-157

158 LEE, Holme (pseud. of PARR, Harriet), *The True, Pathetic History of Poor Match*, Smith Elder 1863. 1992-4-6-158 *Crane*

159 [LEIGHTON, Frederick], *Twenty Five Illustrations by Frederick Leighton*, Smith Elder 1867. 1992-4-6-159 *Leighton*

160 LEIGHTON, John, *The Life of Man symbolised by the Months of the Year*, Longmans 1866. 1992-4-6-160 *John Leighton*

161 LEIGHTON, John, *Moral Emblems*, Longman 1860. 1992-4-6-161 *John Leighton*

162 LEMON, Mark, *The Jest Book*, Macmillan 1864. 1992-4-6-162 *Keene*

163 LEMON, Mark, *Legends of Number Nip*, Macmillan 1864. 1992-4-6-163 *Keene*

164 LEMON, Mark, *Tinykin's Transformations*, Bradbury, Evans & Co. 1869. 1992-4-6-164 *Charles Green*

165 LESLIE, Henry, *Little Songs for Me to Sing*, Cassell, Petter & Galpin [1865]. 1992-4-6-165 *Millais*

166 LETTER from Harold Hartley to a member of the Dalziel family. Dated 12 May 1925. 1992-4-6-166

167 LETTER from Hubert Herkomer to Edward Dalziel dated 16 September 1875. Relates to fund to assist Pinwell's widow. See no. 80. 1992-4-6-167

168 LETTER from Holman Hunt to Jean Ingelow dated 17 May 1875. 1992-4-6-168

169 LETTER from Millais to William Allingham dated 8 January 1855. 1992-4-6-169

170 LETTER from Millais to Lucas dated 19 July 1861. 1992-4-6-170

171 LETTER from J. W. North to Mrs Hart dated 29 June 1909. 1992-4-6-171

172 LIEFDE, Rev. Jan de, *The Postman's Bag*, Strahan 1862. 1992-4-6-172 *Pettie*

173 LINTON, E. Lynn, *The Lake Country*, Smith Elder & Co. 1864. 1992-4-6-173 *W. J. Linton*

174 LLOYD, Mrs W. R., *The Flower of Christian Chivalry*, James Hogg & Sons [1863]. 1992-4-6-174 *Watson*

175 LONGFELLOW, Henry Wadsworth, *The Courtship of Miles Standish*, W. Kent & Co. 1859. 1992-4-6-175 *John Absolon, Birket Foster*

176 LONGFELLOW, Henry Wadsworth, *Evangeline*, David Bogue 1854. 1992-4-6-176 *Birket Foster, Jane Benham (Hay), Gilbert*

177 LONGFELLOW, Henry Wadsworth, *The Golden Legend*, David Bogue 1854. 1992-4-6-177 *Birket Foster, Jane Benham (Hay)*

178 LONGFELLOW, Henry Wadsworth, *Kavanagh*, W. Kent & Co. 1858. 1992-4-6-178 *Birket Foster*

179 LONGFELLOW, Henry Wadsworth, *Poems*, David Bogue 1852. 1992-4-6-179 *Birket Foster, Jane Benham (Hay)*

180 LONGFELLOW, Henry Wadsworth, *Poetical Works*, David Bogue 1856. 1992-4-6-180 *Birket Foster, Jane Benham (Hay)*

181 LONGFELLOW, Henry Wadsworth, *Poetical Works*, Routledge 1857 (first published 1856). 1992-4-6-181 *John Gilbert*

182 LONGFELLOW, Henry Wadsworth, *Poetical Works*, Warne 1867. 1992-4-6-182 *A. W. Cooper, Small, Houghton*

183 LONGFELLOW, Henry Wadsworth, *Poetical Works*, T. Nelson & Sons. 1992-4-6-183 *Small*

184 LONGFELLOW, Henry Wadsworth, *Poetical Works*, Warne 1869. 1992-4-6-184 *North, Cooper, Houghton*

185 LONGFELLOW, Henry Wadsworth, *The Song of Hiawatha*, W. Kent & Co. 1860. 1992-4-6-185 *G. Thomas*

186 LUSHINGTON, Henrietta, *Hacco the Dwarf*, Griffith & Farran 1865. 1992-4-6-186 *Pinwell*

187 LUSHINGTON, Henrietta, *The Happy Home*, Griffith & Farran 1864. 1992-4-6-187 *Pinwell*

188 MACDONALD, Lilia Scott, *Babies' Classics*, Longmans 1904. 1992-4-6-188 *Arthur Hughes*

189 MACDONALD, George, *Alec Forbes of Howglen*, Hurst & Blackett n.d. 1992-4-6-189 *Arthur Hughes*

190 MACDONALD, George, *At the Back of the North Wind*, Strahan 1871. 1992-4-6-190 *Arthur Hughes*

191 MACDONALD, George, *Dealings with the Fairies*, Strahan 1867. 1992–4–6–191 *Arthur Hughes*

192 MACDONALD, George, *The History of Gutta-Percha Willie*, Blackie & Son ?1890s. 1992–4–6–192 *Arthur Hughes*

193 MACKAY, Charles (ed.), *The Home Affections pourtrayed by the Poets*, Routledge 1858. 1992–4–6–193 *Gilbert, Birket Foster, Weir, John Absolon, Pickersgill, Millais*

194 MACKAY, Charles, *The Salamandrine*, Ingram, Cooke & Co. 1853. 1992–4–6–194 *John Gilbert*

195 [MACLAREN, Archibald], *The Fairy Family*, Longman 1857. 1992–4–6–195 *Burne-Jones*

196 MACLAREN, Archibald, *The Fairy Family*, Macmillan 1874. Second edition. 1992–4–6–196 *Burne-Jones*

197 MACLEOD, Rev. Norman, *Character Sketches*, Strahan 1872. 1992–4–6–197 *Artists unidentified*

198 MACLEOD, Rev. Norman, *The Gold Thread*, Strahan 1861. 1992–4–6–198 *Watson*

199 MACLISE, Daniel, *The Story of the Norman Conquest*, Art Union of London 1866. 1992–4–6–199 *Maclise*

200 MAGAZINE: *Britannia*. Vols 1 & 2 1869. 1992–4–6–200 (a & b) *Matt Morgan*

201 MAGAZINE: *Churchman's Family Magazine*. Vols 1 & 2, January to June 1863; July to December 1863. 1992–4–6–201 (a & b) *Millais, Watson, G. Thomas, Armstead, Pickersgill, Lawless, Sandys*

202 MAGAZINE: *Churchman's Family Magazine*. Vol. 1, January to June 1863. As no. 201, but bound in publisher's blue gilt cloth. 1992–4–6–202

203 MAGAZINE: *The Cornhill Magazine*. Vols 1–14, January 1860 to December 1866. 1992–4–6–203 (a–n) *Various artists*

204 MAGAZINE: *The Cornhill Magazine*. Two made-up volumes of illustrations taken from copies of the magazine. 1992–4–6–204 (a & b) *Various artists*

205 MAGAZINE: *The Dark Blue*. Vols 1 & 2, March to August 1871; September 1871 to February 1872. 1992–4–6–205 (a & b) *F. M. Brown, Simeon Solomon*

206 MAGAZINE: *Good Words*. Eleven volumes 1860–71, lacking the 1861 volume. 1992–4–6–206 (a–k) *Various artists*

207 MAGAZINE: *Good Words for the Young*. Vols 1–4, November 1868 to October 1869; November 1869 to October 1870; November 1870 to October 1871; November 1871 to October 1872. 1992–4–6–207 (a–d) *Arthur Hughes, Ernest Griset, Houghton, Herkomer*

208 MAGAZINE: *The Graphic*. Three vols. Vol. 1: December 1869 to June 1870; Vol. 3: January 1871 to June 1871;

Vol. 4: July 1871 to December 1871. 1992–4–6–208 (a–c) *Houghton, Pinwell, S. L. Fildes*

209 MAGAZINE: *The Leisure Hour*. Volume for 1866. 1992–4–6–209 *Simeon Solomon*

210 MAGAZINE: *London Society*. Vol. 2, 1862. 1992–4–6–210 *Crane, Houghton, Lawless, Millais, Poynter, Watson*

211 MAGAZINE: *London Society*. Vols 1, 5 and 6, 1862, 1864, 1864. 1992–4–6–211 (a–c) *Artists as no. 210*

212 MAGAZINE: *Once a Week*. Vols 1, 2, 3, 5, 11, 13: 1: July 1859 to December 1859; 2: December 1859 to June 1860; 3: July 1860 to December 1860; 5: June to December 1861; 11: June to December 1864; 13: June to December 1865. 1992–4–6–212 (a–f) *Various artists*

213 MAGAZINE: *Once a Week*. Three made-up volumes of illustrations taken from copies of the magazine. 1992–4–6–213 (a–c)

214 MAGAZINE: *Punch*. Vol. XLIV 1863. 1992–4–6–214 *Gilbert, du Maurier, Keene, Millais*

215 MAGAZINE: *Punch*. Vol. L, 1866. 1992–4–6–215 *du Maurier*

216 MAGAZINE: *The Quiver*. Four volumes 1866–69. 1992–4–6–216 (a–d) *Various artists*

217 MAGAZINE: *The Shilling Magazine*. Vols 1, 2, 3. 1: May to August 1865; 2: September to December 1865; 3: January to April 1866. 1992–4–6–217 (a–c) *Sandys, Small, J. Lawson, Watson, Paul Gray*

218 MAGAZINE: *The Sunday Magazine*. Five volumes 1866–72, October 1866 to September 1867, October 1868 to March 1869, April 1869 to September 1869, October 1870 to September 1871, October 1871 to September 1872. 1992–4–6–218 (a–e) *Various artists*

219 MASSINGER, Philip, *The Virgin Martyr*, James Burns 1844. 1992–4–6–219 *Pickersgill*

220 McDERMOTT, Edward, *The Merrie Days of England*, William Kent & Co. 1859. 1992–4–6–220 *G. Thomas, Birket Foster, Corbould*

221 MEREDITH, George, *The Shaving of Shagpat*, Chapman & Hall 1865. 1992–4–6–221 *Sandys*

222 MEREDITH, Owen [pseud. of BULWER-LYTTON, Edward], *Lucile*, Chapman & Hall 1868. 1992–4–6–222 *du Maurier*

223 MILLAIS, John Everett, *Millais's Illustrations*, Strahan 1866. 1992–4–6–223 *Millais*

224 [MILLER, William Haig], *The Mirage of Life*, Religious Tract Society [1867]. 1992–4–6–224 *Tenniel*

225 MILTON, John, *Ode on the Morning of Christ's Nativity*, James Nisbet & Co. 1868. 1992–4–6–225 *Small, Albert Moore*

226 MOLLOY, James L., *Our Autumn Holiday on French Rivers*, Bradbury, Agnew & Co. 1874. 1992–4–6–226 *Linley Sambourne*

227 MONTGOMERY, James, *Poems*, Routledge 1860. 1992–4–6–227 *Gilbert, Birket Foster, Pickersgill, Harrison Weir*

228 [MONTGOMERY, Jemima, later TAUTPHOEUS, Baroness von], *Quits*, Richard Bentley 1864. 1992–4–6–228 *du Maurier*

229 *The Months Illustrated by Pen and Pencil*, Religious Tract Society [1864]. 1992–4–6–229 *Gilbert, Barnes, North*

230 MOORE, Thomas, *Lalla Rookh*, Routledge 1860. 1992–4–6–230 *G. Thomas, Pickersgill, Birket Foster, Samuel Palmer*

231 MOORE, Thomas, *Lalla Rookh* Longman 1861. 1992–4–6–231 *Tenniel*

232 MOORE, Thomas, *Poetry and Pictures*, Longman n.d. 1992–4–6–232 *Birket Foster, Maclise, Pickersgill, G. Thomas*

233 MORGAN, Mary de, *The Necklace of Princess Fiorimonde*, Macmillan 1880. 1992–4–6–233 *Walter Crane*

234 [MULOCK, Dinah Maria, later CRAIK, Mrs], *Nothing New*, Hurst & Blackett [1861]. 1992–4–6–234 *Millais*

235 *National Nursery Rhymes*, Routledge & Novello, Ewer & Co. n.d. [1870]. 1992–4–6–235 *Small, Griset, Mahoney, Arthur Hughes, Green, Pinwell*

236 *Nursery Times*. Griffith & Farran 1867. 1992–4–6–236 *John Lawson*

237 *Old English Ballads*, Ward & Lock 1864. 1992–4–6–237 *Birket Foster, G. Thomas, Absolon, Franklin*

238 [ORMEWOOD, Oliver], *Th' Greyt Eggshibishun ...* , Hamilton Adams [1856]. 1992–4–6–238 *Frederic Shields*

239 [ORMEWOOD, Oliver], *Th' Greyt Eggshibishun ...* , Hamilton Adams 1864. 1992–4–6–239 *Unidentified artist*

240 *Our Life Illustrated by Pen and Pencil*, Religious Tract Society [1865]. 1992–4–6–240 *Green, Barnes, Watson, Pinwell, Gilbert, du Maurier*

241 *Our People*, Bradbury, Agnew & Co. 1881. 1992–4–6–241 *Keene*

242 OWEN, Octavius Freire, Mrs, *The Heroines of Domestic Life*, Routledge 1862. 1992–4–6–242 *J. D. Watson*

243 PALGRAVE, Francis Turner, *The Five Days Entertainments at Wentworth Grange*, Macmillan 1868. 1992–4–6–243 *Arthur Hughes*

244 *The Parables of Our Lord and Saviour Jesus Christ*, Routledge 1864. 1992–4–6–244 *Millais*

245 *The Parables of Our Lord and Saviour Jesus Christ*, Society for Promoting Christian Knowledge [1885]. 1992–4–6–245 *Millais*

246 *The Parables of Our Lord and Saviour Jesus Christ*, Twenty India Paper Proofs, Camden Press of Charles Dalziel [1902]. 1992–4–6–246 *Millais*

247 PARNELL, Thomas, *The Hermit*, Camden Press 1904. 1992–4–6–247 *E. Dalziel*

248 *Passages from Modern English Poets*, Day & Son Ltd [1862]. 1992–4–6–248 *Lawless, Tenniel, Whistler, Millais, Clayton, Keene*

249 *Passages from Modern English Poets*, William Tegg [1874]. 1992–4–6–249 *Artists as no. 248.*

250 PATMORE, Coventry, *The Children's Garland from the best Poets*, Macmillan 1873. 1992–4–6–250 *John Lawson*

251 *Pen and Pencil Pictures from the Poets*, William P. Nimmo n.d. 1992–4–6–251 *Small, J. Lawson*

252 PENNELL, Joseph, *An English Illustrator, Sandys*, The Quarto, Vol. 1. 1896. 1992–4–6–252 *Reproduces drawing by Sandys (no. 91)*

253 PERRY, George G., *History of the Crusades*, Society for Promotion of Christian Knowledge n.d. 1992–4–6–253 *J. Mahoney*

254 PHOTOGRAPHS of drawings by Warwick Brookes (18). 1992–4–6–254 (a–r)

255 PHOTOGRAPHS of members of the Dalziel family including Thomas, John, Edward, George, Margaret (on two sheets). 1992–4–6–255 (a & b)

256 PHOTOGRAPHS of six drawings by Frederic Shields for Defoe's *History of the Plague* (no. 78). 1992–4–6–256

257 *Picture Posies*, Routledge 1874. 1992–4–6–257 *Walker, North, Houghton, Pinwell, Watson, Small*

258 *Pictures of English Landscape*, India paper proofs, Routledge [1881]. 1992–4–6–258 *Birket Foster*

259 *Pictures of English Landscape*, Routledge 1863. 1992–4–6–259 *Birket Foster*

260 *Pictures of English Life*, Sampson Low 1865. 1992–4–6–260 *Barnes, Wimperis*

261 *Pictures of Society, Grave and Gay*, Sampson Low, Son and Marston 1866. 1992–4–6–261 *C. H. Bennett, Lawless, du Maurier, Crane, Millais, Pickersgill, Watson, G. Thomas, Morten*

262 PLANCHÉ, J. R., *An Old Fairy Tale Told Anew*, Routledge [1866]. 1992–4–6–262 *Richard Doyle*

263 *Poems and Pictures*, Sampson Low, Son and Co. 1860. 1992–4–6–263 *Cope, Creswick, Pickersgill, Tenniel*

264 *The Poetry of Nature*, Sampson Low 1861. 1992–4–6–264 *Harrison Weir*

265 *The Poets of the Elizabethan Age*, Sampson Low 1862. 1992–4–6–265 *Wimperis, Gilbert, Birket Foster*

266 *Poets' Wit and Humour*, Joseph Cundall n.d. 1992–4–6–266 *C. H. Bennett, G. H. Thomas*

267 POLLOK, Robert, *The Course of Time*, William Blackwood & Sons 1857. 1992–4–6–267 *Birket Foster, Tenniel, J. R. Clayton*

268 POLLOK, Robert, *The Course of Time*. As No. 267 but with 'Effie Gray, Xmas 1858' to first blank. 1992–4–6–268

269 *The Prince of Peace*, Seeley, Jackson & Halliday 1858. 1992–4–6–269 *Selous, Humphreys*

270 PROCTER, Adelaide Anne, *Legends and Lyrics*, Bell & Daldy 1866. 1992–4–6–270 *Samuel Palmer, Tenniel, du Maurier, Watson, Keene, Morten*

271 *The Parable of the Prodigal Son*, James Nisbet & Co. 1867. 1992–4–6 271 *Selous*

272 PROOF: Ford Madox Brown, 'The Prisoner of Chillon' from Willmott's *Poets of the Nineteenth Century*, p. 111. See no. 398. 1992–4–6–272

273 PROOF: E. Dalziel, 'Look back on early childhood ...' from *Golden Thoughts from Golden Fountains*, p. 103. See no. 113. Touched by the artist. 1992–4–6–273

274 PROOFS: M. J. Lawless, *Pictorial Bible and Church History Stories*, Burnes & Oates 1871. 11 proof wood-engravings. 1992–4–6–274 (1–11)

275 PROOF: Frederick Leighton, 'Will his eyes open?' from George Eliot's *Romola*, *Cornhill Magazine* 1862. See no 203. 1992–4–6–275

276 PROOF: John MacWhirter, 'I met a little cottage girl' from Wordsworth's *Poems for the Young* 1863. See no. 422. 1992–4–6–276

277 PROOF: Millais for *Wace, ses oeuvres* (possibly a work never published). 1992–4–6–277

278 PROOF: Millais 'The Fireside Story' from Allingham's *The Music Master*, 1855 facing p. 216. See no. 7. 1992–4–6–278

279 PROOF: Millais, 'The Sisters' from the Moxon Tennyson 1857 p. 109. See no. 374. 1992–4–6–279

280 PROOF: Millais, 'The Lord of Burleigh' from the Moxon Tennyson 1857, p. 353. See no. 374. 1992–4–6–280

281 PROOF: Millais, 'The Foolish Virgins' from *The Parables of Our Lord* 1864, p. 16. See No. 244. 1992–4–6–281

282 PROOF: John Pettie, 'Kalampin the Negro' from *Good Words* 1863. See no. 206. 1992–4–6–282

283 PROOF: Pinwell unidentified. Lady picking weed and a couple strolling. Touched by the artist. 1992–4–6–283

284 PROOF: Sandys, 'Manoli' from *The Cornhill Magazine* 1862. See no. 203. 1992–4–6–284

285 PROOF: William Small unidentified. A woman feeding chickens. 1992–4–6–285

286 PROOF: William Small, 'My Little Gipsy Cousin' from *Good Words for the Young* March 1871. Touched by the artist. See no. 207. 1992–4–6–286

287 PROOF: William Small unidentified. A girl writing at a desk. Touched by the artist. 1992–4–6–287

288 PROOF: William Small unidentified. Sleeping girl shepherdess with sheep. 1992–4–6–288

289 PROOF: William Small unidentified. Boy playing flute by stream. Touched by the artist. 1992–4–6–289

290 PROOF: Artist unidentified. Woman crossing bridge in wood. 1992–4–6–290

291 PROOF: Artist unidentified. Lovers on a garden seat with an old man eavesdropping. 1992–4–6–291

292 PROOF: Frederick Walker, 'Hand and Glove' from *The Adventures of Philip*, *The Cornhill Magazine*. See no. 203. 1992–4–6–292

293 PROOF: J. D. Watson, 'Christiana repents' from *Pilgrim's Progress* 1861. See no. 40. 1992–4–6–293

294 PROOF: J. D. Watson, 'The Curate of Suverdsio' from *Good Words*. See no. 206. 1992–4–6–294

295 PROOFS: A. B. Houghton, Album of proofs from Dalziel's *Don Quixote*, nos 62, 63. 1992 4 6 295 (1ff)

296 PROOFS: Arthur Hughes, Album of proofs from *Enoch Arden* 1866 no. 571. 1992 4 6 296 (1ff)

297 PROOFS: Millais, Album of proofs 1856–62. 1992–4–6–297 (1ff)

298 PROOFS: Williams family, Album of proofs by Samuel, Thomas and Mary Ann Williams. 1992–4–6–298 (1ff)

299 PROOFS: H. N. Woods, Album of proofs by H. N. Woods. 1992–4–6–299 (1ff)

300 *The Proverbs of Solomon*, James Nisbet & Co. 1858. 1992–4–6–300 *Gilbert*

301 RALSTON, William R. S., *Krilof and his Fables*, Strahan 1869. 1992–4–6–301 *Houghton*

302 [RANDS, William Brighty], *Lilliput Lectures*, Strahan 1871. 1992–4–6–302 *Arthur Hughes*

303 [RANDS, William Brighty], *Lilliput Levee*, Strahan 1864. 1992–4–6–303 *Millais, Pinwell*

304 [RANDS, William Brighty], *Lilliput Levee*, Strahan 1867. 1992–4 6 304 *Millais, Pinwell, Basil Bradley, Charles Green*

305 R., E. A., *The Carterets*, James Hogg & Sons n.d. 1992–4–6–305 *T. Dalziel*

306 REFERENCE: Barr, John 'Picture Fables' Offprint from *19th Century STC Newsletter*, no. 7, March 1991. Deals with Otto Speckter. See no. 126. 1992–4–6–306

307 REFERENCE: Barton, J. E., 'The Wood-engraved illustrations of the Sixties', *Penrose Annual*, Vol. xxvii, 1925. 1992-4-6-307

308 REFERENCE: de Beaumont, Robin, Stanley Gibbons book catalogues nos 1–3. 1992-4-6-308

309 REFERENCE: de Beaumont, Robin, Catalogues nos 1–13. 1992-4-6-309

310 REFERENCE: de Beaumont, Robin, 'Sixties Illustrators' offprint from *Discovering Antiques*, issue 68, January 1972. 1992-4-6-310

311 REFERENCE: de Beaumont, Robin 'The Rise and Decline of Wood Engraving', *Print Quarterly*, Vol. iii, no. 1, 1986. Book review. 1992-4-6-311

312 REFERENCE: de Beaumont, Robin Review of exhibition, 'Ladies of Shallott', *Print Quarterly*, Vol. iii, no. 4, 1986. 1992-4-6-312

313 REFERENCE: 'In Memoriam, Warwick Brookes' reprint from *Manchester City News*, 26 August, 2 and 9 September 1882. 1992-4-6-313

314 REFERENCE: Carr, Comyns, *Frederick Walker*, published by Robert Dunthorne's Gallery 1885. 1992-4-6-314

315 REFERENCE: Casteras, Susan P. and others, *Pocket Cathedrals*, exhibition catalogue, New Haven, Yale Center for British Art, 1991. 1992-4-6-315

316 REFERENCE: Dalziel, Gilbert, 'Wood-engravings in the Sixties', *Print Collector's Quarterly*, Vol. 15, no. 1, January 1928. 1992-4-6-316

317 REFERENCE: Gilks, Thomas, *Origin and Progress of Wood-Engraving*, A. N. Myers & Co. 1868. 1992-4-6-317

318 REFERENCE: White, Gleeson, 'In Memoriam – Matthew James Lawless', *The Quarto*, Vol. 4, 1898. 1992-4-6-318

319 REFERENCE: White, Gleeson, *Catalogue of Books from the Library of the late Gleeson White*, A. Lionel Isaacs 1899. 1992-4-6-319

320 REFERENCE: Hartley, Harold, *Eighty-Eight Not Out*, Frederick Muller 1939. 1992-4-6-320

321 REFERENCE: Hartley, Harold, 'George John Pinwell', *Print Collectors' Quarterly*, Vol. 11, no. 2, April 1924. 1992-4-6-321

322 REFERENCE: Hartley Collection, Sarah Phelps, 'The Hartley Collection of Victorian Illustration', xerox from *Boston Museum Bulletin*, Vol. lxxi, 1973. 1992-4-6-322

323 REFERENCE: Houfe, Simon, 'Pleasure to Engrave', offprint from *Country Life*, 17 January 1991. 1992-4-6-323

324 REFERENCE: Landow, George P., *Ladies of Shallott*, exhibition catalogue, Brown University, Rhode Island, 1985. 1992-4-6-324

325 REFERENCE: George Somes Layard, *Tennyson and his Pre-Raphaelite illustrators*, Elliot Stock, 1894. 1992-4-6-325

326 REFERENCE: Letherbrow, T., *Warwick Brookes' Pencil Pictures of Child Life*, J. E. Cornish 1889. 1992-4-6-326

327 REFERENCE: Life, Allan, 'That unfortunate young man Morten', *Bulletin* of the John Rylands Library, Manchester, 1973. Contains an original drawing by Morten referred to on p. 381, note 1. 1992-4-6-327

328 REFERENCE: Millais, J. G., *The Life and Letters of Sir John Everett Millais*, Methuen, 1899. 1992-4-6-328

329 REFERENCE: Millais: *The Drawings of John Everett Millais*, exhibition catalogue, Arts Council 1979. 1992-4-6-329

330 REFERENCE: Catalogue, *The Illustrated Books of the Sixties*, Pickering & Chatto [1906]. 1992-4-6-330

331 REFERENCE: Forrest Reid, 'Charles Keene, Illustrator', *Print Collector's Quarterly*, Vol. 17, no. 1, January 1930. 1992-4-6-331

332 REFERENCE: Spanton, W. S., *An Art Student and his Teachers in the Sixties*, Robert Scott 1927. 1992-4-6-332

333 REFERENCE: Sullivan, E. J., 'Arthur Boyd Houghton', *Print Collector's Quarterly*, Vol. 10, nos 1 and 2, February and April 1923. 1992-4-6-333

334 REFERENCE: Wood, Esther, *A Consideration of the Art of Frederick Sandys*, Archibald Constable [1896]. 1992-4-6-334

335 REID, Captain Mayne, *The Boy Tar*, W. Kent & Co. 1860. 1992-4-6-335 *Keene*

336 *Rhymes and Roundelayes in Praise of a Country Life*, David Bogue 1857. 1992-4-6-336 *Birket Foster, John Absolon, Harrison Weir*

337 *Rhymes and Roundelayes in Praise of a Country Life*, Routledge 1875. 1992-4-6-337 *Artists as no. 336*

338 [RICHMOND, D.], *Accidents of Childhood*, Routledge 1866. 1992-4-6-338 *J. D. Watson*

339 ROBERTS, John R. (ed.), *The Legendary Ballads of England and Scotland*, Warne 1868. 1992-4-6-339 *Walter Crane et al.*

340 ROGERS, Samuel, *The Pleasures of Memory*, Sampson Low [1865]. 1992-4-6-340 *Samuel Palmer, Watson, Wimperis*

341 *Roses and Holly*, William P. Nimmo 1867. 1992-4-6-341 *McWhirter, J. Lawson*

342 ROSSETTI, Christina, *Goblin Market*, Macmillan 1862. 1992-4-6-342 *D. G. Rossetti*

343 ROSSETTI, Christina, *Goblin Market*, Macmillan 1865. 1992-4-6-343 *D. G. Rossetti*

344 ROSSETTI, Christina, *The Prince's Progress*, Macmillan 1866. 1992-4-6-344 *D. G. Rossetti*

345 ROSSETTI, Christina, *Sing-Song*, Routledge 1872.
1992–4–6–345 *Arthur Hughes*

346 *A Round of Days*, Routledge 1866. 1992–4–6–346
Houghton, Morten, North, Pinwell, Walker, Watson

347 ROWLEY, Charles, *A Treasury for the Young of all Ages*,
Sherratt & Hughes 1903. 1992–4–6–347 *Reproductions of*
designs by F. M. Brown, Shields, Watson, du Maurier,
W. B. Scott

348 RUSKIN, John, *The King of the Golden River*, Smith
Elder 1851. 1992–4–6–348 *Richard Doyle*

349 SALE-BARKER, Lucy Elizabeth, *Routledge's Holiday*
Album for Girls, Routledge [1877]. 1992–4–6–349 *Gilbert,*
Watson, Small, Walker

350 SANDS, J., *King James' Wedding*, T. Buncle 1888.
1992–4–6–350 *Keene*

351 SANDYS, Mary, *Reproductions of Woodcuts by*
F. Sandys, Carl Hentschel Ltd [1910]. 1992–4–6–351
Sandys

352 *de Santillane, Gil Blas*, Alan René Le Sage, Routledge
1866. 1992–4–6–352 *Pinwell*

353 SEAMER, Mrs, *The Young Missionaries*, Sunday School
Union [1874]. 1992–4–6–353 *Artist unidentified*

354 SEGUIN, L. G., *Rural England*, Strahan [1885].
1992–4–6–354 *Millais, Small, Pettie, North, Watson,*
Pinwell, Hughes

355 SHAKESPEARE, William, *The Merchant of Venice*,
Sampson Low 1860. 1992–4–6–355 *Birket Foster,*
G. Thomas

356 SHAKESPEARE, William, *Seven Ages of Man*, Art Union
of London 1850. 1992–4–6–356 *Daniel Maclise*

357 SHAKESPEARE, William, *Songs and Sonnets*,
Sampson Low 1863. 1992–4–6–357 *John Gilbert*

358 SHAKESPEARE, William, *The Tempest*, Bell & Daldy
[1860]. 1992–4–6–358 *Birket Foster, Doré*

359 *The Silver Bells*, James Parker & Co. 1870.
1992–4–6–359 *Arthur Hopkins*

360 SMEDLEY, Menella Bute and HART, Mrs E. A., *Poems*
written for a Child, Strahan 1868. 1992–4–6–360 *Zwecker*

361 *Songs of the Brave. In Honorem*, Sampson Low 1856.
1992–4–6–361 *Birket Foster, G. Thomas*

362 *Songs of the Brave. The Soldier's Dream*, A variant of
no. 361. Dates and artists identical. 1992–4–6–362

363 SOUTHGATE, Henry, *What Men have said about*
Woman, Routledge 1865. 1992–4–6–363 *J. D. Watson*

364 *The Spirit of Praise*, Routledge [1866]. 1992–4–6–364
T. and E. Dalziel, Pinwell, Houghton, Small, North

365 *Spiritual Conceits*, Griffith and Farran 1862.
1992–4–6–365 *W. Harry Rogers*

366 ST. A., J. H. (trans.) [J. C. von Schmid], *Basket of*
Flowers, T. Nelson & Sons 1864. 1992–4–6–366 *Small*

367 SWIFT, Jonathan, *Gulliver's Travels*, Cassell, Petter &
Galpin [1865]. 1992–4–6–367 *Thomas Morten*

368 [TAYLOR, Jane and Ann], *Original Poems*, Routledge
1868. 1992–4–6–368 *Barnes, Wimperis, J. Lawson*

369 TAYLOR, Tom, *Ballads and Songs of Brittany*,
Macmillan 1865. Presentation copy from author to Millais.
1992–4–6–369 *Millais, Tissot, Tenniel, Keene*

370 TEMPLE, Ralph and Chandos, *The Temple Anecdotes*,
Groombridge and Sons 1865. 1992–4–6–370 *Houghton,*
T. Dalziel

371 TENNYSON, Alfred, *Enoch Arden*, Edward Moxon
1866. 1992–4–6–371 *Arthur Hughes*

372 TENNYSON, Alfred, *Enoch Arden* (in Latin),
Edward Moxon 1867. In same binding as 371 but without
the Hughes illustrations. 1992–4–6–372

373 TENNYSON, Alfred, *The May Queen*, Sampson Low
1861. 1992–4–6–373 *Eleanor Vere Boyle (EVB)*

374 TENNYSON, Alfred, *Poems* (The 'Moxon Tennyson'),
Edward Moxon 1857. 1992–4–6–374 *W. H. Hunt,*
Millais, Rossetti, Horsley, Stanfield, Maclise

375 TENNYSON, Alfred, *The Princess*, Edward Moxon
1860. 1992–4–6–375 *Maclise*

376 TENNYSON, Alfred, *Some Poems by Alfred Lord*
Tennyson, Freemantle & Co. 1901. 1992–4–6–376 *Artists*
as no. 374

377 [THACKERAY, Anne], *The Story of Elizabeth*, Smith
Elder 1867. 1992–4–6–377 *F. Walker*

378 THACKERAY, W. M., *The History of Henry Esmond*,
Smith Elder 1868. 1992–4–6–378 *du Maurier*

379 THACKERAY, W. M., *Nineteen Illustrations by William*
M. Thackeray, Smith Elder n.d. 1992–4–6–379 *Thackeray*

380 THOMAS, George H., *One Hundred of the best*
Drawings by George H. Thomas, Cassell, Petter & Galpin
[1869]. 1992–4–6–380 *G. Thomas*

381 THOMSON, James, *The Seasons*, James Nisbet & Co.
1859. 1992–4–6–381 *Birket Foster, Pickersgill, Wolf,*
G. Thomas

382 THORNBURY, Walter, *Historical and Legendary Ballads*
and Songs, Chatto & Windus 1876. 1992–4–6–382
Sandys, Morten, Lawless, Pinwell, Houghton, Small,
Tenniel, Whistler, Walker, Keene

383 THORNBURY, Walter, *Two Centuries of Song*,
Sampson Low 1867. 1992–4–6–383 *H. S. Marks, Morten,*
Small, Wolf

384 TILLOTSON, John, *Our Untitled Nobility*, James Hogg
& Sons ?1863. 1992–4–6–384 *Charles Green*

385 *Touches of Nature*, Strahan 1867. 1992–4–6–385
Sandys, Walker, Millais, Pinwell, Houghton, Lawless,
du Maurier, Watson, Small, Keene

386 TROLLOPE, Anthony, *Orley Farm*, Chapman & Hall
1862 (two vols). 1992–4–6–386 *Millais*

387 TUPPER, Martin, *Proverbial Philosophy*,
Thomas Hatchard 1854. 1992–4–6–387 *Tenniel, Gilbert,*
T. Dalziel, Birket Foster

388 TYTLER, Sarah (pseud. of KEDDIE, Henrietta),
Citoyenne Jacqueline, Strahan 1866. 1992–4–6–388
Houghton

389 TYTLER, Sarah (pseud. of KEDDIE, Henrietta), *Papers*
for Thoughtful Girls, Strahan 1863. 1992–4–6–389 *Millais*

390 VAUGHAN, Herbert, *The Cambridge Grisette*, Tinsley
Brothers 1862. 1992–4–6–390 *Keene*

391 [WARNER, Susan Bogert and WARNER, Anna Bartlett],
Ellen Montgomery's Bookshelf, Warne 1867.
1992–4–6–391 *J. D. Watson*

392 WATTS, Isaac, *Divine and Moral Songs*, Sampson Low
1866. 1992–4–6–392 *Barnes, Small*

393 WATTS, Isaac, *Divine and Moral Songs for Children*,
James Nisbet & Co. [1867]. 1992–4–6–393
Holman Hunt, Watson, du Maurier, Morten

394 WATTS, John G., *Little Lays for Little Folks*, Routledge
1867. 1992–4–6–394 *Barnes, Small, Charles Green*

395 *Wayside Posies*, Routledge 1867. 1992–4–6–395
Pinwell, North, Walker

396 WARTON, Thomas, *The Hamlet*, Sampson Low 1859.
1992–4–6–396 *Birket Foster*

397 WARTON, Thomas, *The Hamlet*, Routledge 1876.
1992–4–6–397 *Birket Foster*

398 WILLMOTT, Robert Aris (ed.), *The Poets of the*
Nineteenth Century, Routledge 1857. Contains letter from
Brown to Edward Dalziel. 1992–4–6–398 *Birket Foster,*
Tenniel, Pickersgill, Millais, F. M. Brown

399 WILLMOTT, Robert Aris (ed.), *English Sacred Poetry*,
Routledge 1862. 1992–4–6–399 *Holman Hunt, Watson,*
Keene, Armstead, Pickersgill, Sandys, Walker

400 WILLMOTT, Robert Aris (ed.), *English Sacred Poetry*,
Routledge 1862. As no. 399 but in morocco leather and
containing letter from Holman Hunt to Thomas Combes.
1992–4–6–400

401 WILLMOTT, Robert Aris, *Summer Time in the Country*,
Routledge 1858. 1992–4–6–401 *Birket Foster,*
Harrison Weir, J. M. Carrick

402 WINKWORTH, Catherine, *Lyra Germanica*, Longmans
1861. 1992–4–6–402 *Leighton, Lawless, Armitage, Keene*

403 WINKWORTH, Catherine, *Lyra Germanica*, Longmans
1868. 1992–4–6–403 *Leighton, Armitage, F. M. Brown*

404 WISE, John R., *The New Forest*, Smith Elder 1863.
1992–4–6–404 *Walter Crane*

405 WOOD, Rev. J. G., *Glimpses into Petland*, Bell & Daldy
1863. 1992–4–6–405 *Walter Crane*

406 WOODBLOCK: J. R. Clayton, 'Artevelde in Ghent' from
Poets of the Nineteenth Century, 1857, p. 307. (See no. 398).
1992–4–6–406

407 WOODBLOCK: J. R. Clayton, 'Wine of Cyprus' from
Poets of the Nineteenth Century, 1857, p. 331. (See no. 398.)
1992–4–6–407

408 WOODBLOCK: Edward Dalziel, 'The History of a Life'
from *Poets of the Nineteenth Century*, 1857, p. 351. (See
no. 398.) 1992–4–6–408

409 WOODBLOCK: John Gilbert, 'Luxuriant vines and
golden harvests grew' from *Montgomery's Poems*, 1860,
p. 113. (See no. 227.) 1992–4–6–409

410 WOODBLOCK: John Gilbert, 'They met as they were
often wont to meet' from *Montgomery's Poems*, 1860,
p. 125. (See no. 227.) 1992–4–6–410

411 WOODBLOCK: John Gilbert, 'Throned on a rock the
Giant-king appears' from *Montgomery's Poems*, 1860,
p. 179. (See No. 227.) 1992–4–6–411

412 WOODBLOCK: John Gilbert, 'O'er the ocean's dark
expanse' from *Montgomery's Poems*, 1860, p. 367. (See
No. 227.) 1992–4–6–412

413 WOODBLOCK: A. B. Houghton, 'The Bride of Abydos'
from *The Poetical Works of Byron*, c.1878, p. 190. (See
no. 49.) 1992–4–6–413

414 WOODBLOCK: J. W. North, 'I leaned out of the window
. . .' from Jean Ingelow, *Songs of Seven*, 1866, p. 11. (See
no. 139.) 1992–4–6–414

415 WOODBLOCK: F. R. Pickersgill, 'The Water Nymph'
from *Poets of the Nineteenth Century*, 1857, p. 277. (See
no. 398.) 1992–4–6–415

416 WOODBLOCK: G. J. Pinwell, Unidentified, uncut.
1992–4–6–416

417 WOODBLOCK: John Tenniel, 'Rienzi and his Daughter'
from *Poets of the Nineteenth Century*, 1857, p. 225. (See
no. 398.) 1992–4–6–417

418 WOODBLOCK: Unidentified 'A. R.'. 1992–4–6–418

419 WOODBLOCK: Unidentified 'W. J. M.' 'A Message from
the Grave'. 1992–4–6–419

420 WOOLNER, Thomas, *My Beautiful Lady*, Macmillan
1866. 1992–4–6–420 *Arthur Hughes*

421 WORDSWORTH, William, *Poems*, Routledge 1859.
1992–4–6–421 *Birket Foster, Joseph Wolf, Gilbert*

422 WORDSWORTH, William, *Poems for the Young*, Strahan
1863. Contains letter from Effie Millais to Edward Dalziel.
1992–4–6–422 *Millais, Pettie*

423 WORDSWORTH, William, *The White Doe of Rylstone*,
Longmans 1859. 1992–4–6–423 *Birket Foster*

424 WRAXALL, Sir Lascelles, *Golden-Hair*, Sampson Low
1865. 1992–4–6–424 *Thomas Morten*

425 Descriptive handlist of the collection compiled by Robin
de Beaumont. 1992–4–6–425

The following entries 426–592 are separate sheets and
are listed alphabetically under the illustrator's name.

426 Arthur Boyd Houghton (1836–75)
'My Treasure', wood-engraving from *Good Words*, 1862,
p. 504. Engraved by Dalziel. 1992–4–6–426

427 Arthur Boyd Houghton
'True or False?', wood-engraving from *Good Words*, 1862,
p. 721. Engraved by Dalziel. 1992–4–6–427

428 Arthur Boyd Houghton
'About Toys', wood-engraving from *Good Words*, 1862,
p. 753. Engraved by Dalziel. 1992–4–6–428

429 Arthur Boyd Houghton
'St Elmo', wood-engraving from *Good Words*, 1863, p. 64.
Engraved by Dalziel. 1992–4–6–429

430 Arthur Boyd Houghton
'A Missionary Cheer', wood-engraving from *Good Words*,
1863, p. 547. Engraved by Dalziel. 1992–4–6–430

431 Arthur Boyd Houghton
'Childhood', wood-engraving from *Good Words*, 1863,
p. 636. Engraved by Dalziel. 1992–4–6–431

432 Arthur Boyd Houghton
'The Voyage', wood-engraving from *Good Words*, 1 August
1866, p. 523. No engraver's name. 1992–4–6–432

433 Arthur Boyd Houghton
'Reaping', wood-engraving from *Good Words*, 1 September
1866, p. 600. Engraved by W. J. Linton. 1992–4–6–433

434 Arthur Boyd Houghton
'Harvest', wood-engraving from *Good Words*, 1 September
1866, p. 600. Engraved by W. J. Linton. 1992–4–6–434

435 Arthur Boyd Houghton
'Carrying', wood-engraving from *Good Words*, 1 September
1866, p. 601. Engraved by W. J. Linton. 1992–4–6–435

436 Arthur Boyd Houghton
'Gleaning', wood-engraving from *Good Words*, 1 September
1866, p. 601. Engraved by W. J. Linton. 1992–4–6–436

437 Arthur Boyd Houghton
'Omar and the Persian', wood-engraving from *Good Words*,
1 February 1867, p. 105. Engraved by Dalziel.
1992–4–6–437

438 Arthur Boyd Houghton
'Making Poetry', wood-engraving from *Good Words*, 1 April
1867, p. 248. Engraved by Dalziel. 1992–4–6–438

439 Arthur Boyd Houghton
'The Victim', wood-engraving from *Good Words*, 1 January
1868, p. 18. Engraved by Dalziel. 1992–4–6–439

440 Arthur Boyd Houghton
'The Pope and Cardinals', wood-engraving from *Good
Words*, 1 May 1868, p. 305. No engraver's name.
1992–4–6–440

441 Arthur Boyd Houghton
'The Gold Bridge', wood-engraving from *Good Words*,
1 May 1868, p. 321. Engraved by Dalziel. 1992–4–6–441

442 Arthur Boyd Houghton
'How it all happened', wood-engraving from *Good Words*,
1 August 1868, p. 484. Engraved by Dalziel. 1992–4–6–442

443 Arthur Boyd Houghton
'Dance, my children', wood-engraving from *Good Words*,
1 September 1868, p. 568. Engraved by Dalziel.
1992–4–6–443

444 Arthur Boyd Houghton
'Baraduree Justice', wood-engraving from *Good Words*,
1871, p. 464. Engraved by Dalziel. 1992–4–6–444

445 Arthur Boyd Houghton
'One hand a vase of water bore . . .', wood-engraving from
the *Sunday Magazine*, 5 May 1865. Engraved by Dalziel.
1992–4–6–445

446 Arthur Boyd Houghton
'The Huguenot Family in the English Village',
wood-engraving from the *Sunday Magazine*, 1 October
1866, p. 5. Engraved by Dalziel. 1992–4–6–446

447 Arthur Boyd Houghton
'A Proverb illustrated', wood-engraving from the *Sunday
Magazine*, 1 October 1866, p. 33. Engraved by Dalziel.
1992–4–6–447

448 Arthur Boyd Houghton
'The Huguenot family in the English village',
wood-engraving from the *Sunday Magazine*, 1 November
1866, p. 77. Engraved by Dalziel. 1992–4–6–448

449 Arthur Boyd Houghton
'Heroes', wood-engraving from the *Sunday Magazine*,
1 November 1866, p. 129. Engraved by Dalziel.
1992–4–6–449

450 Arthur Boyd Houghton
'The Huguenot family in the English village',
wood-engraving from the *Sunday Magazine*, 1 December
1866, p. 177. Engraved by Dalziel. 1992–4–6–450

451 Arthur Boyd Houghton
'The Huguenot family in the English village',
wood-engraving from the *Sunday Magazine*, 1 January
1867, p. 228. Engraved by Dalziel. 1992–4–6–451

452 Arthur Boyd Houghton
'The Huguenot family in the English village',
wood-engraving from the *Sunday Magazine*, 1 January
1867, p. 256. Engraved by Dalziel. 1992–4–6–452

453 Arthur Boyd Houghton
'The Huguenot family in the English village',
wood-engraving from the *Sunday Magazine*, 1 February
1867, p. 292. Engraved by Dalziel. 1992–4–6–453

454 Arthur Boyd Houghton
'The Martyr', wood-engraving from the *Sunday Magazine*, 1 February 1867, p. 345. Engraved by Dalziel. 1992–4–6–454

455 Arthur Boyd Houghton
'The Huguenot family in the English village', wood-engraving from the *Sunday Magazine*, 1 March 1867, p. 364. Engraved by Dalziel. 1992–4–6–455

456 Arthur Boyd Houghton
'The Huguenot family in the English village', wood-engraving from the *Sunday Magazine*, 1 April 1867, p. 433. Engraved by Dalziel. 1992–4–6–456

457 Arthur Boyd Houghton
'The Huguenot Family in the English village', wood-engraving from the *Sunday Magazine*, 1 May 1867, p. 506. Engraved by Dalziel. 1992–4–6–457

458 Arthur Boyd Houghton
'The Huguenot family in the English village', wood-engraving from the *Sunday Magazine*, 1 June 1867, p. 580. Engraved by Dalziel. 1992–4–6–458

459 Arthur Boyd Houghton
'The Huguenot family in the English village', wood-engraving from the *Sunday Magazine*, 1 July 1867, p. 651. Engraved by Dalziel. 1992–4–6–459

460 Arthur Boyd Houghton
'The Huguenot family in the English village', wood-engraving from the *Sunday Magazine*, 1 August 1867, p. 723. Engraved by Dalziel. 1992–4–6–460

461 Arthur Boyd Houghton
'The Huguenot family in the English village', wood-engraving from the *Sunday Magazine*, 1 September 1867, p. 798 but placed as frontispiece. Engraved by Dalziel. 1992–4–6–461

462 Arthur Boyd Houghton
'A lesson to a king', wood-engraving from the *Sunday Magazine*, 1 September 1867, p. 817. Engraved by Dalziel. 1992–4–6–462

463 Arthur Boyd Houghton
'Augustine addressing his flock at Hippo', wood-engraving from the *Sunday Magazine*, 1 October 1867, p. 57. Engraved by Dalziel. 1992–4–6–463

464 Arthur Boyd Houghton
'The Tribes go up to give thanks . . .', wood-engraving from the *Sunday Magazine*, 1 October 1867, p. 67. Engraved by Dalziel. 1992–4–6–464

465 Arthur Boyd Houghton
'Agrippa', wood-engraving from the *Sunday Magazine*, 1 November 1867, p. 88. No engraver's name. 1992–4–6–465

466 Arthur Boyd Houghton
'Festus', wood-engraving from the *Sunday Magazine*, 1 November 1867, p. 88. No engraver's name. 1992–4–6–466

467 Arthur Boyd Houghton
'Felix', wood-engraving from the *Sunday Magazine*, 1 November 1867, p. 88. No engraver's name. 1992–4–6–467

468 Arthur Boyd Houghton
'Sunday songs from Sweden', wood-engraving from the *Sunday Magazine*, 1 November 1867, p. 112. Engraved by Dalziel. 1992–4–6–468

469 Arthur Boyd Houghton
'Conveying the poor fever-stricken patients . . .', wood-engraving from the *Sunday Magazine*, 1 November 1867, p. 118. Engraved by Dalziel. 1992–4–6–469

470 Arthur Boyd Houghton
'The Feast of the Passover', wood-engraving from the *Sunday Magazine*, 1 December 1867, p. 185. Engraved by Dalziel. 1992–4–6–470

471 Arthur Boyd Houghton
'The poor man's shuttle', wood-engraving from the *Sunday Magazine*, 1 January 1868, p. 273. No engraver's name. 1992–4–6–471

472 Arthur Boyd Houghton
'The Feast of Pentecost', wood-engraving from the *Sunday Magazine*, 1 February 1868, p. 296. Engraved by Dalziel. 1992–4–6–472

473 Arthur Boyd Houghton
'George Herbert's last Sunday', wood-engraving from the *Sunday Magazine*, 1 April 1868, p. 424. Engraved by Dalziel. 1992–4–6–473

474 Arthur Boyd Houghton
'The Good Samaritan', wood-engraving from the *Sunday Magazine*, 1 June 1868, p. 552. Engraved by Dalziel. 1992–4–6–474

475 Arthur Boyd Houghton
'The Church of the Basilicas', wood-engraving from the *Sunday Magazine*, 1 June 1868, p. 561. No engraver's name. 1992–4–6–475

476 Arthur Boyd Houghton
'Joseph's Coat', wood-engraving from the *Sunday Magazine*, 1 July 1868, p. 616. Engraved by Dalziel. 1992–4–6–476

477 Arthur Boyd Houghton
'St Paul preaching to the Women . . .', wood-engraving from the *Sunday Magazine*, 1 August 1868, p. 681. Engraved by Dalziel. 1992–4–6–477

478 Arthur Boyd Houghton
'The Parable of the Sower', wood-engraving from the *Sunday Magazine*, 1 September 1868, p. 777. Engraved by Dalziel. 1992–4–6–478

479 Arthur Boyd Houghton
'The Wisdom of Solomon', wood-engraving from the *Sunday Magazine*, 1 October 1868, p. 16. Engraved by Dalziel. 1992–4–6–479

480 Arthur Boyd Houghton
'The Jews in the Ghetto of Rome', wood-engraving from the
Sunday Magazine, 1 October 1868, p. 44. Engraved by
Dalziel. 1992–4–6–480

481 Arthur Boyd Houghton
'Rehoboam, The Foolish Man', wood-engraving from the
Sunday Magazine, 1 November 1868, p. 85. Engraved by
Dalziel. 1992–4–6–481

482 Arthur Boyd Houghton
'Three generations of Jewish Patriotism', wood-engraving
from the *Sunday Magazine*, 1 November 1868, p. 125.
Engraved by Dalziel. 1992–4–6–482

483 Arthur Boyd Houghton
'Miss Bertha', wood-engraving from the *Sunday Magazine*,
1 March 1869, p. 384. Engraved by Dalziel. 1992–4–6–483

484 Arthur Boyd Houghton
'More about Miss Bertha', wood-engraving from the *Sunday
Magazine*, 1 May 1869, p. 513. Engraved by Dalziel.
1992–4–6–484

485 Arthur Boyd Houghton
'The Babylonian Captivity', wood-engraving from the
Sunday Magazine, 1 July 1869, p. 633. Engraved by Dalziel.
1992–4–6–485

486 Arthur Boyd Houghton
'John Baptist', wood-engraving from the *Sunday Magazine*,
1 July 1869, p. 641. Engraved by Dalziel. 1992–4–6–486

487 Arthur Boyd Houghton
'Samson', wood-engraving from the *Sunday Magazine*,
1 September 1869, p. 760. Engraved by Dalziel.
1992–4–6–487

488 Arthur Boyd Houghton
'Sundays on the Continent', wood-engraving from the
Sunday Magazine, 1 November 1869, p. 88. Engraved by
Dalziel. 1992 4 6 488

489 Arthur Boyd Houghton
'Achsah's Wedding gifts', wood-engraving from the *Sunday
Magazine*, 1 November 1869, p. 104. Engraved by Dalziel.
1992–4–6–489

490 Arthur Boyd Houghton
'The Old King Dying', wood-engraving from *Once a Week*,
15 April 1865, p. 643. No engraver's name. 1992–4–6–490

491 Arthur Boyd Houghton
'The Knight-Errant of Arden', wood-engraving from the
Argosy, 1867. Engraved by Dalziel. 1992–4–6–491

492 Arthur Boyd Houghton
'A Spinster's Sweepstake, and what came of it',
wood-engraving from *London Society*, 1867. Engraved by
Dalziel. 1992–4–6–492

493 Matthew James Lawless (1837–64)
'Sentiment from the Shambles', wood-engraving from *Once a
Week*, 17 December 1859, p. 507. Engraved by Swain.
1992–4–6–493

494 Matthew James Lawless
'Sentiment from the Shambles', wood-engraving from *Once a
Week*, 17 December 1859, p. 509. Engraved by Swain.
1992–4–6–494

495 Matthew James Lawless
'The Betrayed', wood-engraving from *Once a Week*,
4 August 1860, p. 155. Engraved by Swain. 1992–4–6–495

496 Matthew James Lawless
'Effie Meadows', wood-engraving from *Once a Week*,
8 September 1860, p. 304. Engraved by Swain.
1992–4–6–496

497 Matthew James Lawless
'The Minstrel's Curse', wood-engraving from *Once a Week*,
22 September 1860, p. 351. No engraver's name.
1992–4–6–497

498 Matthew James Lawless
'The Two Beauties of the Camberwell Assemblies',
wood-engraving from *Once a Week*, 20 October 1860,
p. 462. Engraved by Swain. 1992–4–6–498

499 Matthew James Lawless
'My Angel's Visit', wood-engraving from *Once a Week*,
8 December 1860, p. 658. Engraved by Swain.
1992–4–6–499

500 Matthew James Lawless
'The Death of Oenone', wood-engraving from *Once a Week*,
29 December 1860, p. 14. Engraved by Swain.
1992–4–6–500

501 Matthew James Lawless
'The Death of Oenone', wood-engraving from *Once a Week*,
29 December 1860, p. 15. Engraved by Swain.
1992–4–6–501

502 Matthew James Lawless
'Valentine's Day', wood-engraving from *Once a Week*,
16 February 1861, p. 208. Engraved by Swain.
1992–4–6–502

502 (a) Matthew James Lawless
'Effie Gordon', wood-engraving from *Once a Week*, 6 April
1861, p. 406. No engraver's name. 1992–4–6–502 (a)

503 Matthew James Lawless
'Effie Gordon', wood-engraving from *Once a Week*, 6 April
1861, p. 407. Engraved by Swain. 1992–4–6–503

504 Matthew James Lawless
'The Cavalier's Escape', wood-engraving from *Once a Week*,
15 June 1861, p. 687. Engraved by Swain. 1992–4–6–504

505 Matthew James Lawless
'High Elms', wood-engraving from *Once a Week*, 5 October
1861, p. 420. Engraved by Swain. 1992–4–6–505

506 Matthew James Lawless
'Twilight', wood-engraving from *Once a Week*, 2 November
1861, p. 532. Engraved by Swain. 1992–4–6–506

507 Matthew James Lawless
'King Dyring', wood-engraving from *Once a Week*,
16 November 1861, p. 575. Engraved by J. S. (Swain ?).
1992-4-6-507

508 Matthew James Lawless
'Fleurette', wood-engraving from *Once a Week*, 14 December
1861, p. 700. Engraved by J. S. (Swain ?). 1992-4-6-508

509 Matthew James Lawless
'Dr Johnson's Penance', wood-engraving from *Once a Week*,
28 December 1861, p. 14. Engraved by Swain.
1992-4-6-509

510 Matthew James Lawless
'What befel me at the Assises', wood-engraving from *Once a
Week*, 8 February 1862. No engraver's name.
1992-4-6-510

511 Matthew James Lawless
'The Dead Bride', wood-engraving from *Once a Week*,
10 April 1862, p. 462. Engraved by Swain. 1992-4-6-511

512 Matthew James Lawless
'The Lady Witch', wood-engraving from *Once a Week*,
11 October 1862, p. 434. No engraver's name.
1992-4-6-512

513 Matthew James Lawless
'The Linden Trees', wood-engraving from *Once a Week*,
30 May 1863, p. 644. Engraved by Swain. 1992-4-6-513

514 Matthew James Lawless
'Gifts', wood-engraving from *Once a Week*, 20 June 1863,
p. 712. Engraved by Swain. 1992-4-6-514

515 Matthew James Lawless
'The Jester's passing bell', wood-engraving from *Once a
Week*, 18 July 1863, p. 98. No engraver's name.
1992-4-6-515

516 Matthew James Lawless
'Heinrich Frauenlob', wood-engraving from *Once a Week*,
3 October 1863, p. 393. Engraved by Swain. 1992-4-6-516

517 Matthew James Lawless
'Broken Toys', wood-engraving from *Once a Week*,
5 December 1863, p. 672. No engraver's name.
1992-4-6-517

518 Matthew James Lawless
'Rung into Heaven', wood-engraving from *Good Words*,
1862, p. 153. Engraved by Dalziel. 1992-4-6-518

519 Matthew James Lawless
'The Bands of Love', wood-engraving from *Good Words*,
1862, p. 632. Engraved by Dalziel. 1992-4-6-519

520 Matthew James Lawless
'Not for You', wood-engraving from *London Society*, 1864,
p. 85. Engraved by Walter Barker. 1992-4-6-520

521 Matthew James Lawless
'Expectation', wood-engraving from *London Society*, 1868,
p. 363. Engraved by Walter Barker. 1992-4-6-521

522 John Lawson (*fl.* 1865–1909)
'Annabel Lee', wood-engraving from *Roses and Holly*, 1867,
p. 23. Engraved by Robert Paterson. 1992-4-5-522

523 John Lawson
'The Shepherd Boy's Song', wood-engraving from *Roses and
Holly*, 1867, p. 65. Engraved by Robert Paterson.
1992-4-6-523

524 John Lawson
'The Two Sisters', wood-engraving from *Roses and Holly*,
1867, p. 101. Engraved by Robert Paterson. 1992-4-6-524

525 John Lawson
'The Children's Hour', wood-engraving from *Roses and
Holly*, 1867, p. 130. Engraved by Robert Paterson.
1992-4-6-525

526 John Lawson
'Vanity Fair', wood-engraving from *Roses and Holly*, 1867,
p. 143. Engraved by Robert Paterson. 1992-4-6-526

527 John Lawson
'Waiting for the Foe', wood-engraving apparently from a
later and untraced edition of *Roses and Holly* (p. 86). This
illustration does not appear in the first edition of the book
which is dated 1867. Engraved by Robert Paterson.
1992-4-6-527

528 John Lawson
'Edom O'Gordon', wood-engraving which appeared first in
Ballads Scottish and English, 1867, opp. p. 265. Engraved by
Robert Paterson. 1992-4-6-528

529 John Lawson
'Barthram's Dirge', wood-engraving which appeared first in
Ballads Scottish and English, 1867, opp. p. 329. Engraved by
Robert Paterson. 1992-4-6-529

530 John Lawson
'The Cotter's Saturday Night', wood-engraving from *Poems
and Songs by Robert Burns*, 1868, p. 5. Engraved by Robert
Paterson. 1992-4-6-530

531 John Lawson
'Macpherson's Farewell', wood-engraving from *Poems and
Songs by Robert Burns*, 1868, p. 59. Engraved by Robert
Paterson. 1992-4-6-531

532 John Lawson
'The Rigs o'Barley', wood-engraving from *Poems and Songs
by Robert Burns*, 1868, p. 165. Engraved by Robert
Paterson. 1992-4-6-532

533 John Lawson
'Logan Braes', wood-engraving from *Poems and Songs by
Robert Burns*, 1868, p. 197. Engraved by Robert Paterson.
1992-4-6-533

534 John Lawson
'Open the door to me, O', wood-engraving from *Poems and
Songs by Robert Burns*, 1868, p. 215. Engraved by Robert
Paterson. 1992-4-6-534

535 John Lawson
'The Bonnie Lad that's far awa', wood-engraving from
Poems and Songs by Robert Burns, 1868, p. 233. Engraved
by Robert Paterson. 1992–4–6–535

536 John Lawson
'Bruce's Address to his army at Bannockburn',
wood-engraving from *Poems and Songs by Robert Burns*,
1868, p. 319. Engraved by Robert Paterson. 1992–4–6–536

537 Sir William Quiller Orchardson (1832–1910)
'The Caravansary of Bagdad', wood-engraving from *Good
Words*, 1860, p. 425. Engraved by Frederick Borders.
1992–4–6–537

538 Sir William Quiller Orchardson
'The Lone One', wood-engraving from *Good Words*, 1860,
p. 505. Engraved by Frederick Borders. 1992–4–6–538

539 Sir William Quiller Orchardson
'The Little Girl's Lament', wood-engraving from *Good
Words*, 1860, p. 553. Engraved by Frederick Borders.
1992–4–6–539

540 Sir William Quiller Orchardson
'The Little Screw', wood-engraving from *Good Words*,
1860, p. 609. Engraved by Frederick Borders.
1992–4–6–540

541 Sir William Quiller Orchardson
'One In Every Circle', wood-engraving from *Good Words*,
1860, p. 648. Engraved by Frederick Borders.
1992–4–6–541

542 Sir William Quiller Orchardson
'From the Castle looking down', wood-engraving from *Good
Words*, 1861, p. 80. Engraved by Frederick Borders.
1992–4–6–542

543 John Pettie (1839–1893)
'What sent me to sea', wood-engraving from *Good Words*,
1862, p. 264. Engraved by Dalziel. 1992–4–6–543

544 John Pettie
'The Country Surgeon', wood-engraving from *Good Words*,
1862, p. 713. Engraved by Dalziel. 1992–4–6–544

545 John Pettie
'The Monks and the Heathen', wood-engraving from *Good
Words*, 1863, opp. p. 16. Engraved by Dalziel
1992–4–6–545

546 John Pettie
'The Passion Flowers of Life', wood-engraving from *Good
Words*, 1863, opp. p. 141. Engraved by Dalziel.
1992–4–6–546

547 John Pettie
'The Night Walk over the Mill Stream', wood-engraving
from *Good Words*, 1863, opp. p. 185. Engraved by Dalziel.
1992–4–6–547

548 John Pettie
'Not above his business', wood-engraving from *Good Words*,
1863, opp. p. 272. Engraved by Dalziel. 1992–4–6–548

549 John Pettie
'A Touch of Nature', wood-engraving from *Good Words*,
1863, opp. p. 417. Engraved by Dalziel. 1992–4–6–549

550 John Pettie
'Kalampin the Negro', wood-engraving from *Good Words*,
1863, opp. p. 476. Engraved by Dalziel. 1992–4–6–550

551 John Pettie
'Philip Clayton's First-Born', wood-engraving from the
Sunday Magazine, 1 October 1868, opp. p. 69. Engraved by
Dalziel. 1992–4–6–551

552 George John Pinwell (1842–1875)
'I met her by the yard-gate', wood-engraving from the
Quiver, 10 November 1866, p. 113. Engraved by
C. P. and G. (?Cassell, Petter & Galpin). 1992–4–6–552

553 George John Pinwell
'Home', wood-engraving from the *Quiver*, 5 January 1867,
p. 241. No engraver's name. 1992–4–6–553

554 George John Pinwell
'Sally in our alley', wood-engraving from the *Quiver*,
19 January 1867, p. 273. No engraver's name.
1992–4–6–554

555 George John Pinwell
'Other People's Windows', wood-engraving from the *Quiver*,
2 February 1867, p. 305. Engraved by William Thomas.
1992–4–6–555

556 George John Pinwell
'Frederica', wood-engraving from the *Quiver*, 25 May 1867,
p. 561. Engraved by Swain. 1992–4–6–556

557 George John Pinwell
'The Soldier of Foxdale', wood-engraving from the *Quiver*,
29 June 1867, p. 641. No engraver's name. 1992–4–6–557

558 George John Pinwell
'Guild Court', wood-engraving from *Good Words*, 5 March
1867, p. 146. Engraved by Dalziel. 1992–4–6–558

559 George John Pinwell
'Shall we ever meet again', wood-engraving from *Good
Words*, 1871, p. 817. Engraved by Dalziel. 1992–4–6–559

560 George John Pinwell
'Charles looked rather superciliously at the old woman',
wood-engraving from the *Sunday Magazine*, 1 April 1869.
Engraved by Dalziel. 1992–4–6–560

561 Sir Edward Poynter (1836–1919)
'The Castle by the Sea', wood-engraving from *Once a Week*,
11 January 1862, p. 84. Engraved by Swain. 1992–4–6–561

562 Sir Edward Poynter
'Wife and I', wood-engraving from *Once a Week*, 21 June
1862, p. 724. Engraved by Swain. 1992–4–6–562

563 Sir Edward Poynter
'The Broken Vow' wood engraving from *Once a Week*,
13 September 1862, p. 322. No engraver's name.
1992–4–6–563

564 Sir Edward Poynter
'A Dream of Love', wood-engraving from *Once a Week*,
27 September 1862, p. 365. No engraver's name.
1992-4-6-564

565 Sir Edward Poynter
'A Dream of Love', wood-engraving from *Once a Week*,
4 October 1862, p. 393. Engraved by Swain. 1992-4-6-565

566 Sir Edward Poynter
'A Fellow-Traveller's Story', wood-engraving from *Once a
Week*, 13 December 1862, p. 699. Engraved by Swain.
1992-4-6-566

567 Sir Edward Poynter
'A Fellow-Traveller's Story', wood-engraving from *Once a
Week*, 20 December 1862, p. 722. Engraved by Swain.
1992-4-6-567

568 Sir Edward Poynter
'My Friend's Wedding Day', wood-engraving from *Once a
Week*, 24 January 1863, p. 113. Engraved by Swain.
1992-4-6-568

569 Sir Edward Poynter
'Of a Haunted House in Mexico', wood-engraving from
Once a Week, 31 January 1863, p. 141. No engraver's name.
1992-4-6-569

570 Sir Edward Poynter
'Ducie of the Dale', wood-engraving from *Once a Week*,
18 April 1863, p. 476. Engraved by Swain. 1992-4-6-570

571 Sir Edward Poynter
'Ballad of the Page and the King's Daughter',
wood-engraving from *Once a Week*, 6 June 1863, p. 658.
Engraved by Swain. 1992-4-6-571

572 Dante Gabriel Rossetti (1828-82)
'The Palace of Art', wood-engraving from the Moxon
Tennyson (1866 edition), first published 1857, p. 113.
Engraved by Dalziel. 1992-4-6-572

573 Dante Gabriel Rossetti
'The Palace of Art', wood-engraving from the Moxon
Tennyson (1866 edition), first published 1857, p. 119.
Engraved by Dalziel. 1992-4-6-573

574 Dante Gabriel Rossetti
'Sir Galahad', wood-engraving from the Moxon Tennyson
(1866 edition), first published 1857, p. 305. Engraved by
W. J. Linton. 1992-4-6-574

575 Frederick Sandys (1832-1904)
'Legend of the Portent', wood-engraving from *The Cornhill
Magazine*, 1860, facing p. 617. Engraved by W. J. Linton.
1992-4-6-575

576 Frederick Sandys
'Manoli', wood-engraving from *The Cornhill Magazine*,
1862, facing p. 346. Engraved by Swain. 1992-4-6-576

577 Frederick Sandys
'Cleopatra', wood-engraving from *The Cornhill Magazine*,
1866, facing p. 335. Engraved by Dalziel. 1992-4-6-577

578 Frederick Sandys
'Until her death', wood-engraving from *Good Words*, 1862,
p. 312. Engraved by Dalziel. 1992-4-6-578

579 Frederick Sandys
'Sleep', wood-engraving from *Good Words*, 1863, facing
p. 589. No engraver's name. 1992-4-6-579

580 Frederick Sandys
'From the German of Uhland', wood-engraving from *Once a
Week*, 23 March 1861, p. 350. Engraved by Swain.
1992-4-6-580

581 Frederick Sandys
'The Sailor's Bride', wood-engraving from *Once a Week*,
13 April 1861, p. 434. Engraved by Swain. 1992-4-6-581

582 Frederick Sandys
'From my window', wood-engraving from *Once a Week*,
24 August 1861, p. 238. Engraved by Swain. 1992-4-6-582

583 Frederick Sandys
'The three statues of Aegina', wood-engraving from *Once a
Week*, 26 October 1861, p. 491. Engraved by Swain.
1992-4-6-583

584 Frederick Sandys
'Rosamond, Queen of the Lombards', wood-engraving from
Once a Week, 30 November 1861, p. 631. Engraved by
Swain. 1992-4-6-584

585 Frederick Sandys
'The Old Chartist', wood-engraving from *Once a Week*,
8 February 1862, p. 183. Engraved by Swain.
1992-4-6-585

586 Frederick Sandys
'The King at the Gate', wood-engraving from *Once a Week*,
15 March 1862, p. 322. Engraved by Swain. 1992-4-6-586

587 Frederick Sandys
'Jacques de Caumont', wood-engraving from *Once a Week*,
24 May 1862, p. 614. Engraved by Swain. 1992-4-6-587

588 Frederick Sandys
'Harald Harfagr', wood-engraving from *Once a Week*,
2 August 1862, p. 154. Engraved by Swain. 1992-4-6-588

589 Frederick Sandys
'The Death of King Warwolf', wood-engraving from *Once a
Week*, 30 August 1862, p. 266. Engraved by Swain.
1992-4-6-589

590 Frederick Sandys
'The Boy Martyr', wood-engraving from *Once a Week*,
22 November 1862, p. 602. Engraved by Swain.
1992-4-6-590

591 Frederick Sandys
'The Little Mourner', wood-engraving from *English Sacred
Poetry*, 1862, p. 321. Engraved by Dalziel. 1992-4-6-591

592 Frederick Sandys
'Life's Journey', wood-engraving from *English Sacred Poetry*,
1862, p. 60. Engraved by Dalziel. 1992-4-6-592

Index